The Art & Craft of Hand Lettering

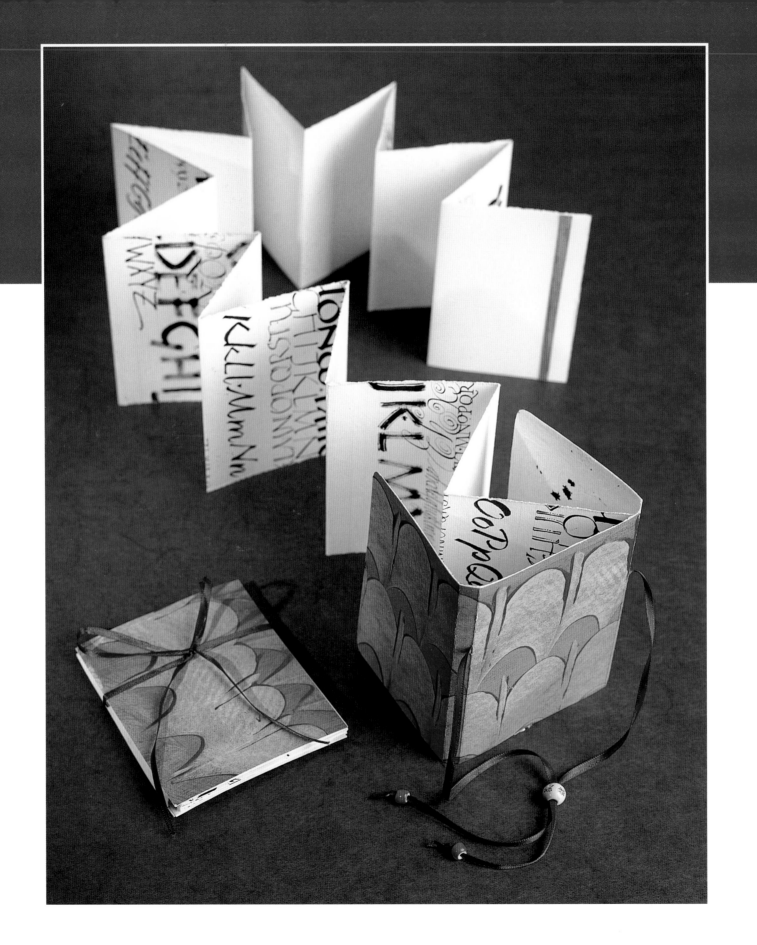

The Art & Craft of Hand Lettering

Techniques Projects Inspiration

Annie Cicale

FEB 03 2005

LARK BOOKS

A Division of
Sterling Publishing Co., Inc.
New York

EDITOR: KATHERINE AIMONE
ART DIRECTORS: CHRIS BRYANT, KRISTI PFEFFER
PHOTOGRAPHER: STEVE MANN
COVER DESIGNER: BARBARA ZARETSKY
ILLUSTRATOR: ANNIE CICALE
ASSISTANT EDITOR: NATHALIE MORNU
ASSOCIATE ART DIRECTOR: SHANNON YOKELEY
EDITORIAL ASSISTANCE: DELORES GOSNELL
ART PRODUCTION: JESSY MAUNEY
EDITORIAL INTERN: RYAN SNIATECKI
ART INTERN: SHAREASE CURL

Library of Congress Cataloging-in-Publication Data

Cicale, Annie, 1950-
 The art & craft of hand lettering : techniques, projects,
inspiration / Annie Cicale.
 p. cm.
 Includes index.
 ISBN 1-57990-403-3
 1. Calligraphy. 2. Lettering. I. Title: Art and craft of hand
lettering. II. Title.
Z43.C59 2004
745.6'1--dc22

 2004000659

10 9 8 7 6 5 4 3 2

Published by Lark Books, a division of
Sterling Publishing Co., Inc.
387 Park Avenue South, New York, N.Y. 10016

© 2004, Annie Cicale

Distributed in Canada by Sterling Publishing,
c/o Canadian Manda Group, 165 Dufferin Street
Toronto, Ontario, Canada M6K 3H6

Distributed in the U.K. by Guild of Master Craftsman Publications Ltd.,
Castle Place, 166 High Street, Lewes, East Sussex, England
BN7 1XU
Tel: (+ 44) 1273 477374, Fax: (+ 44) 1273 478606,
E-mail: pubs@thegmcgroup.com; Web: www.gmcpublications.com

Distributed in Australia by Capricorn Link (Australia) Pty Ltd.,
P.O. Box 704, Windsor, NSW 2756 Australia

If you have questions or comments about this book, please contact:
Lark Books
67 Broadway
Asheville, NC 28801
(828) 253-0467

Manufactured in China
All rights reserved
ISBN 1-57990-403-3

Title Page: Book by Annie Cicale, Kathi Fogleman,
Catherine Langsdorf, and Jayne Brandel

Table of Contents

Introduction

Calligraphy, or *beautiful writing*, captures and elevates the power of the written word. When you see your name, lovingly scribed on an envelope, you think fondly of the person who sent it. Writing with the simplest of tools communicates across time and distance.

When you were a child, you probably picked up a pencil and made your first letters. The power of marks that said "THIS IS MY NAME" was just a beginning. Perhaps you instinctively knew that *other* people with pencils in their hands had written your bedtime stories.

As a child, I was fascinated with writing—not only with the shapes made by the letters that looked like little pictures with personality, but with their connection to communication and literature. My teachers were strict with penmanship, requiring me to write according to traditional Palmer cursive. In the seventh grade, my English teacher wrote a "treasured verse" on the blackboard each week. We copied them down in our notebooks, and in the spring we were required to turn in a small book with them written out in our best handwriting. My friends considered this assignment pure torture, so I kept my delight over the assignment to myself!

The magic of the pen was rekindled when my big brother gave me a calligraphic fountain pen for my eighteenth birthday. The ink that made undulating thick and thin lines was the love potion that began a passion for all kinds of letterforms.

This book, developed out of many years of experience and teaching, covers the foundations that you'll need for learning the craft of lettering—from the fundamentals of tools and equipment to the basics of shape and form. You'll begin with a disciplined approach that teaches you how to see and draw the letterforms. Beyond these basics, you'll learn about drawing and design, topics that are not usually covered in other books on calligraphy. Exposure to a variety of materials, beyond simple pen and ink, will serve to enhance the expressive power of your work. Step-by-step projects at the end of the book guide you through the techniques you'll need to know in order to lay out and design projects. As you work, gallery pieces by internationally recognized artists will lend you inspiration.

You'll begin with formal writing, the traditional scripts that have dominated western literature for hundreds of years. Mastering these forms will take many hours of practice and give you lots of joy. Start with the simpler styles and practice them with a dip pen and ink, since you'll progress more quickly this way.

As you work, don't be tempted to skip steps and jump right into the more complex styles. They're a lot easier to learn once you've covered the basics. At a later point in the book, you'll learn to do thumbnail sketches so you can plan the design of your page. Once you're comfortable with pen and ink, you can try out other surfaces, tools, and inks.

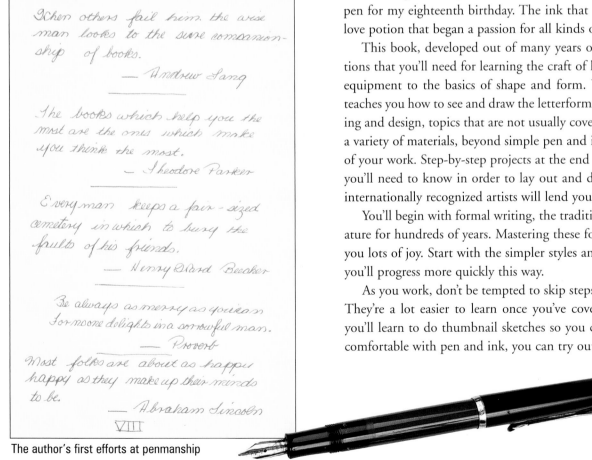

The author's first efforts at penmanship

As you learn to work with your tools and master the basic forms, you might want to supplement your work from this book with a class. A teacher will point out your inconsistencies and show you shortcuts. Of all the things I've learned to do in my life, calligraphy is the field in which teachers made the biggest difference. Their work inspired me to stretch beyond my preconceived ideas of how the written word might be presented.

In my own teaching, I have searched for ways of explaining the complexities of the letterforms. The words you'll read in this book have been distilled from many years of presenting these principles to students of all ages: school children, college students, senior citizens, and hobbyists.

The most important part of your calligraphic education, however, happens with the pen in your hand. Whether you're working from a model or inventing your own forms, you'll find that the more you work, the better you'll get. You'll find lots of uses for your writing, from invitations and posters to drawings and paintings. There's an old teaching adage concerning lettering: "There are a few good letters in every bottle of ink. Unfortunately, they're at the bottom."

—Annie Cicale

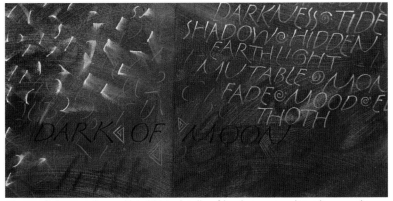

Nancy Culmone, *Lunar List*, 2000, details of book pages written in gouache and colored pencil on paste-painted paper, pointed-pen lettering, book closed: 6 x 6 in. (15.25 x 15.25 cm), photo by artist

Annie Cicale, *Balance*, 1999, mixed media, book closed: 5¾ x 7 in. (14.5 x 18 cm)

The Tools of the Scribe

Since the dawn of literacy, people have been picking up a writing tool, dipping it in a liquid, and scrawling on a surface. Writing tools have been made from materials such as sticks, feathers, and fur; and inks have been created from fireplace ashes, berry juice, and nut hulls. Every kind of surface has been used for writing, from animal skins to palm leaves.

Lettering supplies are still simple. In essence, all you need is a writing tool, some ink, and some paper. Keep in mind that each pen is designed for a specific purpose, and some don't work well on all papers. Even the humidity and the temperature can affect your tools and materials. For this and other reasons, it's best to experiment and try out various combinations of materials and tools before committing them to final pieces.

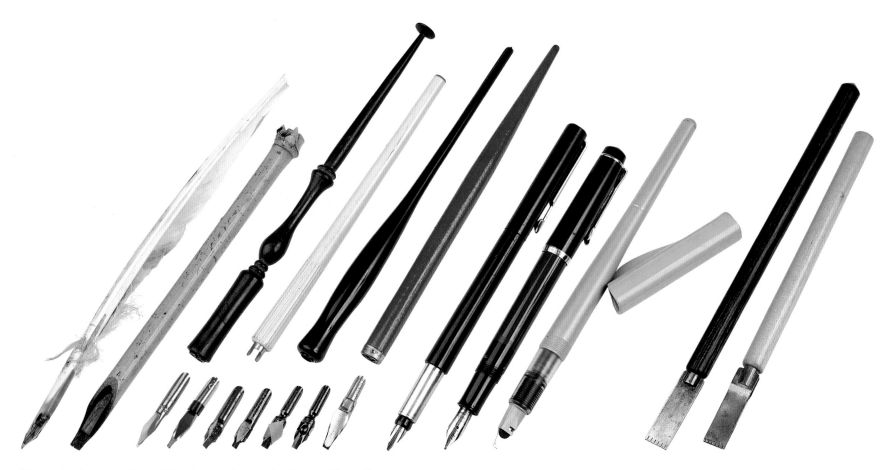

Broad-edged pens are the traditional tools of the scribe. Left to right: quill cut from wing tip of a large bird, reed cut-from bamboo, pen holders and assorted metal nibs, fountain pens, and wide brass pens

PENS

The beginning alphabets in this book are written with a *monoline* tool, such as a pencil or ballpoint pen, that makes lines of even thickness. Writing these forms first will help you understand the underlying or skeletal letter structure. Then you'll learn to use a broad-edged pen that draws undulating lines of thick and thin, depending on the angle at which you hold it and the direction you move it.

Traditional Western scripts were originally written with a reed or quill (a precursor to the broad-edged pen), but are now done primarily with broad-edged metal pens dipped into ink or loaded from a cartridge. These pens come in a number of styles—from those with a built-in ink reservoir to handmade ones with ink held between two pieces of soldered brass. The metal dip pen is made up of a *nib* inserted into a pen holder.

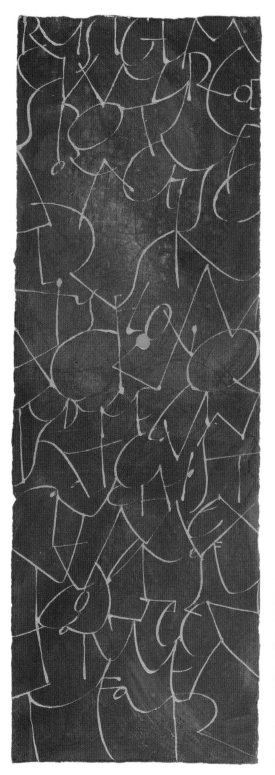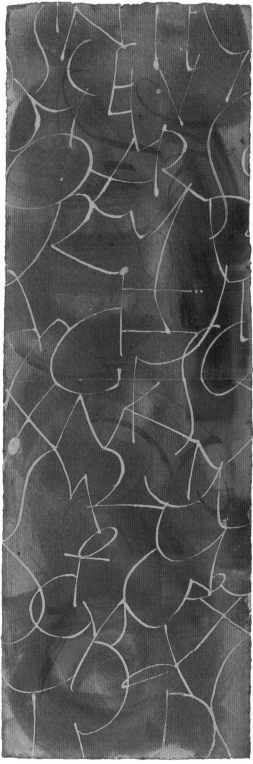

Judy Melvin, *Red Side/Blue Side,* gold goauche on paper, lines written with brushes and a crowquill pen, 4½ x 13½ in. (11.4 x 32.3 cm), photo by artist

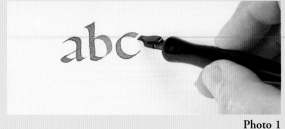

Photo 1

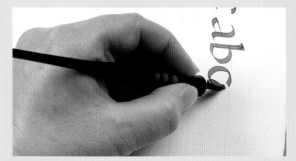

Photo 2

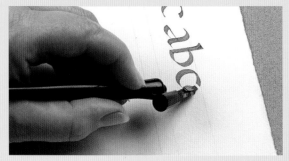

Photo 3

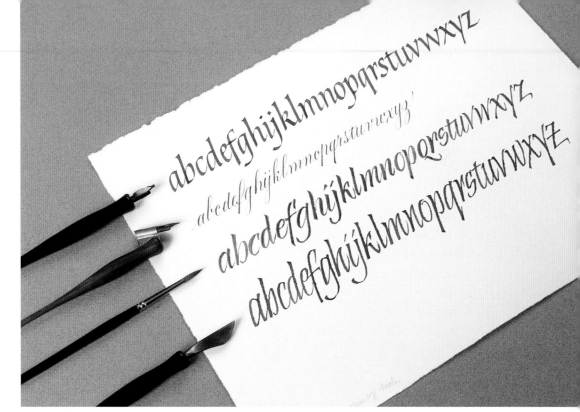

The effect of different tools on the alphabet (top to bottom):
broad-edged pen, pointed pen, brush, ruling pen

LEFT-HANDED SCRIBES

Throughout history, alphabets and pens were designed by right-handed scribes whose natural hand position was approximately a 30° angle (photo 1). A lefty has to achieve this by turning the paper so that the pen creates this same angle (photo 2). If you "hook" your hand to hold it above your writing, you'll find it impossible to achieve the correct pen angle. Position your hand underneath the writing line in order to keep it out of the wet ink. All of this may seem awkward at first, but remember, writing with a calligraphic pen also feels strange to right-handers in the beginning. There are many excellent left-handed calligraphers, who have proved that perseverance pays off. If you're left-handed, you also have the option of using a nib made for left-handed people with an offset pen holder that positions the nib at the correct angle (photo 3).

Many holders are available on the market, including plain plastic ones and more ornamental styles made from wood. Most important, find one that is comfortable in your hand. Calligraphic fountain pens and felt-tipped pens used for handwriting, design work, and experimentation also fit this category of the broad-edged pen.

The lettering style that you use may be highly dependent on the type of pen. For instance, a pen with a pointed metal nib is used for certain script styles, notably *Copperplate* and *Spencerian*. Since metal nibs won't work on every surface, you can also use pointed and flat brushes to lend a different character to your writing. Hold a draftsman's ruling pen on its side to make letters with their own distinct style.

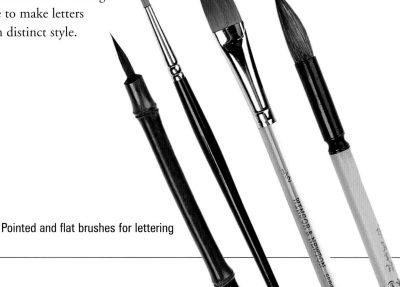

Pointed and flat brushes for lettering

INKS

Traditional lettering is often done with black ink on white paper. For most lettering, choose a non-waterproof ink because it flows readily and is easy to clean if it dries in your pen.

Be sure to read the label carefully before using an ink. Some inks are labeled as permanent. This can mean one of two things: Either the dyes and pigments are *light fast* and won't fade over time when exposed to light, or they're waterproof and won't run when wet. Use waterproof, light fast inks if you're designing something intended to be used outside and exposed to moisture, such as envelopes and outdoor signage. Waterproof inks contain shellac, which dries quickly and can clog your pen, so clean the pen immediately after using it.

For general purposes, you should buy light fast, non-waterproof ink. The most common inks for lettering are fluid, carbon-based, black India inks. Many kinds are manufactured, each with a slightly different purpose. Check the bottle to make sure that you're buying non-waterproof ink.

Japanese *sumi ink* is another version of a black ink. Buy it in bottles or make your own by grinding an ink stick on a *suzuri* stone. Although this process takes some time, you'll find it meditative and calming, preparing you to write. You'll also be able to control how black and smooth the ink is, so that it flows easily from your pen.

Dye-based fountain pen inks are not as black as India inks but are lighter in color, ranging from blue-black to brown. They can be used in dip pens as well as fountain pens.

Black ink on white paper is a traditional way of working, but color opens up new avenues of expression. There are many colored pigment and dye-based inks available on the market. Some work well in lettering pens; others clog the nib. Transparent brown *walnut inks* are another option. You can make one version of this ink from black walnut hulls. Most of the commercial kinds are made, surprisingly enough, from peat moss.

When buying an ink, be sure to read the bottle for specifications.

Japanese sumi ink can be made by grinding an ink stick on a suzuri stone.

WALNUT INK

The nuts of black walnut trees, found in the eastern United States, are used to make this kind of ink. In the fall, after the nuts fall to the ground and ripen, the hull becomes pulpy and black. At this point, the nuts are ready to be made into ink.

To make this ink, place the whole nuts (or the hulls alone) in just enough water to cover them. Allow them to sit overnight or for up to several weeks. After soaking them, simmer them over heat for a couple of hours. Strain them through a fine sieve. Return the liquid to the pot and simmer them again. The longer you do this, the more the water is reduced, deepening the color. Strain it a final time through a very fine mesh (such as old nylon hosiery) or coffee filters, to remove sediment.

Color can be added to obtain muted shades. Add ¼ to ½ teaspoon (1.25 to 2.5 mL) of watercolor paint to a small amount of ink in a 35 mm film can. At room temperature, this mixture will stay fresh for a couple of weeks. If you refrigerate it, it will keep for a couple of months. You can use it to write on paper or fabric, although you should use it on fabric projects that you don't need to wash.

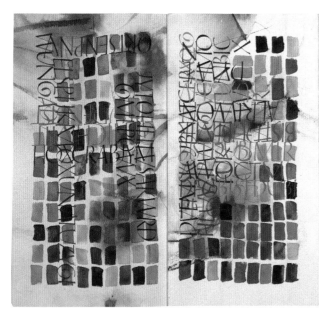

Nancy Ruth Leavitt, *Color Studies One*, page from book of design, color, and lettering tests, gouache, gilding, walnut-stained paper executed with various tools, 6 x 11 in. (15.2 x 27.9 cm), photo by artist

PAINT

Because most colored inks are transparent and don't offer even coverage, there are times when paint is more appropriate to work with than ink. Paint can be used on a palette and mixed to create an infinite variety of shades and tints, bringing the full spectrum of color to your work. For this purpose, calligraphers write with *designer's gouache* (an opaque watercolor), acrylic paint, and sign painter's paint. Gouache can be used in a dip pen, but most other paints must be applied with a brush. Depending on your needs, you'll have to experiment before you start on your final project, learning to adjust the viscosity of the paint so it flows readily from the pen or brush.

PAPER

Calligraphers store up paper like woodworkers collect wood or knitters hoard yarn, with a backlog available for any kind of project. The paper is an integral part of any piece of writing that you do. Not only does it show between the letters and in the margin, but its surface affects how the ink flows from the pen. You'll use different papers for practicing lettering versus doing finished work.

To keep the ink from bleeding into the paper and spreading, paper often contains *sizing*. In manufactured papers, sizing is added to the paper pulp or coated on the surface after the paper dries. Sizing helps to hold the fibers together that make up paper. In lithography—the most common commercial printing process—the sizing enables a crisp printing job. Fortunately, some commercial printing papers are an economical choice for hand lettering because the ink will stay where you put it, rather than bleeding into the paper. Many of the papers used by fine artists for bookbinding, painting, and printmaking are also well-sized and take the ink of the calligrapher beautifully.

If you're making a project to keep, such as a family tree, memory book, or scrapbook, make sure that all of your materials—from the paper to the paste to the inks—are *archival*. In general, this indicates that the acids used in making the paper were neutralized or buffered (or not used at all), the inks are lightfast, and all the other materials are designed to last.

Nevertheless, there are many brightly colored papers and inks that you may find irresistible, even though they aren't archival. Use these for ephemeral projects such as party decorations or greeting cards.

At left, five kinds of paper were tested for a project. Clockwise from left: On the first two, the ink bled into the paper. On the third, the ink sat on top of the textured surface. The remaining two show smooth crisp marks exactly the width of the pen.

Some of the papers you'll use for practice, design, and finished work are described below:

• *Tracing papers* and *tracing vellums* (made of wood pulp) can be used for rough drafts and layouts. You can buy inexpensive tracing paper and use it without having to worry about the cost. More expensive vellums are also useful if you do a lot of erasing as you plan a design and can sometimes be used for final camera-ready work as well.

• *Layout bond paper* is useful for designing and practicing. Make sure the label says that it works well with ink. You can see through the lighter weights of this paper, which is useful when tracing. The lighter weights tend to crinkle a bit as the ink dries.

• *Graph paper* with a blue grid works well for practicing and for designing work that will be reproduced. There are a number of calligraphic suppliers who make 11 x 17-inch (28 x 43 cm) pads of this paper. The blue grid drops out (does not reproduce) when you photocopy or print from it, so you won't have guidelines to erase.

• Better grades of *drafting papers, vellums,* and *thin polyester* film can be used for lettering a design that you plan to have reproduced—such as a greeting card, logo, flier, or brochure. In these cases, you'll need paper or other materials that showcase the shapes of your letters so that they're crisp and reproduce well. Since the surface texture of each kind of paper or material is different, you should test them out first to see what suits your lettering style.

• *Acid-free, well-sized text paper* is best for finished original work. This paper usually has a high rag content because it is made from cotton or other fibers, rather than wood pulp.

Use better grades of paper when lettering important projects.

A light coating of gum sandarac adds sizing to paper that needs it. Pounce can be used to add nap to a slick surface.

Sizing

At some point, you'll work on paper that doesn't have enough sizing, and the ink will spread and bleed into the fibers. To remedy this, lightly dust the paper with *gum sandarac* to create a very thin non-absorbent surface for the ink to sit on. You can buy this material from calligraphy suppliers in powder or crystal form. Grind the crystals in a mortar and pestle, and wrap it in a piece of finely woven cotton fabric to make a little sack, tied up with a piece of string. A light coating of sandarac can save a beautiful paper.

If the paper is too slick to write on, you can treat it with an abrasive powder called *pounce* to loosen the paper's surface enough for the ink to settle in. Available through traditional drafting suppliers, pounce comes in a can with a felt spreading tool on the top and works well on both smooth papers and plastic drafting materials.

There are a vast number of decorative papers on the market, but not all are archival.

• For finished work, you can also buy less expensive, *pH neutral papers* with a good writing surface. For instance, well-sized commercial printing papers made from wood pulp come in a variety of colors. If you care about the permanence of your piece, make sure the commercial papers you use are pH neutral by checking with your retailer or the catalog description of the paper.

• You can also do finished work on *watercolor and printmaking papers* as well as text papers. Many other papers are available in beautiful colors and have interesting surfaces. Some are not sized, however, and the ink will bleed into them.

• *Decorative papers* can be used effectively to complement your projects. Whether you collage a strip of paper onto a piece as a border or create a cover for a small book, there are many choices in Asian, European, and American decorative papers. Some of these papers take ink well while others don't, and some are not archival.

Paper Weight

The paper's weight is expressed in one of two systems: pounds or gms/m². Most papers, such as watercolor papers, come in a variety of weights. For example, "90#" (90-pound) watercolor paper indicates that 500 sheets weigh 90 pounds. Text papers are usually lighter than this, making them suitable for small books. It's easier to fix your mistakes if you work on a heavier paper, but very delicate papers can be quite elegant.

In the English system, the given weight is expressed in pounds, but is also dependent on the *parent size,* or manufactured size, of the paper. For instance, paper that is sold as 140# with a parent size of 22 x 30 inches (56 x 76 cm), and as 260#, with a parent size of 25½ x 40 inches (65 x 102 cm), is actually the same thickness. This confusing situation has been remedied by using the European system which gives weights in gms/m². Since all weights are given for the same size paper, you can compare these numbers to have a better idea of the thickness of your paper.

Art supply stores often carry a variety of these papers, and you can judge the weight in the store. Specialty papers are also available by mail order, and understanding paper weight will help you know what you're ordering.

Each of the categories above include a wide variety of papers. Because papers are organic (made from natural fibers), characteristics can vary from batch to batch, even within a relatively well-known manufacturer's traditional papers. Your best option is to buy a sheet or two and test it out. If it works for your needs, buy enough for the entire project with a few sheets to spare for possible mistakes.

If you're accustomed to buying reams of copier or notebook paper, a sheet of good paper may seem exorbitant to you at first. Soon you'll learn that it's a good investment in the long run, because you'll be spending many hours on projects. For instance, 100-percent rag paper that is archival is much easier to work with and gives you better results than less expensive papers designed for commercial printing.

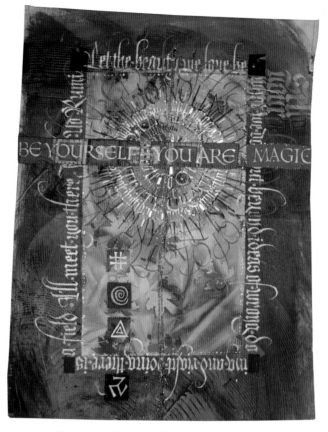

Lisa Engelbrecht, *Be Yourself,* 2001, banner using acrylic and pearlescent inks, foil on fabric, backing of paste-papered canvas, 18 x 24 in. (4.5 x 6 m), photo by artist

Alternative Writing Surfaces

Almost any surface—whether a wooden plaque, a garment, or piece of stone—can be written on. Before undertaking a project, you should experiment on a sample of the material with different tools and inks. Some materials may require using a brush rather than a pen. Others may require inventiveness, such as adapting tools to serve as pens, and various liquids to serve as ink.

In this book, a few of these options are described in the project section at the end, including stamping letters on paste paper and painting on fabric. Scattered throughout the book, you'll also see examples of work by various scribes from around the world. When you look at them, note the media used to create each piece—many were chosen for their unique use of materials as well as the quality of the design and the impact of the image.

An adjustable slanted easel works well for lettering.

if the eyes are looked up on as the windows to the soul—then a smile must be the doorway to the heart · ANONYMOUS

OTHER TOOLS AND SUPPLIES

To rule lines precisely, you'll need a drafting board, a T-square, and a triangle set up on a table so you can write comfortably. A simple slanted easel that folds flat can be brought out of a closet when you need it. If you wish, you can use a piece of translucent plastic sheeting for the drafting board so it can also be used as a light table.

Other basic tools and supplies for lettering include:

• Pencils of various hardness—2H, HB, and 2B are suggested

• Soft erasers, both white plastic and kneaded for removing guidelines and stray marks

• Water container close to your working area for keeping nibs clean

• Old toothbrush for cleaning pens

• Masking or drafting tape for securing papers to the drafting board

• Rags or tissues for blotting ink and wiping pens

• Inexpensive brushes for mixing and loading colors

• Palette with recessed wells for holding mixtures of colors

• Cutting mat, craft knife, and scissors for cutting papers and boards

Tote bag and portfolio for carrying supplies and paper (design by Julie Gray)

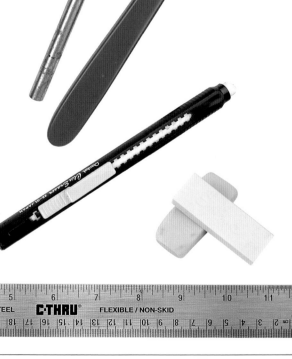

- Metal ruler for measuring, cutting, and scoring, 18 or 24 inches (45.7 or 61 cm) long
- Paste and glue, such as a glue stick, and PVA for collage, bookbinding, and paste-ups. Check the labels on glue sticks. The best go on clear, stay clear, and are archival. PVA is white glue that comes in a bottle under a variety of names. The better brands have more glue and less water. PVA glues are designed for different tasks, so make sure you buy one made for use on paper.
- Black Arkansas stone and crocus cloth for smoothing and shaping your pens
- Fishing tackle box to protect and transport your supplies
- A portfolio for carrying projects and papers. (Although these are available commercially, you can make one out of fabric with sewn straps for easy carrying and pockets on the outside for holding your rulers, T-square, and other awkward supplies. Your drafting board and easel can fit inside, and the board will stiffen it to protect your papers.)

APCHAIC CAPITALS
ROMAN CAPS
RVSTIC CAPS
SQVARE CAPS
UNCIAL
IИSULAR half-uncial
VERSALS
Carolingian-Tours
Carolingian-Ramsey
Black Letter
Humanist Bookhand
Humanist Italic
Copperplate Script
Spencerian Alphabet
Palmer Handwriting
Italic Handwriting
Contemporary Scrawl

The shapes of the alphabet have evolved over time. This chart shows the basic families of alphabets as the scribes adapted the forms to their current needs. Shapes were sometimes influenced by the materials available as well as how the text was to be used.

A BRIEF HISTORY OF WRITING

People have been recording their thoughts and calculations on all sorts of surfaces for thousands of years. Before the written word, they made records of hunting trips, accountings of crop yields, inventories of animal herds, and tributes to their gods. As these images became more stylized, abstract graphic marks were used as symbols for the spoken word, replacing detailed illustration.

Many of the written records we have of ancient cultures are carved into rock or stamped into clay tablets. These durable records have survived, and show us the forms that scribes were using.

The Sumerians are credited with developing a phonetic system of writing. This system evolved into our present Roman alphabet, as well as Hebrew, Greek, Aramaic, and Arabic alphabets. The shapes of the letters were dependent in part on the tool that they used, and the sharpened reed and quill created thick and thin lines in each of these writing systems. Although the materials have changed, the shapes of these tools are similar to those we use today—brushes, reeds, quills, papyrus, and vellum, have been replaced by steel pens and paper.

The writing of Asia has a separate pedigree. The written language has remained a pictographic system with a syllabary of basic sounds, rather than a phonetic one. Since the beginning, the brush has been the writing tool for this system.

Pointed brush for Asian lettering

Writing Surfaces

The Egyptians are credited with the invention of pen, ink, and *papyrus* that allowed the scribe to write anywhere and their documents to be portable. Papyrus is made from strips of a tall aquatic plant, *Cyperus papyrus*. Thin strips are laid side by side, with a second layer placed at a right angle to the

Papyrus sample

first, which are pressed and dried. Found in Ethiopia, Palestine, and formerly in Egypt, papyrus was used by the Egyptians to make scrolls. It is a brittle material, and consequently won't withstand repeated folding and unfolding like paper or vellum.

It was replaced by *vellum* and *parchment* made from animal skins, which proved to be much more substantial. These materials are still available today and are used for fine calligraphy. Today, papers are made that resemble parchment and vellum, but they are usually not very easy to write on and aren't as beautiful as the real thing.

Paper was invented by the Chinese around A.D. 100 and was a well-kept secret for hundreds of years. The Arabs were using it by the eighth century, but it didn't arrive in Europe until the 12th century, most likely via the Arabs to Spain and Italy. It gradually replaced vellum, but was considered less valuable. There are papermakers in Europe that have been making paper in the same place for centuries. For instance, the Italian city of Fabriano has had paper mills in constant production since 1283.

Besides traditional writing surfaces, scribes have used wood, metal, stone, bone, silk, linen, leather, bark, and leaves. Today, the search continues for materials that are portable and easy to write on. Modern papermakers revive old recipes and invent new ones, while scribes experiment with new surfaces—from high-tech plastics to building materials. Their goal is to preserve information on beautiful and durable surfaces.

Inks

Inks have been made from lots of different materials, but the ones that stood the test of time were primarily carbon-based, such as India ink. These are made by adding water and gum to soot, resulting in a rich black ink. The art of ink-making is a delicate process of obtaining the finest particles so the ink will flow readily from pen to paper.

Some inks of the past eventually ate through paper, leaving a lacy network of letter-shaped holes, as you see in the manuscript on this page. Some faded away in the light, inspiring the imagination of detective story writers, while others spoiled in the bottle, blasting the scribe with a noxious smell when the bottle was opened. The search continues, and modern manufacturers have developed brilliantly colored inks, some containing interference pigments that lend a beautiful pearlescent effect.

Brushes and Pens

Egyptians' hieroglyphs were most likely created with a brush made by chewing the end of a reed to soften it. This tool was soon replaced by a cut-reed (broad-edged) pen that greatly influenced the shapes of the forms that this culture wrote.

Although we can speculate that a number of different tools were used for broad-pen lettering, the most common was the quill, made from the large wingtip feathers of birds such as geese, turkeys, and swans. Once cured, its hard, horny material doesn't absorb ink and maintains a sharp point for a long time. The quill was replaced by the development of the metal nib. It came into use as early as 1700, but it was not until the 19th century that steel nibs were manufactured in large quantities. The stiffness of the metal allowed the maker to give it a fine point, helping to change the look of writing from broad-edged pen forms to monoline or round-point, since this type of point moves in any direction with ease.

During the 20th century, many different pens became available. Fountain pens were more portable, and ballpoint pens did away with some of the mess. Today, felt-tipped pens write well with no more effort than removing the cap.

Unfortunately, none of these developments have encouraged people to improve their handwriting. In fact, the ease with which marks can be made has taken away the need to master the forms while battling with the flow of the ink.

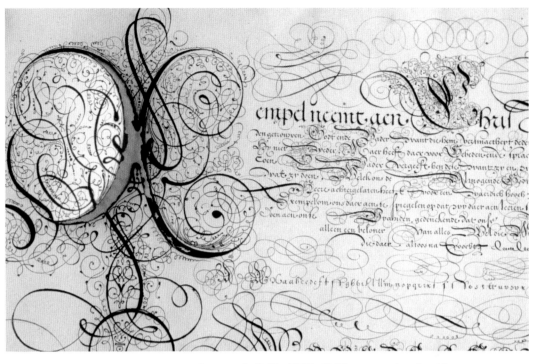

Jan van de Velde (1593–1641); manuscript of writing samples written for students; ink on paper; approximately 8 x 10 in. (20.3 x 25.4 cm); Konijnklijke Bibliotheek, The Hague, The Netherlands; photo by Annie Cicale

Notice that the ink in this book has eaten holes in the paper.

Quills and reeds were the original broad-edged tools prior to metal nibs.

Getting Started

The fascination with beautiful writing often begins with the realization that simple letterforms can be made elegant with a few basic tools. Your initial challenge will be to get the ink, pen, paper, and tools to work well together. Following that, the arrangement of the text to compose a design requires planning before you begin a final piece of writing.

In this chapter, basic concepts such as ruling guidelines and principles of letterforms are introduced. Many of these apply to all styles of writing, so spend time with these basics as you learn the styles in the subsequent sections of the book.

THE BASICS OF WRITING

At the turn of the 20th century, a young Englishman named Edward Johnston was studying medieval manuscripts in the British Library and noticed that the lettering appeared to be made with a broad-edged pen, unlike the writing of his day that was done with a flexible monoline tool. Most of the writing with which he was familiar had been done with a pointed metal pen that created thick and thin lines under different amounts of pressure. Through experimentation with pages of writing, Johnston made the keen discernment that the angle of an edged pen had impacted the shape of letters.

Imagine a medieval scribe rising early, eating his porridge, saying his prayers, and settling into the scriptorium for a day of copying. First, he pins the parchment to a slanted desk—square to the table—and rules the guidelines for his work. Since he anticipates being there for hours, he positions his hand in the most comfortable way possible for writing. Then he dips his quill in ink and begins writing.

As Johnston discovered, this natural position is about a 30° angle for most right-handed people. This angle, coupled with the thick and thin strokes that the quill made, influenced the letterforms. He was also able to break down the other aspects of an alphabet into simple terms that can be applied to all styles.

Further observation of the consistent weight and height of manuscript lettering led Johnston to uncover the scribes' efficient methods for marking off guidelines. He surmised that each letter was based on a basic shape, with the **o** and the **n** being the fundamental letter forms. Depending on the style of lettering, a scribe wrote with consistent vertical or sloping stems. A careful analysis of similar letters showed Johnston the number, order, and direction of strokes needed to make each letter.

Johnston's observations and studies led to the publication of his book *Writing and Illuminating and Lettering* (1906), which is still in print today. Adhering to high standards of craftsmanship, Johnston taught calligraphy for many years, and contemporary calligraphers often trace the lineage of their teachers to his students.

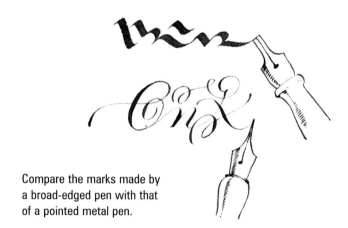

Compare the marks made by a broad-edged pen with that of a pointed metal pen.

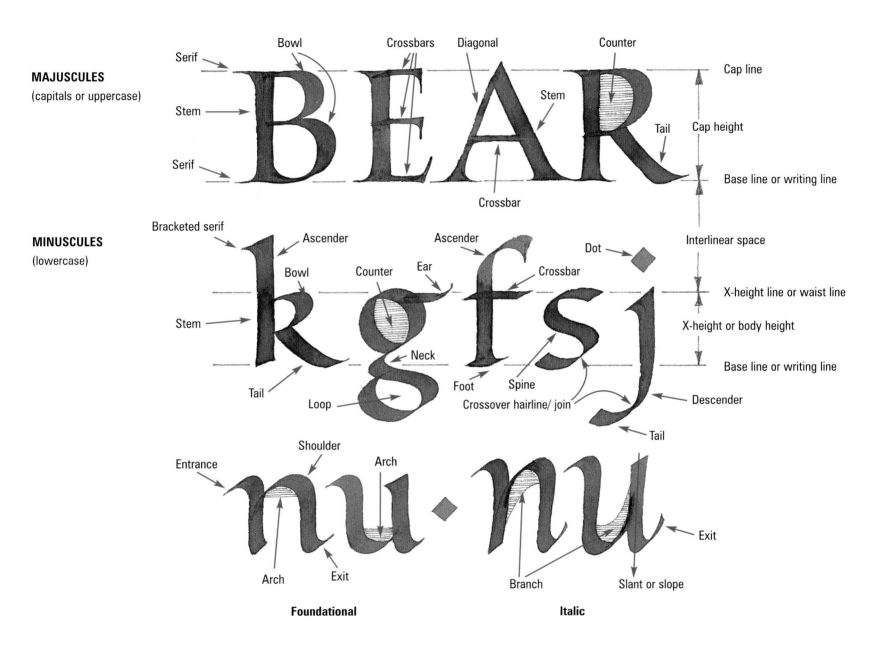

Serif · Bowl · Crossbars · Diagonal · Counter · Cap line

Stem · Stem · Cap height

Serif · Base line or writing line

Crossbar · Tail

MINUSCULES
(lowercase)

Bracketed serif · Ascender · Ascender · Dot · Interlinear space

Bowl · Counter · Ear · Crossbar · X-height line or waist line

Stem · X-height or body height

Neck · Base line or writing line

Tail · Foot · Spine · Descender

Loop · Crossover hairline/ join · Tail

Shoulder

Entrance · Arch · Exit

Arch · Exit · Branch · Slant or slope

Foundational · **Italic**

Specific terms are used to describe the various parts of letters and their guidelines.

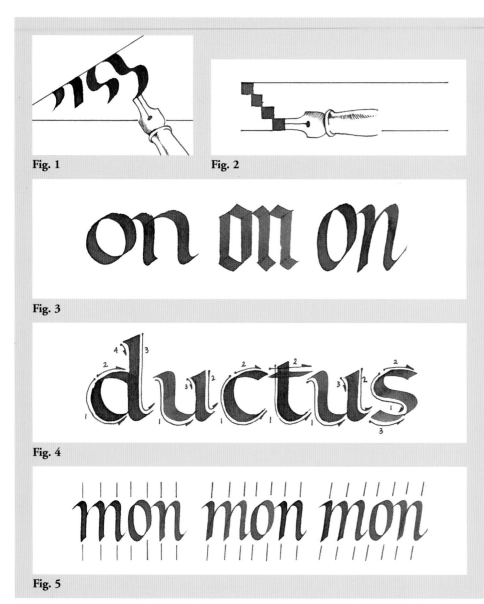

Fig. 1

Fig. 2

Fig. 3

Fig. 4

Fig. 5

Johnston's main contribution to the field of lettering was his analysis of the basics of letterforms, which could be applied to any historical script. In other words, he showed students how to look at manuscripts and adapt them for contemporary use. He developed the *Foundational* Hand as a starting point for his beginners. His seven attributes can be applied to any alphabet style:

1. *Pen angle* measured from the writing line up to the angle at which the broad-edged pen is held (figure 1)
2. *Letter height* expressed in *nib widths (n.w.)*, (figure 2)
3. Basic shape of each letter of the alphabet based on the **o** and the **n** (figure 3).

Stroke sequence composed of:

4. direction,
5. order,
6. and number of strokes. A diagram of the stroke sequence of lettering with numbered arrows is called a *ductus* (figure 4)
7. Speed at which the scribe wrote

In addition to Johnston's list, the forward *slant* or *slope*, is measured in degrees from the vertical. The stems of the letters fall on this slope, and the curves have an optical relationship to it, as shown in figure 5. Many styles of writing are vertical, but some have a forward slope of anywhere from 5° to 35°.

PREPARING TO WRITE

Johnston's characteristics combine to form the basics of any hand, whether you're using a classic Renaissance script or modern poster lettering. All scripts require attention and patience to master. There are some crafts that can be done curled up on the couch in front of a television, but, needless to say, lettering isn't one of them!

In the next chapter, you'll write letterforms with a monoline pen to learn their skeletal shapes, and then in chapter 4 move on to a broad-edged pen, which is the basis of all Latin scripts used in European languages. This tool will help you learn the classical calligraphic forms, which can be modified for contemporary applications. A metal dip pen simulates marks made by a quill by medieval scribes, while giving you the most versatility for contemporary design. You can experiment with both tools before taking on the letterforms.

In preparation for writing, set up your drawing board. Leave enough room for ink pots and other materials close by. You'll also need a good desk lamp. Secure a few sheets of paper to the board with masking tape to act as a cushion for your writing. When you press against this surface, the ink will flow more readily from pen to paper. Tape a guard sheet across the bottom to protect your work from oils in your hands (figure 6). Adjust the slant of the board to a height that allows you to sit up straight and hold your hand in a comfortable position. Your ink and tools should be on your right-hand side (or on the left if you're left-handed), along with a jar of water and an ink rag.

Keeping your fingers clean while dealing with ink is always a challenge, and there are ways to consistently set up your ink that help. First of all, if you dip your pen directly into a large bottle, you'll soon have ink all over the pen holder and your fingers. Instead, pour some of it into a smaller container, such as an empty film can or shot glass, and dip your pen into this container instead. If you use a container with a good seal, you can save the ink for your next writing session.

It's a good idea to tape your ink container to the table or place it in an empty tuna can or lid of a jar to keep from knocking it over. Place a small sponge in the container to help clean the outside of the pen as you dip it, giving you a surface to press the pen against to gauge the amount of ink you're loading. For some kinds of ink, especially colored, it helps to use a paintbrush to load the pen reservoir, or you can squeeze the ink from an eyedropper.

As you work with various materials, the area around your drafting board will become cluttered with bottles, pencils, brushes, papers, and other materials. Although some of this clutter is unavoidable, you should minimize it by straightening up as you work. There's nothing more agonizing than accidentally laying a beautiful finished piece in a puddle of wet ink!

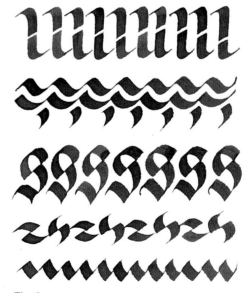

Pouring ink into a smaller container such as a film can will save your ink and keep your fingers clean.

Pen Angle Practice

To begin practicing with a dip pen, load it halfway up the reservoir. Test it on a piece of scrap paper to get the ink flowing and avoid blobs made by an overloaded pen. Position the pen's tip firmly on the page so the whole end is in even contact with the paper. Wiggle it a bit to get the ink flowing, then lighten up the pressure and make a stroke. Pause at the end of each stroke before lifting the tip to make a crisp finish (see figure 7). The repetitive forms shown in figure 8 can be used as decorative borders around a piece of writing.

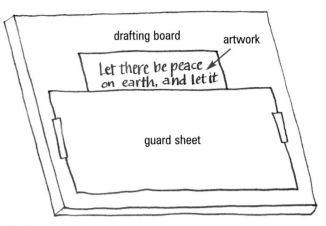

Fig. 6

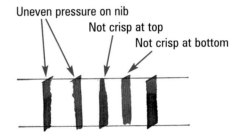

Uneven pressure on nib
Not crisp at top
Not crisp at bottom

Fig. 7
Learn to judge the pressure on the nib to get a crisp stroke similar to the one shown on the right.

Fig. 8
Practice pen control by making rows of repetitive marks.

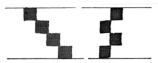

Fig. 9
Nib marks can be stair-stepped or alternated.
Precise placement is very important.

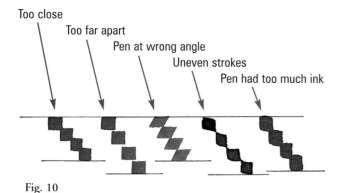

Too close
Too far apart
Pen at wrong angle
Uneven strokes
Pen had too much ink

Fig. 10

Ruling Guidelines

Everyone from beginner to pro uses guidelines to help keep letters even and control their weight. The shapes of the letters depend on their relationship to these lines that act as a guide for the proportions.

To begin, position a piece of paper on a padded drafting board, square it up with a T-square, and tape it lightly in place at the top.

Begin by ruling a margin around your page. Use a T-square for horizontal lines and a triangle for vertical lines. Historically, margins were used to keep the readers' fingers away from blocks of text in books meant to be used for hundreds of years. Today, this is not as much of a consideration. Even without this need, margins set off the writing, giving the words their own small universe in which to exist. Ample margins have become part of the aesthetic of modern page design.

Keep this general rule in mind for guidelines: For any style of lettering, the letter height is determined by the width of the pen you're using. Consequently, the height of each style of letterform is set at a specific number of nib widths. Begin by holding the pen at a 90° angle to the vertical to "*nib off*" (mark off) the guidelines by making parallel marks with your pen in a stairstep formation.

The basic rule of letter height as it relates to the width of the pen is fundamental to understanding how the broad-edged pen works. For each size of pen nib and letterform that you use, you'll have to pull pen widths to determine the guidelines. Make these marks carefully so they don't overlap or have any white space between them—they should barely touch (see figures 9 and 10). For each style that you write, remember to refer to the ductus for the number, order, and direction of the strokes to make each letter.

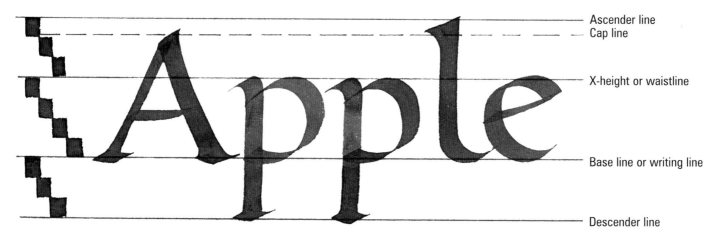

Ascender line
Cap line
X-height or waistline
Base line or writing line
Descender line

Fig. 11

Lowercase alphabets are "three-story" letters, with a space for the letter's *body height* (the distance between the baseline and the waistline) the *ascender* (pen strokes that project above the waistline), and the *descender* (strokes that extend below the baseline). To understand this concept, take a look at figure 11. You'll pull the nib widths for each of these areas (photo 1), let the ink dry, and rule the first set of guidelines (photo 2).

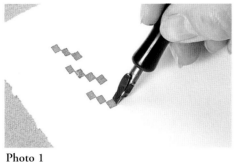

Photo 1

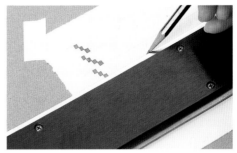

Photo 2

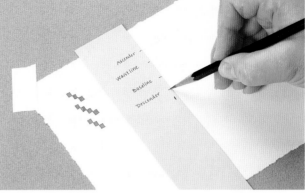

Photo 3

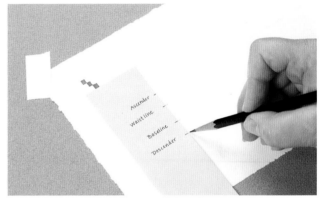

Photo 4

Then make a paper ruler by transferring the distances you've established with the marks to a strip of scrap paper (photo 3), using a very sharp pencil and as much accuracy as you can muster. You'll use this ruler to transfer these marks down the page, placing the mark for the ascender line on the descender mark from the row above (photo 4). Rule off the remaining lines with your T-square.

The space between the baseline and the following waistline is called *interlinear space*, and provides a specific space for the ascenders and descenders. The ascender and descender line is shared from one line of writing to the next, and the letters can touch them without crossing over them (figure 12). Avoid collisions between ascenders and descenders, and keep their structure fairly simple.

Interlinear space aids legibility. When you reach the end of a line as you're reading text, your eye returns to the beginning of the next line while quickly darting through this space. Although the interlinear space can be varied according to the needs of your design, you should keep it consistent while learning each hand. In general, the longer the line of writing, the more space you'll need between lines.

As you gain experience, you might not need to rule all these lines. Many manuscripts have been written with only one guideline, but the scribes that made them were most likely writing the same style day after day. Modern scribes often work with both a baseline and a waistline, eyeballing the ascenders and descenders.

As you practice, you might wonder if there are shortcuts for ruling all of these guidelines. You can buy pre-ruled pads, but they may not match the letter heights for the pens you're using. For convenience, you can make your own master sheets for each pen size and alphabet style by accurately ruling guidelines with a black ballpoint pen before slipping them under lightweight bond paper. Then you can see the guidelines through your page and spend your practice time working on the letterforms.

Another shortcut is graph paper sold by calligraphy supply houses. These commercial bond papers provide consistently good surfaces on which to write. Mark your guidelines down the left side of the page, and use the blue grid. This paper also works well for reproduction. When it is photocopied or printed, the blue lines drop out. The quality is excellent, and you can use the reverse side if you don't need the blue grid.

However, there is nothing more satisfying than ruling guidelines on a sheet of beautiful handmade paper. It can serve as a time for centering and preparation for the project ahead. At this point, you can also review all your design decisions about placement of lettering. Taking the time to practice this aspect of calligraphy from the very beginning will prepare you for writing out a poem or a bit of prose.

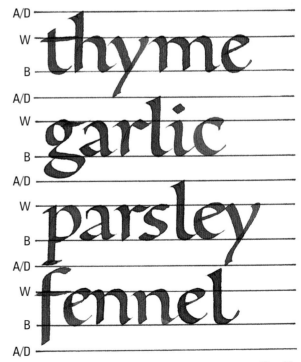

Fig. 12

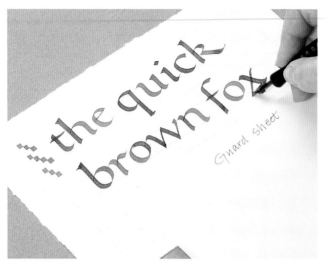

Use a guard sheet to protect your work.

BEGINNING TO WRITE

After ruling your guidelines, tape a guard sheet to your board. Slip the ruled sheet underneath the sheet to protect it from dirt and oils on your hands. Slide your work up the board as you complete a section, keeping your hand in the same position as you write.

The letters of the alphabet can be broken down into families of similarly shaped letters. In this book, you'll notice that the diagrams for each letter style show these groupings. Note the relationships among them—if you radically change one form, it won't harmonize with the rest of the family.

When you begin a practice page (see page 27), carefully analyze the forms as you work through the families of letters. Keep the models in front of you, looking back and forth to see each detail as you look at the arrows on the ductus showing the direction and order of the strokes. If you try to make the letters in a different stroke order, you'll change the form. The results of experimenting with letterforms can be exciting, but you'll need the wisdom of experience to make them harmonize as a style.

Look for similarities in shape among the letters: how is the top of a lowercase **c** like that of a lowercase **f** or **s**? Can you see the relationship between lowercase **b**, **p**, **q**, and **d**? Do your lowercase **o**'s match? Practice writing a couple of each letter before moving on to the next. If you repeat the same letter for a whole row, trying to make them the same, you'll only prove to yourself that you're not a typewriter! Since you're working toward control at this point, doing this can be disheartening.

Annie Cicale, journal page, 1990, ink and gouache on paper, 10 x 13 in. (25.4 x 33 cm)

This piece was an experiment using a small area of dense texture to contrast with a more open one in the larger area. The quotations were chosen to fit the available space.

Marriage is the aftermath of love. NOEL COWARD A book of which the first chapter is written in poetry and the remaining chapters in prose BEVERLY NICHOLS Marriage is an adventure like going to war. G.K. CHESTERTON

Marriage is a bribe to make a housekeeper think she's a householder THORNTON WILDER Marrying a man is like buying something you've been admiring for a long time in a shop window. You may love it when you get it home, but it doesn't always go with everything else in the house. JEAN KERR I'd marry again if I found a man who had $15 million and would sign over half of it to me before the marriage, and guarantee he'd be dead within a year. BETTE DAVIS An honorable agreement among men as to their conduct toward women, and it was devised by women. DON HEROLD A long conversation chequered by disputes. RL STEVENSON

aobocodoeofog
hninjnknlmnon

Fig. 13

The lowercase **n** and **o** are called the father and mother of the alphabet because they are the basic forms from which the others are derived. A useful exercise for developing rhythm is an alphabet chain—writing an alphabet with either of these letters sandwiched between each letter. As you write, the forms enter your muscle memory, and you begin to feel the shapes emerge from your pen (figure 13).

As you begin to get the rhythm of making the letters, you'll want to write words. One of the most rewarding things about calligraphy is pondering the meaning of the words as you carefully write them down, and you can draw from the vast collection of literature.

You can write an alphabet sentence—a sentence that contains all 26 letters, such as "sphinx of black quartz judge my vows." Another option is to make a list of things such as foods, animals, or flowers. You can write in a stream-of-consciousness mode that captures thoughts while you're practicing, or select quotations from a book to serve as a source for practice pieces. The possibilities are endless.

As you work, pay attention to your breathing and posture. If your projects are long, you'll be sitting in your chair for quite some time. Relax and keep the pen loose in your hand. A tight grip will shoot tension up and down your arm, resulting in stiff or wobbly letters. Take frequent breaks. After a few paragraphs, get up and stretch, walk around the room, or fix a cup of tea. It's normal to lose track of time when you're working, and if you rush through your work, it will show.

When you've written a couple of pages, stand back from your work and evaluate the overall effect. Is the writing consistent? Is the texture of the lettering even? Do you have hot spots—dark lines where the strokes are too close together? Have you left holes between words that create rivers of white running down the page? Look at the spaces between lines and columns. Do they work together?

PRACTICE PAGES

Practice pages are an opportunity for you to learn the forms of the letters and a chance to train your hand to write consistently and evenly. Each page should be as carefully ruled and lettered as a finished piece. Do your initial practice pages with a fairly wide pen nib (between 2 and 3 mm) that makes bold strokes, allowing you to see the forms clearly and to correct mistakes immediately.

Although correct spelling is important, practice pages require a right-brained concentration that often causes even the best spellers to slip once in a while. If you make a mistake or misspell a word, keep going. Don't call attention to mistakes by crossing them out.

Date and save these pages. After you have a small collection of this work, you can put them in a portfolio or make a simple binding for them.

CREATING A PRACTICE JOURNAL

For years I practiced lettering on layout bond paper and chucked these pages into a drawer—only to be thrown out later. Instead, I began to develop a way of practicing that allowed me to experiment with new forms, work on the rhythm of writing them, make small decisions about layout and design, and use collected quotations. My self-imposed rules are as follows:

• Buy large sheets of paper (such as a text laid paper), and tear them down to pages that are about 10 x 13 inches (25 x 33 cm) each. Keep a stack handy to use when the urge to write strikes.

• Work on good paper so the transition to this kind of surface is not so difficult when you're doing a finished project. Keep all your practice pages together, and you'll have something beautiful to show for your efforts. Working seriously will give you courage to undertake larger projects, and you'll have samples of your experiments to refer back to.

• For each group of studies, such as a series done over a year or so, develop and use a template that defines the margins and column widths. Consistent margins allow you to see how they affect different styles of writing. You might write one page with two columns, another with three, or experiment with uneven column widths. Transfer these dimensions to good paper, nib off some guidelines, and begin to write.

Annie Cicale, journal page, 1990, ink, gouache, and colored pencil on paper, 10 x 13 in. (25.4 x 33 cm)

This page shows an experiment with column widths. Note the uneven column space on the lower left and the rigid space on the lower right. Both areas of lettering are legible.

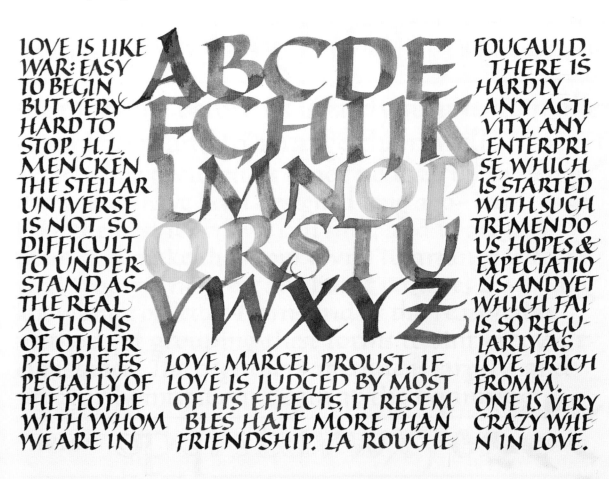

• For this kind of study, the text you choose is determined by the space available. If you keep a lot of books of quotations on hand, you can always find something that's a fitting length. It's intriguing to combine quotes to create a new meaning. One of the most freeing aspects of this kind of study is that you don't have to plan a layout first. If you like the results enough to do it again, you'll have a basic sample that can be used to plan a better layout.

• Respect the rules of spelling and grammar without doing it slavishly. Because this is practice, the letterforms are more important. Hyphenate wherever you need to, break a letter in half if it fits better, or leave out a word or two. Even if you change someone else's writing slightly in your practicing, always give the author credit.

• Write the pages with joy and confidence. If it's painful, you're trying too hard. Vitality in your lettering is more important than draftsmanship.

• There are no rules as to what you should practice. If you're struggling with spontaneity, use up 10 sheets in an afternoon, making lots of marks to use as starting points for future designs. If you're inventing a new script for a project, write out a good sample of it for your journal so you can refer back to it later. Try to invent a language of new forms that you can refine into a legible script. Periodically return to the basics, and write a lovely sample of simple classic forms.

• There are a number of ways to assemble these pages. A simple Japanese stab binding is ideal for collecting about 10 to 15 pages in a book. If your pages are odd sizes, paste them into a larger journal. You can also make a portfolio to hold them together loosely, allowing you to add to your collection over time. If you find a bound journal with good paper that will open flat, work directly on its pages. There is no correct way to keep a journal.

• You can use a sketchbook and a ballpoint or felt-tipped pen for informal studies. Less formal than a journal, you can tote it along wherever you go. Use it to write recipes, phone numbers, and directions to friends' houses. Copy quotations from bumper stickers and billboards. Doodle letterforms. If you see a new typeface, copy a few forms. If you're waiting in a doctor's office, pull out a pen and write out the alphabet, adding inventive new twists. This is practice with no agenda or expectations, and from this kind of practice, some of the most innovative ideas can emerge.

Top and middle:
Sharon Zeugin, journal pages, 2002, mixed media including ink, colored pencil, and gouache, 8.5 x 11 inches (22 x 33 cm)

Bottom:
Carol Pallesen, journal page, 1999, watercolor and ink on paper, 6½ x 7 in. (17 x 18 cm)

3

Chapter Three

Monoline Letterforms

Your first writing tool was most likely a monoline tool—a pen or pencil that you used to learn letters, compute sums, and sketch drawings. Because this tool is easy to use, it's virtually the only writing tool that most of us now use when we write a check, sign a form, or compose a thank-you note. This familiar and comfortable tool is our starting point for understanding letterform design.

Sherrie Lovler, *I Have Always Known*,
India ink and watercolor on paper,
5 x 5¾ in. (12.7 x 14.5 cm), photo by artist

This small manuscript shows monoline Roman caps with color painted between the letters to make a pattern. The repetition of the words makes the text into a kind of mantra.

Fig. 1

The structure of any lettering style is based on its underlying skeletal shape. Each *style* has a basic form, whether oval, round, or hexagonal. Using a monoline tool, such as a pencil, ballpoint pen, or dip pen with a round end, to study the structure of a style, will give you a strong foundation before using a broad-edged pen (figure 1). Monoline forms can be used on their own as well as for studying more complex styles.

As a child, you learned to write simple capital letters. The basic shapes of these monoline letters have been a part of European and North American culture for more than 2000 years. Some of the most impressive examples were carved in stone during the Roman Empire. Most likely, these forms were written with a brush before being carved with a chisel. The same forms, with thins and thicks added to the skeletal form, were adapted for use in manuscripts and eventually used as a basis for modern typefaces. As enticing as these historic forms are, they're all much easier to master if you first understand the underlying *form*. As you study the forms that follow in this chapter, notice their elegant proportions and graceful curves.

The combined qualities of *proportion*, *structure,* and *rhythm* produce beautiful writing. Although each quality is present in all hands, some styles emphasize one more than others. The three basic alphabets used by the modern scribe—*Roman Capitals, Foundational* (a lowercase Roman), and *Italic*—exhibit these qualities. But in each, one quality predominates. When studying Roman Capitals, the proportions of the letters will be your emphasis. In Foundational, you'll see the effect of the broad-edged pen on the structure of the letter. And, in Italic, you'll learn to write with a rhythm that will give your letters grace and elegance.

As you work your way slowly, drawing the forms of any alphabet, you'll begin to make sense of them. Making the letters again and again will help the shapes to become a part of your visual and muscular memory. Patient study leads to the mastery of the forms.

The letters of various alphabets can be grouped in families according to their basic shapes and proportions. Rule guidelines according to the model you've chosen, or mark them on pre-ruled graph paper. Then, use a monoline tool to write the letters—first in their family groups, then in words or sentences.

In the beginning, write whole pages of a particular style. Pay attention to the overall texture of the page as well as the individual letters. You probably won't develop a rhythm until you get about halfway through a sheet. When you have a feel for the shape and structure of the letters, begin to write words and sentences, stroking the letters confidently and consistently. When you've written a page, you'll be able to stand back and evaluate its appearance.

The round ends of these dip pens come in different sizes, allowing you to make heavy or lightweight monoline letters.

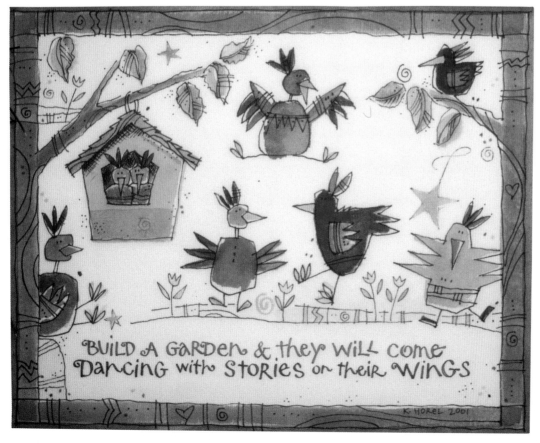

Kirsten Horel, *Bird Garden*, pigment pen and gouache on paper, 6 x 7 in. (15.2 x 17.8 cm), photo by artist

This distorted monoline script made of upper and lowercase letters complements the illustration style.

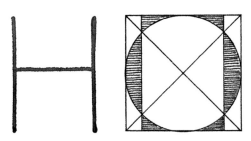

Fig. 2

ROMAN CAPITALS

Let's begin studying specific letterforms by looking at Roman Capitals—a style that is considered to be the basis of many others. Classic Roman letters are guided by simple geometry—the circle, square, and triangle (figure 2). From these different shapes, letters were developed that harmonize with one another.

To begin understanding how this works, look at figure 3 in which a circle is placed inside a square containing two diagonals. Vertical lines are drawn through the intersecting points, creating a rectangle that has approximately the same area as the original circle. This rectangle is the basis for many of the Roman letters, starting with the **H**. The other letters of the alphabet are designed to contain areas that are proportional to this rectangle.

The section that follows talks about and shows illustrations of various Roman Capitals grouped together into families of similar widths. Training your eye to judge proportion takes a good deal of practice, and the proportional guide shown in figure 4 will help you see your mistakes quickly so that you can correct them. Make a photocopy of the proportional ruler in figure 5, and use it to measure the widths of the letters indicated inside each shape. As you work, move it along underneath a line of writing, placing the guides at the widest part of each letter. As you continue down the page, adjust letters that give you trouble.

Fig. 3

Fig. 4

Fig. 5

Photocopy and use the proportional ruler in figure 5 to measure the widths of letters that are one inch (2.5 cm) high. Here the artist is checking the width of the N.

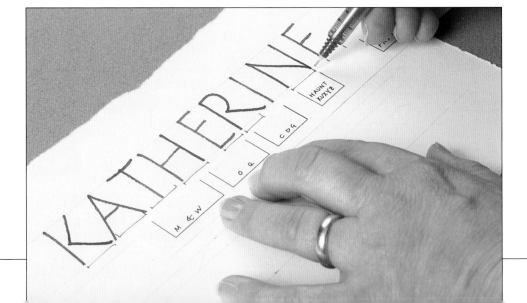

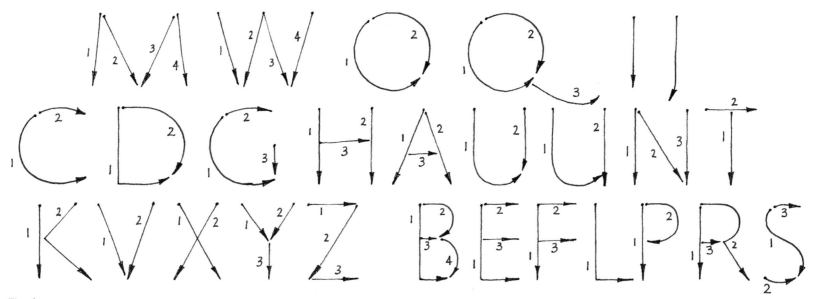

Fig. 6

To practice the letters, rule guidelines that are 1 inch (2.5 cm) high with about ½ inch (1.3 cm) between writing lines. Begin by practicing them in width groups, paying attention to the descriptions discussed below, and then combine them into words and phrases. Refer to the ductus (figure 6) for the stroke sequence of these forms.

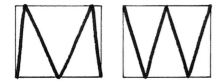

M and **W**, each composed of four downstrokes, are wider than they are tall, fitting into a rectangle that is slightly wider than its height. Note that these two letters differ slightly from one another—the legs on the **M** are splayed out only slightly from the vertical, while the lines on **W** divide the area into equal triangles.

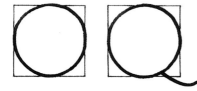

O and **Q** fit within a square. Follow the ductus and practice writing the circle shape in two strokes, beginning at the upper left side. The **O** is a circular form that seems to demand perfection, but as you write it, you'll discover that varying it subtly gives it more liveliness. To make a **Q**, add a graceful tail to the **O** that is straight for about two-thirds of its length before it opens into an arc. Avoid hooking the end of the tail because it will look clunky.

C, D, and G fit into a space slightly narrower than a square, or about seven-eighths its height. As you make the C, keep the bottom of the letter low and lift the top of it so it remains close to the guidelines. To make a G, add a third downstroke to the C, making a crisp corner on the lower right. This third stroke on the G begins about halfway up the letter, directly below the end of the second stroke.

When making a D, composed of two strokes as shown in figure 6 (page 33), note that the bowl is smooth. Imagine the bowl of the D as a balloon and that you have a small air valve on the back side of the first stroke to blow into the counter space of the D, making the curve as tight and smooth as possible (figure 7). Follow the stroke sequence carefully, noting that the bottom portion of the letter is made as part of the first stroke. This will help as you bring the pen around for the second stroke, and you'll be able to visualize the finished form more easily.

Fig. 7

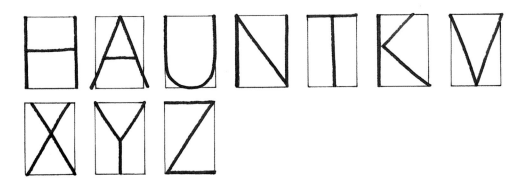

The widths of H, A, U, N, T, K, V, X, Y, and Z are about two-thirds the height of the letter. H, N, T, and Z are defined by this rectangle. The legs on A and V splay just a bit beyond the confines of this rectangular boundary, trapping the same amount of space as the other letters. The U has a curve on the bottom similar to the curve you so carefully made on the bowl of the D—a smooth arc that grows from connecting the two downstrokes. There are two skeletal forms that can be used to make the U. Refer to the monoline ductus (figure 6, page 33) for these forms, and you'll see that the stroke on the right side can join with the curve, or it can come all the way down to the baseline.

The K, X, and Y fit within the rectangle, and you must balance the triangles created by the angled stroke(s). To help with this, pay attention to the shapes of the negative spaces you're creating while making the lines.

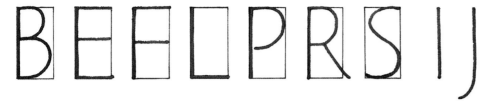

B, E, F, L, P, R, and S are about half the height of the letter. All of these letters, with the exception of L, have two stories. The area contained by these smaller shapes is proportional to the wider letters.

Take a look at the shape of B in comparison with D (figure 8). When you make a B, think of stacking two Ds on top of each other, and the shape of the two bowls of the B remain proportional to that of the D. There is an optical illusion that occurs with two-story letters. If the bottom story is the same size as the top, it looks smaller. In order to compensate for this, the bottom is made slightly larger.

The top of the P is the same as the top bowl of the B, making it slightly larger to balance the empty space below the bowl. An optional third stroke can be added to close the bowl on the P.

The E, F, and L are all defined by the width of the rectangle. Draw the middle crossbars on the E and F just above the halfway point of the letter. Line up the top and middle bars on the right side of the rectangle as shown. On the E, make the bottom stroke so that it extends slightly from the rectangle.

The R is not simply a P with a tail added on; its stroke sequence gives it a more refined shape than this. Add the tail of the R as part of the second stroke. Then, if desired, close up the bowl with a short horizontal stroke.

The S requires you to visualize a smooth spine, making a transition from a counterclockwise curve on top to a clockwise curve on the bottom. If two circles are stacked within the rectangle, your pen will trace the top one first before shifting to the bottom one. The second and third strokes continue this smooth shape on the top and bottom of the letter.

Make the I with a single downward stroke. Make the J with the same stroke, but extend and curve it so that it reaches slightly below the baseline. None of these skeletal letters have serifs, so the I and J are minimal forms.

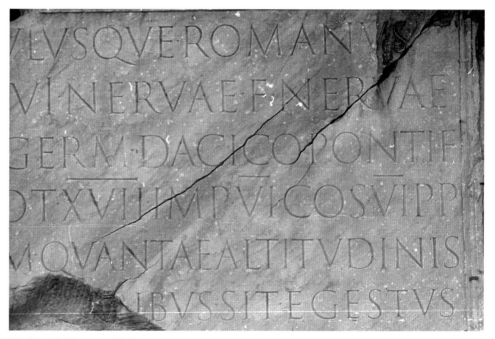

Fig. 8

The Imperial Roman alphabet, such as you see on a portion of the Trajan inscription shown here, had only 23 characters. The Romans didn't use the W, and it wasn't added until the Middle Ages. They also didn't have a special shape for either the U or the J because they used the V and the I to represent these sounds. Modern interpretations of these three letters are based on geometry rather than historical models, and you'll see many versions of these letters used by both scribes and type designers. (Photo by F. Edward Catich, Courtesy of Catich Gallery, Davenport, Iowa)

UNDERSTANDING SPACING

A page of good writing has an even texture. When the evenly proportioned shapes of the square, circle, and triangle are used as a guide, they produce harmonious letters. But, you must also make the spacing between the letters proportional. Learning to see the negative space formed by shapes within and between letters gives you more information and control over your writing.

Pen angle practice naturally gives your pages this kind of evenness, because you're repeating a minimal number of forms. But when you're working with 26 distinct shapes, you'll have to plan for some odd combinations, adjusting the spacing of the shapes accordingly.

As you write, think first of the form of the letter as you make it. Then pause for a moment to gauge the space between this letter and the next, based on the relationship between the two letters. Then return to the form of the next letter, and so on. A rhythm of positive and negative space as well as dark on light will emerge as you move between letters and spaces.

As an exercise, decode the shapes in figure 9 by looking at the spaces between them. Then practice blocking out the shapes/letters that make up your name by drawing the negative shapes between them.

Fig. 9

If you compare the shapes between letters to the shapes of bottles, you'll see how different shapes can hold the same volume (figure 10). Apply this principle to lettering, and you'll see that the lettering artist must also learn to evaluate the space between letters in order to balance it across the page.

Unit Spacing

To achieve even texture in your writing, begin by comparing the space within and between the letters. The letter **O** contains the most area, and our initial study of proportions showed that the **H** takes up about the same amount of space (see figure 3 on page 32). The system described here will allow you to leave the same area between letters as is trapped within the **O** or the **H**. Let's use these two letters as a starting point. Take a look at figure 11 as you read through the text that follows.

The distance between the two stems of the **H** is roughly two-thirds of the letter's height. Allowing for a bit of black taken up by the crossbar, the area within the **H** is a little less than two thirds of the height. To determine a *unit* for even spacing, first draw an **H**, then draw a slightly narrower rectangle next to it, as shown in the first section of figure 11. This shape will vary with the thickness of your pen—from the same width if using a sharp pencil, to a narrower rectangle if your pen makes a fatter mark. This is the size of the unit

Fig. 10

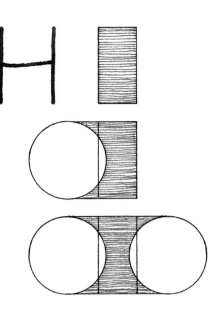

you'll use to space the other letters. The verticals of this rectangle are referred to as *uprights* in the following discussion. It's helpful to mark this distance on your photocopied proportional ruler used to judge letter widths.

If a curved letter is followed by a straight one, the curved part of the letter intrudes into this unit space. When you draw an upright on the curve, as shown in the second section of figure 11, the two shaded areas to the left of the upright should equal the open area inside the **O** to the right of the line. This is the "robbing Peter to pay Paul" principle of letter spacing. When two **O**'s are juxtaposed, an hourglass shape is formed between them that should be roughly equal to the area inside the **O**, as shown in the bottom section of figure 11. The uprights through the facing curves of the circles are the same distance apart as the unit space established in the beginning, and you can use this spacing to determine where to place the next letter. In figure 12, you can see that these forms can be converted into the word "OHIO," and the unit space is consistent across the word, slightly narrower than the **H**.

Fig. 11

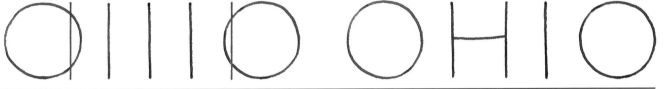

Fig. 12

Next, take a look at the word "HAWAII" as it's written in figure 13. As you apply this principle to letters with angles, such as **A** and **W**, you'll see that the area between the two letters (shown in blue) is approximately the same area as the unit space between the two **I**'s at the end of the word. The upright of the unit divides the angles on the letters into two triangles above and below the middle of the letter. The word "HAWAII" has an equal amount of blue shading between each letter, resulting in an even texture. If this principle is carried further, you'll see that you can convert the space between any two letters into a unit space rectangle by placing an upright at the point where the space given up equals the space taken away.

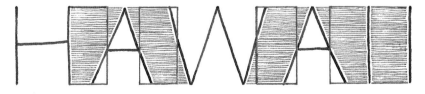

Fig. 13

To further understand this principle, consider the spacing of the word "OKLAHOMA" (figure 14). Try writing this word as shown, using your proportional ruler as guide. Notice that the **O** is intersected by the left upright of the spacing unit. Using the unit on your proportional ruler, mark this upright on the letter **O**, followed by the right upright that forms the stem of the letter **K**. Complete the **K**, then divide the right edge of it into three triangles with the next upright, judging the balance of the two triangles on the right of the upright to the larger triangle to the left of it.

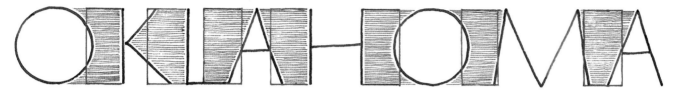

Fig. 14

Next, mark the distance to the right upright of the unit to place the stem of the letter **L**. Notice the ligature between the **L** and the **A**. This letter combination takes up more space than any other. If you prefer closer spacing, shorten the cross bar on the **L** to bring the **A** to the left a bit. Placing them close to each other creates the balance needed in the word as a whole.

To finish writing the word, mark off the next unit spaces to write the **H** followed by the **O**. Finish with the **M** and the **A**, and notice that the space between them is an irregular trapezoid, but can still be broken down into the rectangular unit.

If all the letters were simple geometric shapes such as the ones we've just looked at—with no open areas—this system of spacing would give us even texture with any combination of forms. But a good portion of the alphabet is composed of letters that aren't closed, but optically trap some area inside them. These include **C**, **G**, **E**, **F**, **L**, **P**, **S**, **T**, and **Z** (figure 15).

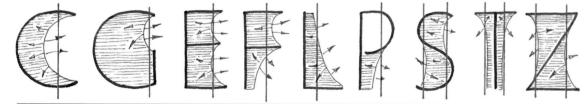

Fig. 15

When you look at the **C**, intersected by an upright, notice that the inner space of the letter (noted in blue in figure 15), is directed toward the inner curve, while the area shown in white is directed toward the space. The red line indicates an approximation of the left upright.

In comparison, notice how much more area is trapped inside the letter **G** and blocked by the third vertical stroke. This means that the **G**'s left upright is placed farther to the right than on the **C**.

Look back for a moment at the word "OKLAHOMA" in figure 14. Notice that the unit space on the **L** begins to the right of its stem. This is because the crossbar on the **L** influences your vision of exactly what belongs to the letter. As you can see, some of the inner space is hemmed in by the extended portions of the letterform, and your eye reads it as part of the form.

MICHIGAN CAROLINA CONNECTICUT MONTANA MISSOURI TENNESSEE

Fig. 16

To determine the unit spacing on these forms, you'll sense how much area should be trapped inside the letter and how much given up to the space. Draw the unit upright at the point where you feel the letter ends and the space begins. When you've written out a page of text, look for hot spots of tight spacing or white areas, and adjust your letters accordingly on the next page.

Now, look once more at our example of the word "OKLAHOMA." The unit between the **L** and the **A** allows some of the space to be part of the **L**. Now take a look at the words "MICHIGAN" and "CAROLINA" in figure 16. These words illustrate the subtle spacing adjustments that you need to make in words containing open letters. "MISSOURI," with its double **S**, is another good example that you have to balance by eye when you write it. The space between the **M** and **I** can be established by the unit space, but the double **S** must be balanced by eye, allowing for some of the area to be a part of the letter, some to be a part of the space.

Balanced spacing is easiest to achieve when writing words derived from Latin, such as "CAROLINA" and "MONTANA." Since our letterforms were written in Latin for more than 2,000 years, the language and the forms evolved together compatibly. When you write words whose roots come from other languages, you'll find that the forms don't fit together quite as well. For instance, "CONNECTICUT," with its angular **N**s at the beginning of the word and the tricky **CT** combination, is a difficult word to balance gracefully. Other state names based on Native American words, such as "TENNESSEE," pose difficulties. Trying to write "MISSISSIPPI" is also a challenge because of its repetitive letters.

Uniform spacing principles apply to all alphabets, whether written with a monoline or a broad-edged pen. When writing Foundational, you'll think of stringing pearls in a row across your page. For an alphabet such as Black Letter, you can visualize a picket fence. When you run into awkward combinations, adjust the shapes of the letters to accommodate the space, and balance the negative spaces between them. You won't lose legibility, and the texture will improve. Keep in mind that your hand-formed letters aren't mechanical type—they are malleable and can be adjusted to your needs.

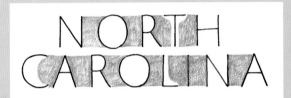

Fig. 17

PRINCIPLES OF LETTER SPACING

The basics of letter spacing can be broken into four principles. These apply to all hands, although the details vary for some of them.

1. Your goal is to make an even texture on the page with a consistent overall tone.
2. Space within letters should equal the space between them. If your letters are well-proportioned and balanced, spacing should match.
3. To achieve this balance, begin by placing vertical lines farthest apart, a curve next to a vertical a bit closer, and two curves the closest, as shown in figure 11 on page 37.
4. Space between words is equal or less than a small letter **o**.

As you practice your letters, use colored pencils to fill in the spaces within and between the letters. You'll quickly see where you're leaving too much or not enough space. And you'll create a pretty pattern of color at the same time (figure 17).

Spacing must be carefully thought through each time you begin a lettering session. Work for a while, and then step back and evaluate the overall texture of the page. It is helpful to squint at the page from a distance. This tends to blur the shapes together and the dense black areas or open white areas will pop out. At first you must make a conscious effort to look at the negative shapes as you work, but soon you will find that it will be second nature. After all, by looking at both the letters and the spaces between, you have twice as much information to work with.

The text of some manuscripts from prior to the fifth century often have no spacing between words. Like the spoken word, which leaves the listener to sense where one word ends and the next begins, writing was continuous. However, scribes discovered that spaces between words improved legibility, especially for readers who weren't reading their native language.

This space doesn't need to be very large, especially if the letters within each word are spaced well. The space between words should only be slightly more than the space between letters, and the general rule of thumb is not to exceed the area of a lowercase **o**. Any more than this creates rivers of white down the page, detracting from legibility.

Sherrie Lovler, *I Have Always Known*, page from manuscript book, India ink and watercolor on paper, 5 x 5.75 in. (12.7 x 14.5 cm), photo by artist

MONOLINE CAPITAL VARIATIONS

Changing the *weight* of the letters changes their impact, as you'll notice if you take a look at figure 18. There are times when you might want a thin line, others when you'll want a bold letter. Practice monoline letters with a variety of tools, from pencils and ballpoint pens to felt-tip or ornamental pens.

Using Classic Roman proportion is just one way to write monoline capitals. As you master these forms, try varying different families of letters (groups with similar proportions and shapes) one at a time. For example, you might keep the **O**, **Q**, **C**, **D**, and **G** round and full, while making all the other letters extremely narrow. Or add a slight wiggle to the classic forms to soften them (figure 19).

Fig. 18

A QUIZZICAL GAWKY CHILD
SCAMPERED FORTH, VENDING BIJOUX.

SPHINX OF BLACK QUARTZ
JUDGE MY VOWS.

JUST REXIA HARVEY, OF WYOMING,
QUIZZED PATRICK ABOUT THE FLIGHT.

A QUICK MOVEMENT OF THE ENEMY
WOULD JEOPARDIZE SIX GUNBOATS

Fig. 19

MONOLINE LOWERCASE ROMANS

These lowercase letters are simple, harmonious, and legible forms based on a circle. They have little or no ornamentation. As you learn these forms, you're preparing for the study of Foundational in the next chapter, because monoline lowercase Romans are the skeletal forms for this hand (figure 20).

In these forms, the square and circle used to make capital letters are adapted to lowercase. Following the ductus in figure 20, rule guidelines with the body height a bit larger than the ascender/descender space. Use a ratio of 3/4/3, since it matches the Foundational letters you'll write later. Practice the letters in the families as they're illustrated before combining them into words and phrases. The stroke sequence shown will prepare you for making the same letters with a broad-edged pen.

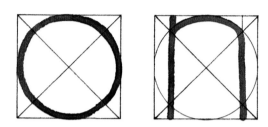

nmhruy · oecs · bpdqg

wvxyz · nae · ftz · ijl · k · g

a b c d e f g h i j k l m n o p q r s t u v w x y z

as if you could kill time

without injuring eternity

THOREAU

Fig. 20

Monoline Italic letters are based on an oval rather than a circle. These letters can be used in their simplest form, as shown in figure 21, or exits and entrances can be added. When they're joined, they become the basis for italic handwriting.

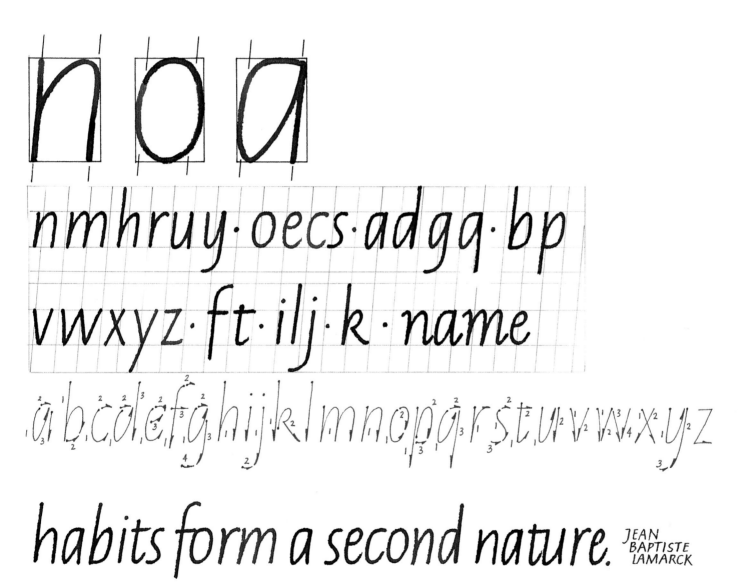

Fig. 21

The Broad-Edged Pen

Through practicing the letters shown in the previous chapter, you've begun to see relationships between shapes of letters and watched a pattern of texture unfold underneath your pen. In this chapter, you'll be introduced to the broad-edged pen, the tool that virtually shaped our alphabet. It makes thick and thin lines, and its application to monoline letters results in an infinite variety of fascinating forms.

When we discuss the form of the letter, we're talking about its physical, visual qualities. An **A**, for instance, can take many forms, although its phonetic meaning stays the same. As a scribe, you'll be concerned with these visual qualities. This might require a new way of thinking because your mind is trained to read letters for the words they make and the stories they tell, not to look at them for their shape and structure.

When you learn lettering, you begin with classical forms. These forms have the cleanest geometry—structured on triangles, circles, ovals, rectangles, and parallelograms—giving them a universal quality. As you work, you'll use these shapes as a guide to produce crisp, simple letters with the pen. Each scribe puts a bit of her own personality into the marks she makes on even the most traditional forms. They can be modified or altered; each generation of lettering artists lends their own contemporary touch. Examples include Art Nouveau, Art Deco, and psychedelic typefaces based on distortions of pen forms or drawn forms.

Today, artists experiment with lots of unusual shapes, developing alphabets that can easily be converted into a typeface on a desktop computer. Consequently, our books and magazines are flooded with _fonts_ that have a hand-lettered look. Some of these are almost illegible, while others are quite elegant.

Because the lettering world has included many kinds of professionals, alphabet styles often have different names. Typographers may use one term, while sign painters use another. For instance, a style might be known by one name in the United States and another in England. Because of increased communication among these fields, there's been an attempt to unify the names of letter styles, but it can still be confusing. The style names used in this book are common to calligraphers, but might be new to graphic designers or sign makers.

Hermann Zapf, _Hora Fugit,_ design for three-dimensional letters executed in matte-finished aluminum by John Borell, Steel Art, Boston, Massachusetts, 15.75 x 16.5 in. (40 x 41.9 cm), photo by artist

Fig. 1

penangle

The term *typeface* applies to a letter set in type—both handset using individual pieces of metal type or computer-generated versions. The term font historically meant both size and style of type, indicating the particular drawer in which the bits of metal were found. Today, it refers only to the style, since the size can be easily adjusted through computer software.

As you use the styles in this book, you'll see some parallels to the world of type, but there will also be disparities. Our letterforms are made one at a time with a tool in the hand, not with a computer.

In this chapter, a number of classical alphabet styles are diagrammed—a starting point for mastering the broad-edged pen. As you work on the forms of each style, study every nuance, mastering the subtle shapes and developing a rhythm as you write. These standard forms are a universal starting point for developing your own unique interpretations. Keep a copy of the ductus in front of you as you work on a particular alphabet, following the directional arrows as you did in chapter 3.

Since our alphabets evolved from forms created by reeds and quills, the modern broad-edged pen imitates those tools. Made from steel, wood, brass, or plastic, these pens make marks that change in width while you're moving them in different directions.

As we've discussed, the natural pen angle for most right-handed people sitting directly in front of a page squarely taped to a drawing board is about 30°. Holding the pen at this angle results in vertical strokes that are about twice as thick as the horizontal ones. As you curve the stroke of the pen, the line changes from thick to thin (figure 1).

When Edward Johnston looked at medieval manuscripts in the British Library, he discovered one that he felt would be a good model for learning to use the broad-edged pen. The letters have a basic circular shape, a consistent pen angle is used to make them, and the forms are simply structured. This manuscript, known as the *Ramsey Psalter,* was written in southern England in the 10th century. Johnston used it as a model for the teaching hand that he developed called Foundational.

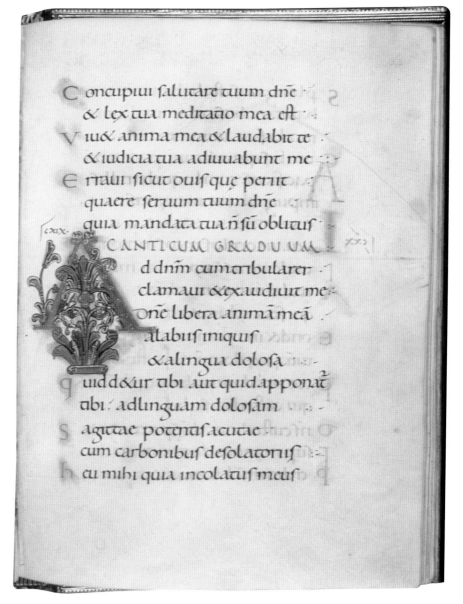

Ramsey Psalter, ca. 974-986, ink on vellum, 13 x 9 3/4 in. (33 x 25 cm), by permission of the British Library (Harley Ms. 2904 f164)

This manuscript was used by Edward Johnston as a basis for developing the Foundational Hand. Note the similarities, as well as the differences, between these letters and the hand you're learning.

FOUNDATIONAL

In this section, you'll learn how to write the Foundational alphabet, a lowercase alphabet. You'll use an adaptation of Roman capitals for the accompanying uppercase letters.

Before you begin writing, nib off guidelines according to the models shown in figure 2. Although you could write on evenly spaced lines, using every third space for the baseline, you'll find the proportions more pleasing if you allow 3 nib widths (n.w.) for ascenders, 4 n.w. for the body height, and 3 n.w. for descenders—the same proportions that you used for monoline lowercase letters. These guidelines are the basis for the proportions of the classical form. Later, as you become experienced, you can alter the line spacing if you wish.

As you learned in chapter 3, every hand has qualities of proportion, structure, and rhythm. The hallmark of the Foundational hand is its structure, which is directly related to the overlapping marks made by the broad-edged pen, giving the letters their unique form. The proportions are relatively straightforward, since all the letters have a round quality. The rhythm of this hand is like stringing round pearls that form an undulating pattern of circles.

Fig. 2

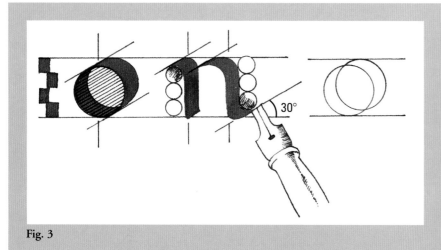

Fig. 3

BASICS OF FOUNDATIONAL

Pen angle: 30° from the baseline

Letter height in nib widths: ascender = 3, body height = 4, descender = 3, commonly abbreviated as 3/4/3 n.w.

The basic shape of the letterforms, looking at the **o** and the **n**: The **o**, made with a broad-edged pen, is based on a circle whose contours are made up of two overlapping circles. Look at the perfect circle made by the left edge of the nib. The arched shape on the **n** connects to the stem and traces a portion of the circle used to make the **o**. The curves in the entrances and exits are made of smaller circular arches that repeat the overall circular shape of the letters.

Slant/slope: In general, this hand is written vertically, although there may be occasions to give it a slight slant.

Speed: This alphabet, in most of its versions, should be written slowly, since form is sacrificed if it is written too quickly.

abcdefghijklmn

opqrstuvwxy&z

abcdefghijklmnopqrstuvwxy&z

Fig. 4

To begin writing Foundational, review the skeletal shapes of the lowercase Roman letters in chapter 3, and refer to the Foundational ductus in figure 4. Hold your pen at a 30° angle. If the ink doesn't flow readily, you may have to press on the pen a bit to get the ink started, or twist or jiggle the nib a bit. At the same time, release the pressure once the ink has started to flow, sliding the pen on the wet ink. Next, begin to write the letters in families, or similar groups. After this, you'll begin to combine them to make words.

• Begin with the **o**, considered to be the "mother" of the alphabet. Start the first stroke just below the waistline, moving the pen to the left and curving it around to the thinnest part of the stroke. Overlap the first stroke slightly to begin the second stroke, moving around to join the thin part of the previous stroke at the bottom. Watch the negative space carefully as you work, visualizing the edges of a perfect circle (the one that touches the baseline in the skeletal drawing) traced by the left edge of the pen (see figure 3 on page 46).

The N Family: Arches Top and Bottom

The **n** is the "father" of the Foundational alphabet. It is part of a family of letters that includes the **h**, **m**, **r**, **u**, and **y** (figure 5). To make this letter, place the pen just below the waistline at a 30° angle. Slide it up and over to make an entrance stroke. Watch the shape of the curve under this stroke. Just before reaching the baseline, move the pen a tiny bit to the right to soften the foot of the letter.

Fig. 5

• The second stroke creates the arch. Place the pen at a 30° angle within the stem, just below the waistline. Drag a bit of wet ink out of it, making the same shape you see on the top of the **o**. Smoothly move into a straight *downstroke* and make an exit stroke by curving the pen around and lifting it when the stroke is at its thinnest point. Like a plane taking off, the pen's movement as you lift it should be smooth—consistent with the direction of the movement it made on the paper. Make a pattern of **o**'s and **n**'s, balancing the curves with the verticals (figure 6).

Fig. 6

• The **h** is related to the **n**, but notice that the *bracketed entrance* on the **h**'s ascender differs from the curved one of the **n**. For this entrance, place the pen just below the ascender line at 30°. Slide straight up along the pen angle before dropping directly down the stem of the letter. The movement feels similar to making the number seven. You can *bracket* this serif by filling in the space you have just made with a curved stroke (figure 7).

Fig. 7

• Begin the **r** as you did the **n**. When making the second stroke of the **r**, place the pen at the same point within the stem that you did when you began the arch on the **n**. Follow the arch for a very short distance before finishing the stroke with a flick of the pen (figure 8). (It's tempting to put a longer mark resembling a handlebar mustache on this letter, but it can intrude too much into the space of your next letter. Save this idea for the end of a line of writing.)

Fig. 8

• The **m** is almost twice as wide as the **n**. The first two strokes are the same as **n**, matching the small wiggle at the bottom for the foot (figure 9). The third stroke repeats the arch, with a curved exit stroke.

On an old-style typewriter, the **m** was a narrow letter because it had to fit on the same size key as all the other letters. When lettering by hand, however, you'll strive for an even texture. Because you may have seen so many narrow **m**'s in your life, you might have to make a conscious effort to make yours wider so that they balance white spaces within and between the letters. Note that the counter space inside the **n** (and hence, the **m**) is 2 n.w.

Fig. 9

• The **u** is basically an upside-down **n** (figure 10). Begin writing it with an entrance stroke, then drop to the baseline and make an arch that is the reverse of the arch on the top of the **n**. Imagine the pen tracing the same arch you made on the bottom of the **o**, ending with a hairline at 30°. The second stroke has a bracketed entrance, and drops straight down to the baseline, with an exit at 30°.

• There are two **y**'s that can be used in this hand, the first one based on the **u** and the second on the **v** (figure 10). The first has a descender that is shaped like the **j**. Begin with the first stroke of the **u**, then begin the second stroke with a bracketed entrance. Drop below the baseline, curving to the left in the descender space, ending on a hairline about halfway into this space. Place the pen just above the descender line, and bring the third stroke across to meet the hairline of the second stroke with a smooth connection between. You'll notice that this stroke repeats the arch you have made on the **n** and the **u**.

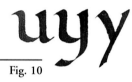

Fig. 10

• The **a** is a cousin to the family of letters that have been discussed so far. The shape of it can be varied, from the very stiff version shown on the left to the slightly softer second version on the right in figure 11, though the underlying skeletal form remains the same. A three-stroke letter, the first stroke is the same as the right-hand stroke of the **n**. To make the loop on the bottom, the second stroke traces the section of the arch on the bottom of the **o** that we have used on the **u** and the **y**. The third stroke moves from left to right, from the top of the second stroke to the stem.

Fig. 11

Basic Vertical Forms

The letters **l**, **i**, and **j** are made of strokes you've already learned (figure 12). The letter **l** begins with a bracketed entrance, as in the **h**, and ends with the round bottom you used on the **u** and **y**. True to its historical model, this form harmonizes with other round-bottomed letters. The **i** is made with the same bracketed entrance used on the ascenders of **h** and **l**. The dot is variable and is either a diamond-shaped wedge or a flick of the pen made from upper right to lower left. You made a **j** when you made the second stroke of the **y** above. It uses the bracketed entrance, and the bottom stroke is the same as the arch on the bottom of the letter **o**. Don't make this tail too large, or it will trap too much space and interfere with the line of writing below.

Fig. 12

The O Family: Strings of Pearls

The round letters **o**, **c**, **e**, and **s** shown in figure 13 all fit within the shape of a circle. You practiced the **o** as you got comfortable with your pens. Repeat a few more to compare with the other letters in this group. The **c** is made of the first stroke of the **o**, with a short arch stroke across the top. Notice that this second stroke of the **c** hangs from the guideline without closing up the counter space.

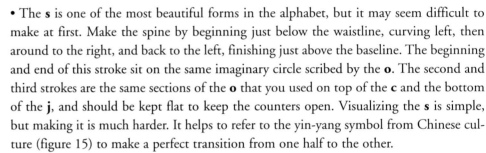

Fig. 13

• The first two strokes of the **e** are the same as the **c**. To make the third stroke, begin halfway up the first stroke, bringing the pen up to the right to connect to the end of the second stroke. This may seem like an extra stroke because it seems as though you could just continue the second stroke around to the middle of the first stroke. Nevertheless, you'll find that this sequence makes the letter appear round, so it matches the rest of the family. Notice how the loops in the **a** and the **e** are inversions of the same form (figure 14).

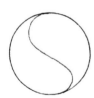

Fig. 14

• The **s** is one of the most beautiful forms in the alphabet, but it may seem difficult to make at first. Make the spine by beginning just below the waistline, curving left, then around to the right, and back to the left, finishing just above the baseline. The beginning and end of this stroke sit on the same imaginary circle scribed by the **o**. The second and third strokes are the same sections of the **o** that you used on top of the **c** and the bottom of the **j**, and should be kept flat to keep the counters open. Visualizing the **s** is simple, but making it is much harder. It helps to refer to the yin-yang symbol from Chinese culture (figure 15) to make a perfect transition from one half to the other.

When making an **s**, let go of perfectionism by ignoring guidelines, at least momentarily. If your spine is too long or short, add the top and bottom where they need to go to finish the letter beautifully rather than wedge the spine between unforgiving lines. This way, you'll train your hand to make a beautiful **s** that you can modify to fit the rest of the letters. After all, you'll be erasing the guidelines, but the ink will remain.

Fig. 15

• Also included in the round family are **b**, **d**, **p**, and **q** (figure 16). These letters all take the basic **c** shape and add the ascender or descender. In the case of **b** and **p**, the bowl is simply a reversed **c**. The ascender of the **b** has a bracketed serif. The **p** begins with an entrance at the waistline, dropping to a small foot made by stopping the pen at the bottom of the stroke and bringing it sharply to the right. Notice how open the counters are in these letters. Make sure the arched strokes are flat enough to avoid closing up the counter.

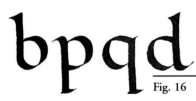

Fig. 16

• An alternate **q** uses the **o** shape with a tail. This form is less legible, but it can be a sophisticated addition, as shown in figure 17.

Fig. 17

Contrasting Forms

The first groups of letters that we've shown are all somewhat consistent in shape, with a great deal of structural repetition. The basic structure of the remaining letters—**f**, **t**, **k**, **v**, **w**, **x**, and **z**—contrasts with the circle, so you'll have to find ways of harmonizing them when they're juxtaposed with the round ones.

As you can see in figure 18, the **f** relates to the **j** because the curve on the top should be a small, smooth arc like the one on the bottom of the **j**. The **f** can have either a little foot on it or can drop just slightly below the baseline without going all the way to the descender line (see figure 20 below).

Fig. 18

• The **t**, which begins just above the waistline, relates to the **l** because of the open curve on the bottom (see figure 19). Cross both the **f** and **t** with a thin stroke that begins just to the left of the downstroke and lines up on the right-hand side with the first stroke, as shown in figure 20.

Fig. 19 Fig. 20

• The next group of letters breaks the rule of the 30° pen angle. Since the strokes of **v**, **w**, **x**, **z**, and the second version of the **y** are angled (figure 21), you need adjust the pen angle to maintain the same weight as the vertical strokes. Experiment with strokes to find a steeper angle for your pen that gives the **v**, **w**, and **x** a better contrast between thick and thin, around 40 to 45°. As a bonus, you'll get a nice point on the bottoms of the **v** and **w**.

When you make the angular **y**, extend the second stroke below into the descender space, adding a tiny foot to the end by moving the pen slightly to the right as you exit. The downstroke of the **z** is made with a flatter pen angle of almost 0° to strengthen the back-slanting downstroke. The top and bottom strokes of the **z** match the cross strokes on the **f** and **t**. Make a conscious effort to keep them thin so that they contrast with the downstrokes.

Fig. 21

• In figure 22, you'll see two versions of the **x**, one with the second stroke sliding up to the right, the other with the second stroke sliding down to the left. Notice the effect that this difference has on the shape of the letter.

Fig. 22

• There are two versions of the **k** (figure 23). The first rounder form echoes the bowl of the **e**. Begin the second stroke on this letter by bringing an arch out of the stem, then bring it back to barely touch the stem with the left-hand corner of the nib. The tail is a straight line with a bit of curve on the end. The second, more angular form repeats the second stroke of the **v**, then adds a tail as above.

Fig. 23

Fig. 24

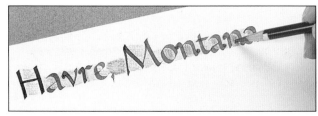

Fig. 25

• The **g** is in a family all by itself (figure 24). The first version shown here is a handsome form, but its structure can look daunting. Begin with the top, a two-stroke circular form that hangs from the waistline but sits about a nib width above the baseline. The neck and spine is a swinging s-curve that attaches to the bottom of this circle. The bottom loop is closed by the fourth stroke. The final stroke is an ear attached to the circular form just beneath the waistline. The simpler version of a **g** that you see to the right is another option, but it isn't as elegant as the first.

As noted above, more than one form of **k**, **f**, **g**, and **y** are shown for this style. You can choose the ones that are rounded to emphasize the basic circular forms, but if you want a livelier version of these letters, use the angular form of **k** and **y**, or the longer **f** and more complex **g**. To maintain consistency, use the same version of the letter throughout a piece of writing.

Spacing Foundational Letters

The goals of even texture apply to all hands, and the rounded pearls of Foundational, when evenly spaced, fall into place quite readily. To these letters, you can apply the basic rules of spacing already explored in chapter 3. For instance, take a look at the writing of the word "minimum" (figure 25) that shows the relationship of the counters to the spaces between them. As a general rule, remember that the verticals of the letters should be placed farthest apart, a curve next to a vertical should be a bit tighter, and two curves should almost touch.

To check your spacing, use colored pencils to fill in the spaces within and between your letters. You should be putting down about the same amount of color in each enclosed area (photo 1). Notice, for instance, how the arch on the **n**, if made well, traps about the same amount of space that you find in the letter **o**.

Some letter combinations don't seem to fit together very well, but these can be modified as you write. Imagine sitting on an airplane next to an aggressive seatmate whose elbows intrude on your space. Instinctively, you pull in your elbows or try to tuck them into any leftover space.

You can adjust odd-shaped letter combinations in a similar way. Change the shape of the letter slightly by altering the entrances or exits. Refer to figure 26 for several examples. In the the word "verve", the entrance to the second **v** has been turned around to accommodate the second stroke of the **r**, reducing the space between **r** and **v**.

If letters don't fit together smoothly, you can also attach one letter to the next to create ligatures as noted with arrows. In "verve" the entrance on the **r** flows from the third stroke on the **e**. In the word "peace", the **e** and the **a** are joined to create another ligature. The cross strokes on a double **t** or **f** can be made as one stroke, or these cross strokes can flow into the next letter, as in **fi** or **ty** in the word "infinity". Note the smooth flow of the strokes that join the letters in the other examples: "grace", "affirm", and "attitude".

Historically, ligatures in manuscripts were very common, so much so that early printers used typefaces with specially designed characters to imitate hand-lettered books. They would combine two letters onto one piece of metal type, which helped to maintain even spacing.

Photo 1

peace infinity
grace verve
affirm attitude

Fig. 26

As you write, you'll find occasions where you need to adjust the forms to even up the spacing, but make sure that the writing remains legible as you do this. Because modern readers are used to seeing typefaces without ligatures, there are some historical combinations they won't be able to decipher.

The Origin of Foundational

In chapter 2, you were briefly introduced to the history of the alphabet, from Inscriptional Romans through the varied pen forms used in manuscripts. The Foundational hand you're now learning is a later addition to writing, from a time when books and learning were beginning to spread throughout Europe. The model for this hand, the *Ramsey Psalter,* came about in the middle of the Carolingian era, about A.D. 750 to 1100.

Although there were pockets of literacy throughout Europe, notably in the British Isles, where beautiful manuscripts such as the *Book of Kells* (ca. A.D. 700) and the *Lindisfarne Gospels* (ca. A.D. 698) were written, much of Europe had regressed since the time of the Roman Empire. However, when Charlemagne became king of the Franks in the late eighth century and was crowned Holy Roman Emperor, a period of prosperity, culture, and literacy spread throughout Europe. He ruled over a wealthy kingdom that supported monasteries and brought Alcuin of York to Europe to preside over his centers of learning. The many disparate hands in use at that time were standardized throughout Charlemagne's kingdom.

Bartolomeo Sanvito, *Petrarch's Trionfi*, ca. 1480, ink and paint with gold on vellum, 8½ x 5⅜ in. (22 x 14 cm), Walters Art Gallery, Baltimore, Maryland, (I Trionifi WAM no. W. 755, folios 46v-47 by Francesco Petrarch/Bartolomeo Sanvito)

Based on a late Carolingian manuscript, Foundational is a working alphabet with very simple, legible forms. Lowercase Roman typefaces evolved from Carolingian hands. During the 14th and 15th centuries, Renaissance scribes based their *Humanist* bookhands on these earlier manuscripts and refined them.

When you look at a much later manuscript written by Bartolomeo Sanvito, notice that the forms are much more precise than those in the *Ramsey Psalter*. The serifs are more refined, the spacing more even, the letters sit exactly on the guidelines, and the illuminations are extremely fine. The early Italian type designers used Humanist manuscripts as prototypes for some of the first typefaces, many of which are still used as models for the typefaces used in books and magazines today.

There has always been a design tradition of using more than one style of lettering in a manuscript. For example, in illuminated manuscripts, *Rustics* or *Uncials* (see page 18) were often used at the beginning of a section, and *Versals*, or larger drawn letters, were used to begin paragraphs. At times these initial letters were highly decorated with abstract forms and pictures. Gold was added, which caught the eye as the page is turned, resulting in the term *illumination*. The Sanvito manuscript shows a mixture of capitals and Humanist lowercase on the same page, with elegant illuminations. The variations in form were used to emphasize different parts of the text and lend elegance to the book. The contemporary lettering artist uses contrasts in lettering styles to create emphasis in the design.

art is nothing
without form

art is nothing
without form

art is nothing
without form

art is nothing
without form

art is nothing
without form

F L A U B E R T

Fig. 27

Foundational Variations

You can personalize the Foundational hand to suit many purposes—formal writing for such pieces as small books or certificates, or bouncy lettering for things like cards and envelopes. Take a look at figure 27 to see the effect of altering the single attribute of spacing in Foundational. In the first example, the spacing is relatively uniform within and between the letters. In the second, the spacing has been widened. In the third, the spacing is a bit compressed as well as the letters, keeping the texture even.

You can also experiment with the alphabet's other attributes—pen angle, slant, basic shape, weight, and speed. The basic shapes of letters are fairly simple to alter, stretching the **o** from a round form to a squat, wide oval, or compressing it to a taller one. The **n** must be modified to match, and the other letters adjusted to follow suit.

For instance, in the fourth example in figure 27, the **o** and the **n** are narrower than the previous ones. The other letters must then be changed, and the result is a sturdy, upright, and very legible hand. By changing its weight to 5 n.w. from the standard 4, it appears lighter. In the fifth example, the forms are 3 n.w. and compressed vertically; and, as a result, they expand horizontally.

Although there are many Carolingian manuscripts, books written under the direction of the scholar Alcuin of York have an elegant simplicity. A modern interpretation from the Carolingian era, shown in figure 28, is based on manuscripts that date from about A.D. 750 to 850. We can assume that this was an era of prosperity since there were plenty of sheepskins and goatskins available for making large books with wide margins and open line spacing. The body height is compact, only 2.5 to 3 n.w. tall, but the interlinear space between the lines is ample at 8 to 10 n.w. between the baseline and the next waistline. Notice that the **o** is a very wide, squat form, and the arch of the **n** extends sideways.

As we saw in the Sanvito manuscript, Humanist scripts from the Renaissance, especially Italian, show a refinement of the Carolingian forms. Scribes as well as scholars, such as Petrarch, Poggio, and Niccolò Niccoli, wrote a clear, round version. Petrarch modeled his forms on Carolingian manuscripts, and other scholars followed suit. They rejected the condensed black letterforms of the late middle ages as illegible, regarding the rounder forms as more aesthetically pleasing and reflective of their interest in all things classical. The wide, open letters took up more space on the page, resulting in books that were larger and more expensive.

As you work with these lowercase letters, refer to photographs of actual manuscripts to see details the scribe incorporated. Working from a manuscript, you'll see the work of a scribe who wrote consistently, day after day, and the fluidity and texture you see can be used to improve your own forms.

However great a man's natural talent may be, the art of writing cannot be learned all at once. ❀➤➤➤➤➤➤➤➤➤➤➤➤➤➤➤➤

abcdefghijklmnopqrstuvwxy&z

➤➤➤➤➤➤➤➤➤➤➤➤➤➤➤➤❀ For several days after my first book was published I carried it about in my pocket, and took surreptitious peeps at it to be sure the ink had not faded. ROUSSEAU ◆ BARRIE

Fig. 28
Annie Cicale, modern adaptation of a Carolingian style from old manuscript, 1999, ink and gouache on paper

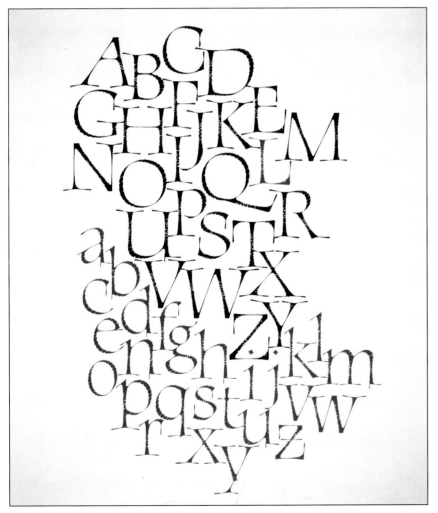

Jean Larcher, *"L" Alphabet*, ca. 2001, gouache on paper, photo by artist

An alphabet panel with a very refined combination of capital and lowercase letters.

BROAD-PEN ROMAN CAPITALS

Since you worked with monoline capital Roman letters in chapter 3, you have an understanding of their proportions and spacing. By using a broad-edged pen to make these forms, you can create whole families of letterforms, from elegant lightweight caps with delicate serifs to sturdy, informal caps. Broad-pen capitals can be used by themselves or in combination with lowercase letters. Study them as a group in the beginning, then combine them later with lowercase letters.

The weight of these capitals can vary from 6 n.w. to as large as 20. Start with letters that are about 8 n.w. tall—enough height to show the effect of the pen on the structure of the letters, while allowing you to monitor the proportions (figure 29). If you practiced the monoline letters in chapter 3 at a height of an inch (2.5 cm), a 3-mm pen will produce letters that are about 8 n.w. tall and match these forms shown.

ABCDEFGHIJKLM
NOPQRSTUVWXYZ
SHORTER·HEAVIER
LIGHTWEIGHT

Fig. 29

Fig. 30

Hold your pen at a 30° angle, and make a series of plus (+) signs and capital **T**'s. This angle gives you a downstroke that is about twice as thick as the cross stroke. These thick and thin strokes are used to make rectangular-based letters, such as **H**, **E**, **F**, **L**, and **T**. You'll notice that this thick downstroke isn't the full width of the pen, however.

To begin, refer to the ductus for Roman monolines (figure 30), and start with the rectangular forms, watching the relationship between the thick downstroke and thin cross stroke. To make the round strokes, hold your pen at 30° as well. Tapered thick and thin strokes are made by the pen's movement as it traces circular letters at a constant angle. Watch the inside counters as you form the shapes, making smooth transitions between thick and thin lines, paying careful attention to the spots where the strokes adjoin each other.

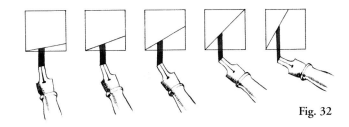

Fig. 31

As with the angled letters in Foundational, there are exceptions to the rule of constant pen angle. The angled letters of broad pen Romans—**A**, **W**, **V**, **X**, **Y**, **Z**, **N**, and **M**—all have strokes that use a different angle, shown by the diagonal lines passing through the strokes (figure 31). Before you begin, check the pen angle against a line drawn in a box, as seen in figure 32.

When writing the letters **A**, **W**, **V**, **X**, and **Y**, hold the pen at a steeper angle, thinning the stroke to compensate for the change in direction from the vertical. In addition, this pen angle results in a point on the top of the **A** and the bottom of **V** and **W**, producing the same relationship between thick and thin that's found on the rectangular forms. On the **Z**, flatten the pen angle on the diagonal stroke to make a thick line. On the **M** and **N**, the verticals are made with a 60° angle to make the thin downstrokes.

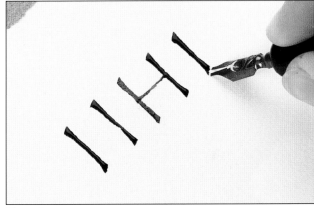

Fig. 32

By practicing these strokes, you'll familiarize yourself with the marks made by moving the pen in different directions while you hold it at various angles. Consequently, the correct letterform will emerge from your pen because you'll visualize it before beginning.

With practice, you can use pressurized strokes to lend forms an elegant, narrow waist in the middle. This narrowing is called *entasis* (see photo 2). This feat is accomplished by putting calculated pressure on the beginning and end of the stroke making up the stem of the letter. On curved strokes such as the bowl of the **R** and **O**, put pressure on the widest part of the stroke to accentuate the weight. These virtuoso forms take time to execute well.

Photo 2

This narrowing of the stem can also be accomplished by making the stems in two strokes, each side with a slightly concave middle. The strokes that make up these forms tend to exaggerate the waist of the stems, resulting in a letterform slightly bolder than those made with single pressurized strokes, as shown in figure 33.

Fig. 33

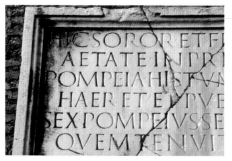

Detail of Appian Way Inscription (Rome, Italy), carved stone, ca. 1st or 2nd century, photo by Patricia Dresler

Lorinda Moholt, journal page, 1999, crayon rubbing on paper pasted onto watercolor paper, painted with watercolor and written with ink, 6 x10 in. (15.2 x 24.5 cm)

While traveling in Italy, the artist created the rubbing of an ancient inscription that you see in this piece.

Photo 3

Photo 4

Photo 5

Serif Variations of Romans

If you've mastered the monoline proportions of skeletal Romans, adding weight to them with a broad-edged pen will produce classical forms. Monumental Romans with serifs, such as those found on the Trajan or Appian Way inscriptions (left), were most likely written with a brush before they were carved with a chisel. Serifs were incorporated by using the brush to make an entrance before moving directly into the stem without lifting the brush, then sliding into an exit (figure 34). These strokes required the scribe to rotate the brush in his hand as he moved from serif to stem and back to serif. Although doing this isn't easy, it's a lot easier with a brush than a pen! Therefore, scribes writing with reeds and quills found easier ways to make serifs on the smaller Roman lettering used in early books.

Fig. 34

You've already seen two of these approaches in chapter 2 in the form of Square and Rustic capitals. For contemporary use, there are a number of other possibilities. The most straightforward variation is a *slab serif* in which simple horizontal strokes are added to the top and bottom of the stem (figure 35). This process must be done with care because any slight misplacement can make them look sloppy. They are a good choice for small letters because most of the other options require even more precision.

The informal variation uses the same sorts of exits and entrances as Foundational (figure 36). Made with a fairly consistent pen angle, the curved serifs lend these letters an asymmetrical quality. They can be used alone or combined with Foundational minuscules.

On many of these variations, you'll notice a twist serif atop the **C**, **G**, and **S** that curves sharply downward. This serif is made by pulling a bit of wet ink out of the stroke with the left-hand corner of the nib, or by *rotating the pen from 30° to almost 90° as you finish the stroke* (see photos 3, 4, and 5). They take a bit of practice, and subtle changes in approach will give you a wide variety of options.

Renaissance-style serifs are an elegant choice for formal writing (figure 37). The Sanvito manuscript on page 53 shows how the scribe has used them to introduce a section of the book. These diamond-shaped serifs are made by adding an extra stroke to informal serifs. To make them, place the pen on the top of the entrance, move it to the right, and then curve it back into the stem. They are an excellent choice to use with a refined version of the minuscules. Hold the pen at a relatively flat angle rather than a steep one to avoid making them too big and clunky. You will need to use the corner of the nib to retouch the strokes on letters such as the **N** or the **M**.

The most refined version of serifs—the hairline serif—is made by holding the pen at a 0° angle to create the thinnest horizontal line possible (figure 38). This will make a wedge-shaped opening inside the outline of the serif as you stroke it, so use the corner of your nib to fill in the form. These elegant letters take some time to make, so you might want to use them for headings or small sections of text.

Figure 39 shows a version of pressurized Romans with a tick serif, a serif added to just one side of the stem. These letters can also be written with full hairline serifs. If you wish, these serifs can be added to double-stroked letters as well.

As you can see, Roman capitals are quite versatile. Your choice among the many styles depends on both your skill and the impact you're trying to make. There are lots of variations of each of these versions, and more to be invented in the future.

II DREAM INK

Fig. 35 Slab serifs

l DREAM INK

Fig. 36 Informal serifs

II DREAM INK

Fig. 37 Renaissance-style serifs

II DREAM INK

Fig. 38 Hairline serifs

l DREAM INK

Fig. 39 Tick serifs

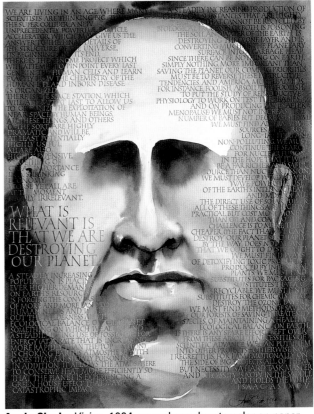

Annie Cicale, *Vision*, 1994, gouache and watercolor on paper, 21 x 29 in. (53.3 x 76 cm)

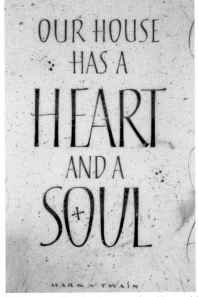

Diane von Arx Anderson, *Our House* (detail), 2001, gouache, ink, and gold leaf on calf skin vellum lettered with brush and metal pens, 11 x 7 in. (28 x 18 cm), photo by artist

The narrowing of Classical Roman proportions lend this piece an elegance.

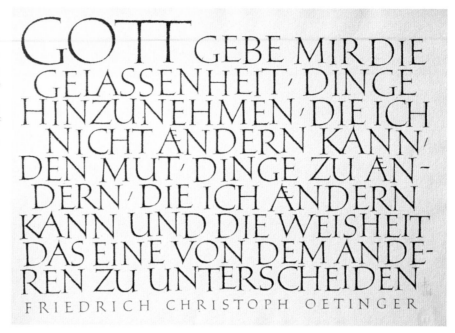

Friedrich Poppl (1923-1982), *Gott Gebe Mir...*, ca.1964, ink on paper, 22 x 30 (56 x 76.2 cm), Klingspor Museum, Offenbach, Germany (by permission of Gertraude Poppl), photo by Annie Cicale

Most likely, Poppl wrote these Romans quite slowly, retouching them as needed. The proportions and balance of negative space are a result of his virtuosity with the pen.

WE MUST ALWAYS KEEP IN MIND THAT BURIED IN DRY STATISTICS ABOUT DIFFERENCES BETWEEN RICH AND POOR IS AN ENORMOUS AMOUNT OF HUMAN MISERY· AN ENDLESS SERIES OF ALMOST INCOMPREHENSIBLE TRAGEDIES· BUT· EVEN IF YOU DON'T CARE ABOUT STARVING CHILDREN AND OVERBURDENED PARENTS WHO LIVE WITHOUT HOPE FOR A BETTER FUTURE· SELFISHNESS ALONE DEMANDS ATTENTION TO THE POVERTY STRICKEN· THAT IS BECAUSE THE PLIGHT OF THE UNDERPRIVILEGED OF EARTH IS PROBABLY THE SINGLE MOST IMPORTANT BARRIER TO KEEPING OUR PLANET HABITABLE·

PAUL EHRLICH

Annie Cicale, *Paul Ehrlich quotation*, 1994, brush letters in gouache on frosted Mylar, 42 x 96 in. (107 x 244 cm), photo by Jon Riley

Using Roman Capitals

Roman capitals can be used alone or with lowercase letters. In either case, you'll need to plan the guidelines carefully.

Used alone, Roman capitals don't require much interlinear spacing. A good practice distance is a quarter to half the letter height for line spacing. For the sake of legibility, longer lines of writing will require more space between lines. If the lines are short, you can stack masses of capital letters as texture without losing legibility because you don't have to plan for ascenders or descenders. You can also allow the letters to touch in interesting ways as one stroke meets the next. But, for more formal pieces, you'll probably want to use wider letter spacing.

When using Roman caps along with lowercase letters, make them of similar weight and proportion to create an even, overall texture. A general rule is to make the cap line (for cap height) at least halfway into the ascender space. (If the caps are made the same height as the ascenders, they'll take up too much space and make open, white spots in the texture.) For example, in Foundational, the body height is 4 n.w., the ascender is 3 n.w., and the cap that accompanies it should be about 5.5 to 6 n.w. tall (figure 40). This height creates a sturdy cap that blends well with lowercase letters. If the body and ascender heights are more, your cap height will increase accordingly. You can make the serifs on your capital letters look formal or casual, depending on the tone of your piece. Informal caps (figure 36) or Renaissance caps (figure 37) are both effective companions to Foundational minuscules.

Fig. 40

ITALIC

As you learn to control your pen, you'll want to learn more than one style of lettering. Foundational and Italic are the two basic lowercase hands, and they correspond to what are known as lowercase Roman and Italic used by typographers. These styles contrast in many ways, giving you a variety of design options.

As you now know, each alphabet can be characterized by its qualities of proportion, structure, and rhythm. A study of Roman capitals requires attention to the proportions of the forms, whereas the structure of the letters in Foundational becomes clear through the stroke placement. The third quality, rhythm, finds its truest expression in Italic (figure 41). When you write Italic, the uniformity of its forms and the naturally rhythmic nature of its upward and downward strokes make you feel as though you're dancing instead of just walking across the page.

Fig. 41

Italic History

In the history of writing, there seems to have been two general approaches to alphabet design that have grown out of different purposes. The first is the clear and legible presentation of important literature in a refined manner, usually done by a scribe working slowly. In this first type of writing, the pen angle is consistent, the shapes of the forms are balanced carefully to unify the script, and the letters are precisely positioned on the guidelines.

The second purpose results from the need to write the words down quickly for the sake of content with little emphasis on presentation. Personal handwriting, or *cursive*, has a wide range. Some people write rhythmically and legibly, while others scribble rapidly, bordering on indecipherability. Cursive hands tend to be compressed and have a forward slant, and they have fewer pen lifts both within and between the letters.

Over time, these two purposes have blended together to create new writing styles. Formal writing imposes discipline on cursive forms, while cursive scribbles loosen them up. Think about how this plays out in personal handwriting. Grocery lists and phone messages, written in haste, are often barely legible, while love letters, thank-you notes, and numbers on bank checks are written with more care and accuracy.

Italic, a beautiful hand originated by Renaissance scribes, combines these two approaches into a rhythmical script that can be written slowly or quickly, depending on your needs. The Italic form became a basis for cursive handwriting. It can be adapted to formal presentations, such as wedding invitations, or used on informal pieces, such as children's birthday cards. Its structure is based on a slanted ellipse and rhythmical arcades of downstrokes created with an up-and-down pen movement (figure 42).

Fig. 42

Italic has had many names throughout history. The more fluid versions are called *Italic Cursive, Humanist Cursive,* and *Sweet Roman Hand.* It is sometimes called a *Chancery* hand because during the Renaissance it was used for correspondence and writing legal documents in the chanceries of the Vatican. The idiosyncratic nature of each scribe's writing was encouraged to help prevent forgeries. A more restrained and legible version of Italic was used for writing books in which several scribes used the same script for consistency and legibility.

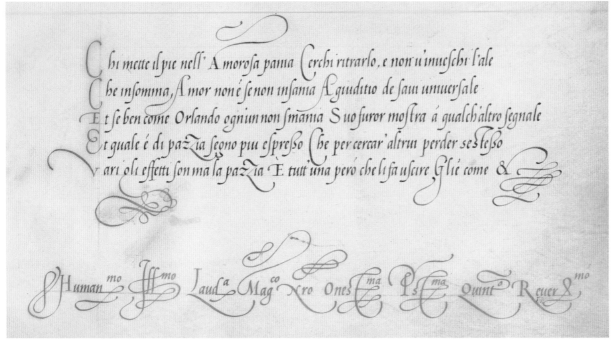

Bernardino Cataneo, *The Cataneo Manscript*, 1545, ink on vellum, 5¾ x 8¼ in. (14.5 x 21 cm), Department of Printing and Graphic Arts, Houghton Library, Harvard College Library, Cambridge, Massachusetts (MS Typ 246)

This handwritten specimen book contains 20 leaves, each page showing a slight variation on the Italic hand. This is the more cursive style called *cancellaresca corsiva*. Note the inventive swashing and flourishing in the margins and across the bottom of the text.

One of the most famous writers of Italic was the Venetian Ludovico degli Arrighi (Vincento), whose elegant writing is a hallmark of this hand. In 1522, he produced the first writing book, *La Operina*, used as an exemplar for students. Its pages were printed from carved wooden blocks, a process that had its limits for copying and showing the letters and skill of the writer. In 1545, the Italian scribe Bernardino Cataneo wrote an exercise book (copybook) composed of 20 leaves showing subtle variations on this hand. If you look at the tracings of quill on vellum in this document, you'll get a sense of how this hand was written during its prime. Cataneo includes more than one style of Italic in this manual, including *cancellaresca corsiva*, a showy and ornamental script (shown in our example), and *cancellaresca formata*, a more restrained and formal style.

The Italic form became the basis for cursive handwriting. Renaissance artists such as Michelangelo and Leonardo da Vinci used an Italic form for writing in their diaries and journals. This style spread throughout Europe, from Spain to England. Lady Jane Grey, one of the wives of Henry VIII, wrote it beautifully. Queen Elizabeth I of England was tutored in this style, and her cursive signature was quite inventive.

The versatility of the Italic family has resulted in many different styles. As you'll see, subtle changes in its structure produce dramatic variations that we'll investigate later in this chapter.

Writing Italic

Italic's most basic form is graceful and can be written quickly once mastered. Nevertheless, its underlying structure is quite sophisticated—based on a slanted elliptical or oval form with branching arcades joining the letters. Compare it to Foundational, which is based on a circle that fits in a square, and you'll see how the elliptical form fits in a parallelogram.

The pen angle of Italic is steeper than Foundational (about 40°), as shown in figure 43. The angle varies a bit from scribe to scribe. To write Italic, rotate the pen slightly counterclockwise from the Foundational angle. This angle allows branching to occur more easily, and a letter such as an **n** can be made in one stroke instead of two.

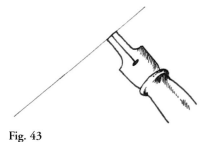

Fig. 43

abcdefghijklmn

opqrstuvwxyz

abcdefg hijklmn opqrstuvwxyz

Fig. 44

To rule guidelines, allow three separate spaces for the ascender, the body height, and the descender. Renaissance scribes such as Arrighi or Cataneo wrote Italic on evenly spaced guidelines, using every third space as a baseline. This system simplified the page ruling, but also produced widely spaced lines of writing. In the contemporary model shown here (figure 44), the guidelines are ruled with an ascender of 4 n.w., a body height of 5 n.w., and a descender of 4 n.w.—more pleasing proportions for today.

It's helpful to rule slant lines on the page, providing guides for aligning the stems of the letters. You can use a protractor to make a 5° slant from the vertical (see photo 6). After marking the angle on your paper, loosen the tape holding it in place, and turn it so that your triangle and T-square are square to the angle (see photo 7).

Since the paper is now repositioned on the board, you can quickly rule more lines at this angle. The size of your lettering loosely determines the slant line placement; space the lines closer together for smaller writing and more broadly for bigger writing. The distances needn't be exact because these lines guide the alignment of the letters, not the spacing.

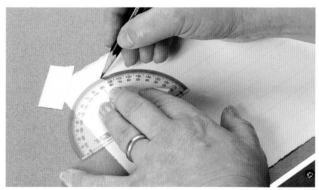

Photo 6

Photo 7

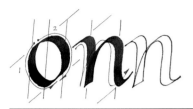

Fig. 45

As in Foundational, you'll practice the letters of Italic in families, beginning with the **o** and the **n**, as shown in figure 45. There are lots of possibilities for slanted elliptical forms, from a nearly circular shape to one with straighter sides. Once you've developed a consistent form for your **o**, practice the **n** until it relates to this shape. Whatever your variation, make the letters consistent. To keep them balanced and proportional, watch the interior spaces as you form the letters.

Fig. 46

One of the main structural differences between Foundational and Italic is the approach to letters in the **n** family (figure 46). The Italic **n** is a one-stroke letter, unlike the one you learned in Foundational. Make the entrance with an elliptical curve before descending into the downstroke. Then slide the pen halfway up and continue the stroke so that it branches out and up to the right, touching the waistline before it makes a sharp turn down again. The exit has an elliptical-shaped curve as well, unifying the design of the letter.

The letters that contain this curve or branch—**n**, **m**, **h**, and **r**—have a smooth arcade on the top. If the **n** is inverted, it becomes the basis for the first strokes of the **u** and the curved version of the **y**. To make this inverted curve, flick the pen on its left corner as you come up from the baseline. The **j** is composed of the second and third stroke of the **y**.

Fig. 47

The Italic **a** presents another major difference between the structures of Foundational and Italic. This particular form introduces a new shape to the alphabet. Over time, the loop on the **a** gradually moved up the letter until it began at the top, becoming the shape that is so familiar to us (see figure 47). This shape is known as the *a-counter*.

Fig. 48

To make this form, hold the pen at a 40° angle and place it just below the waistline. Then move it left into a slightly curved downstroke, reversing the direction immediately when it touches the baseline. Slide up to the waistline on the left corner of the nib, making a smooth transition similar to the branching stroke on the **n**. The second stroke, across the top, is a fairly flat one that moves to the right, and the third stroke is a vertical that blends smoothly with the upswing on the first stroke and finishes with an exit (figure 48).

This *a*-counter shape is the basis for the **a**, **d**, **g**, and **q** (figure 49). When inverted, it becomes the loop on the **b** and **p**. Notice that, like the **a**, the **g** also differs from the one in Foundational. The arcades on these six letters and those of the **n**-family are made with nearly identical movements of the pen, lending this script its dynamic rhythm. The remaining shapes also contain aspects of this rhythm, completing the set of 26 similar but legible shapes.

Fig. 49

Even though similar in stroke sequence to those in Foundational, the **o**, **c**, **e**, and **s** also fit within the elliptical form and have a narrower and slightly more tilted slant (figure 50). To practice them, draw an oval in pencil, and write them so they fit within that shape.

Fig. 50

The angled letters—**v**, **w**, **x**, and the angled variation of **y**—have a slightly steeper pen angle to compensate for the change in direction of the stroke (figure 51). As you practice these, adjust the angle of your pen to make the thin strokes about half as wide as the thick ones. The **z** is made with a flatter pen angle (usually about 10°) to keep the middle stroke strong. The **f** and **t** are both crossed just beneath the waistline and line up on the right-hand side (figure 52).

Fig. 51

Fig. 52

The **j**, **i**, and **l** are all verticals (figure 53). You can make a pointed entrance on these letters and other ascenders or add a bracket to them.

Fig. 53

The **k** can be made in two ways—it can either have a loop similar to the **e**, or it can begin at the right, similar to the right side of the **v** (figure 54).

Fig. 54

g g kyfpQXRz

Fig. 55

Figure 55 shows a number of variations of the basic Italic forms. Because of Italic's fluidity, it is more subject to the whims of the designer than other styles. As with all variations, choose to work with one for a while, working to make it harmonize with the rest of the hand. Since the fluidity and harmony of writing depends on consistent repetition with subtle variety of form, you'll find that too much variety will lead to illegible scripts.

The rules for spacing we've used in the other hands apply to Italic as well. Because of its angular rhythm, Italic letters fall more readily into line, as seen in the word "maunday" in figure 56, but the few letters that don't have straight sides must be placed carefully with their neighbors, such as the **x**, **t**, and **e** in "exactly." Watch the white space between the letters, equalizing the areas between them.

maunday exactly

Fig. 56

Connie Furgason, *Nature's Dance*, 2002, watercolor on paper, 7 x 10 in. (18 x 25.4 cm)

A freely written Italic hand combines well with loose watercolor painting.

Italic Capitals

The Italic capital letters need a strong underlying skeletal form, as shown in the first alphabet of figure 57. The simple caps shown in the second alphabet are useful for straightforward designs in which legibility is important and elegance must be restrained.

When *swashes* and *flourishes* are attached to Italic letters, they attract attention. The strokes of letters can be extended further to form swashes. More adornment can be added with flourishes of undulating lines that cross themselves to form ornate shapes. Swashes and flourishes are often used on formal pieces, such as certificates and invitations, lending an elegance to the page that eliminates the need for illumination or illustration.

Letters with simple swashes (see the third and fourth alphabets in figure 57) work well as capitals within a body of text, such as the first letters of names or places. At the beginning of a paragraph, you may choose to use letters with more ornate swashes. Keep in mind that these letters require generous space on the page and shouldn't be used in a context where they'll be crowded.

Compare the design of your page of letters to dancers in a crowded dance hall. In the middle of the floor, people are constrained to vertical movements and must watch carefully to avoid stepping on the toes of their neighbors. But at the edges of the floor, couples swing and twirl in the open space, taking more open steps and extending their arms—gracefully, we hope! Consider this idea when thinking of the overall effect of flourished letters on a page. Allow room for swashes in the spaces around a block of text as you carefully choreograph your work to avoid painful collisions.

The study of Italic capitals, like each of the hands you've studied so far, begins with a strong understanding of their underlying skeletal form. As you know, the lowercase Italic **o** is a slanted elliptical form. Skewing a circle to fit into a parallelogram gives us this

ABCDEFGHIJKLMN
OPQRSTUVWXYZ

ABCDEFGHIJKLMN
OPQRSTUVWXYZ

ABCDEFGHIJKLMN
OPQRSTUVWXY&Z

ABCDEFGHIJKLM
NOPQRSTUVWXYZ

ABCDEFGHIJKLMN
NOPQRSTUVWXYZ

Fig. 57

shape. To make capital letters that match, the round **O** from the skeletal Romans is skewed sideways and the proportions made narrower. The other letters follow suit—they are narrower, slanted versions of the classical skeletal Romans.

As in Foundational, a rule of thumb for writing caps is to make them slightly shorter than the ascenders of the lowercase letters that accompany them. Since the body height of the lowercase Italic letters you just learned is 5 n.w. and the ascenders are an additional 4 n.w., you should practice writing caps at about 7 n.w. Rule your guidelines and slant lines accordingly, and begin your edged pen practice with the simple caps shown in the second alphabet of figure 57 on page 67. Repeat the entrances and exits used on the lowercase as the serifs on these forms, while maintaining the proportions and overall shape of the skeletal forms shown in the first alphabet.

Adding swashes to these forms begins with simple strokes added to the basic shape, as shown in the third and fourth alphabets in figure 57. Not all of these letters adapt well to added swashes—notably **C** and **S**—both of which rely on smooth shapes, balanced proportion, and the relationship of thick and thin lines for their elegance.

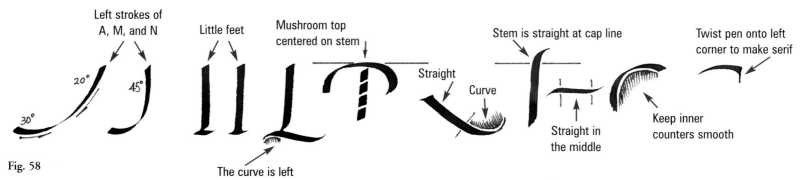

Fig. 58

Left strokes of A, M, and N

Little feet

Mushroom top centered on stem

The curve is left of the stem

Stem is straight at cap line

Straight

Curve

Straight in the middle

Twist pen onto left corner to make serif

Keep inner counters smooth

Scribes tend to develop their own personal versions of swash caps. Figure 58 shows some basic components of swashes that are integrated into the letters. Look closely at the diagrams as you read the following section, and refer back to them to relate the particular letters in figure 57.

• Note that you must adjust the pen angle to maintain the weight of the left stroke of the **A**, **M**, and **N**. This stroke needs some strength, so it's wise to avoid a hairline. Nevertheless, the basic weight of this stroke should never be more than about half the thickness of the second diagonal stroke.

• When you create the small foot at the base of a vertical stem, you can choose to leave a tiny wedge of white showing or make a stronger serif to support it by filling in the white space all at once.

• When a stem continues into a bottom stroke, such as you see in **B**, **D**, **L**, or the rectangular **E** shown on the ductus in figure 57, you must swing the pen back to the left and then to the right. As you bring the pen to the right, make sure you're making a straight line at the point directly below the stem to preserve the rectangular shape of the form.

• The mushroom cap on top of letters such as **B**, **D**, **P**, or **R**—or the left side of the angular **E** or **F**— should be centered over the stem, trapping at least as much white space on the left as the right side. If you don't have room for this swash, use an alternate shape. This stroke should sit just underneath the cap line; if you make it taller, you'll change the letter's proportions.

• In general, tails on letters such as **K**, **L**, **Q**, and **R** are straight for two-thirds of their length, swinging into a wide arc at the end. The broad-edged pen contributes to this elegant line, and you don't have to have many of these curves to achieve a dramatic effect in your design.

• If you begin the stem of a letter with a hairline stroke above the cap line, which is an option for the **B**, **D**, **E**, **F**, and **P**, bring the stroke back to the correct width by the time you reach the cap line. When you add a mushroom top to the letter, or cross it (as in **E** or **F**), the weak stem will distort the form.

• The cross stroke should be almost straight, with small curves on each end. The broad-edged pen will do most of the work for you and make a subtle change in line quality as you move it.

• Watch the inner counters of all curves to make them smooth and dent-free, especially at the point where one stroke joins the next.

• The serif on the upper right-hand stroke of **C**, **E**, **F**, and **G** is made by turning the pen up on its left corner and dragging a bit of wet ink out of the bottom side of the stroke. As you master this stroke, you'll be able to do it in one move, creating the twist serif (see page 58).

• The swashes are built into the simple skeletal forms of these letters, integrating curves on the straight lines. The skeletal forms of the swash caps in figure 59 show the position of the letters relative to the guidelines. Note how one critical part of the letter, noted with a dot, is always firmly attached to a guideline. If one side of the letter has a swash added to it, the other side must be anchored. (Not even the greatest dancer can remain suspended in midair!)

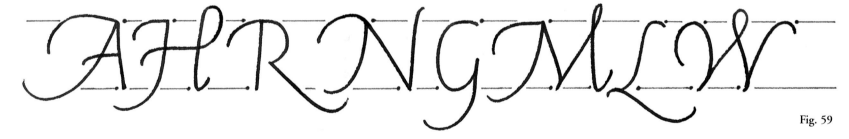

Fig. 59

• The next group of letters (figure 60) shows the application of the broad-edged pen to a few letters that contain the basic skeletal shapes. Some variations are developed, but they adhere to the principles discussed so far. Notice how the counter shapes are closely controlled, matching the basic skeletal forms. As you write with more spontaneity (see figure 61), try to maintain these proportions within the basic letter structure, even as the swashes expand into the surrounding space.

Fig. 60

Fig. 61

Writing *alphabet panels* is an excellent way to practice these letters (figure 62). Because of their infatuation with letter shapes, calligraphers write the alphabet hundreds of ways as they experiment with form, sometimes as a meditative warm-up for a day of serious writing, sometimes as an end in itself.

To make an alphabet panel, begin by writing the letters in pencil on tracing paper, arranging them in a pleasing overall pattern. Pay attention to the shape of the whole alphabet as well as patterns of light and dark. Maintain the same proportion and height. Use swashes to fill in white space between letters, and leave them off in tight places.

You might need several layers of tracing paper to get a good initial design, copying parts that work and adjusting areas that are too open or tight. Once you have a design you like, trace the design onto a lightweight paper, and write the letters with pen and ink. As you progress, try to eliminate the tracing paper stage and work directly on your design, contemplating the overall pattern as you make the shapes. Practice writing in color, and add a short quotation. Sign your name, and the piece is finished.

Italic Variations

Italic is a versatile style. The style introduced in this chapter is a legible teaching hand that illustrates the basics. In this book, you'll see other examples of this hand that are ruled differently, so that the weight of the letters varies from lighter to heavier and the ascenders and descenders are of various lengths. In general, interlinear space can be adjusted to suit the needs of your design.

To determine the ascender/descender line (A/D), divide the interlinear space—the space between the baseline and the next waistline—in half. Regard this line as a boundary that shouldn't be crossed, rather than a goal to be reached. Avoid collisions between ascenders and descenders; they decrease legibility and create an unsightly hot spot in the texture. If lines of text are long, you must increase line and word spacing accordingly to maintain legibility. Since you're making these letters by hand instead of typing them, you can adjust the form as needed to accommodate the space, as shown in figure 63.

The following section will explain two ways of varying Italic—by changing one feature and by working intuitively. As you master the Italic hand, you'll want to vary other aspects of it. There are many ways to experiment.

Fig. 62
Sharon Zeugin, *Alphabet*, 2001, gouache on paper,
6 x 9 in. (15.2 x 23 cm)

Zeugin has combined uppercase and lowercase letters in this gestural presentation of the alphabet, allowing swashes and flourishes to mingle with the forms.

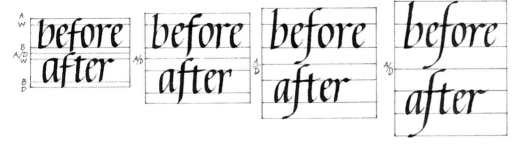

Fig. 63

Modulating One Feature

One approach to varying Italic, which is somewhat scientific in nature, is to gradually change one feature at a time, keeping the others constant. Choose a short phrase, and write out a sample to see how the overall style changes when you do this.

As noted in chapter 2, the influential British teacher Edward Johnston lists seven constant features that distinguish manuscripts: pen angle; weight; basic shape of the letter **o**; number, order, and direction of strokes; and speed. To Johnston's list, we can also add the slope of the letters.

You can explore these traits as you imitate historical scripts, or alter them to invent your own scripts. The success of an altered script is limited only by your ability to maintain consistency and legibility.

When you study the illustrations that follow (figures 64 through 71), you'll see a number of experiments, each showing one possible variation while keeping other aspects of the forms constant. Choose a word or a short phrase, and try each variation.

• Alter the shape of your basic forms, such as changing the shape of the **o** from narrow to wide and from almost round to more square (figure 64). Then find a branching letter **n** to accompany the **o** that harmonizes with it.

Fig. 64

• Make the pen angle flatter or steeper in increments to see the results.

Fig. 65

• Experiment with slanted lines ruled at different slopes. Don't be timid, some of your experiments won't be beautiful and calligraphic.

Fig. 66

• When you change both the pen angle and slant, some of the variations are elegant.

Fig. 67

• Vary the branching from low to high on the stem. The shape of the branched portion can vary, from spiky to round. The bottom branches should match the top.

Fig. 68

• Vary the width, as noted in figure 64. Adjust spaces between letters accordingly. Branching will change, and exits and entrances will be altered as well, as the hand adapts to the new form.

Fig. 69

• Exits and entrances are also variable, and subtle manipulations of the pen will change the forms as well.

Fig. 70

• Speed also changes the forms; Italic can be elegant and formal when written slowly, and expressive and dynamic when written quickly. Once you've found a variation you like, practice until you can write it fluently.

Fig. 71

• Italic, with its rhythmical arcades and straight sides, can be stretched and pulled like no other hand. Another example (figure 72) shows the results of an experiment in weight and width. To do this yourself, rule guidelines for a number of heights and columns to determine the widths. Force the letters into the compartments you've created, compressing and stretching them in both directions. Your entrances and exits as well as branching will be altered. Develop an entire alphabet based on one of these experiments. Choose one set of proportions, and write the remaining letters to match. Give care to spacing the letters with open counters (e, s, r, k, x, z). As you work with these altered forms, the interlinear spacing may also need to be adjusted. Your experiments will result in some unusual forms that look strange and illegible, but there will also be lots of useful variations.

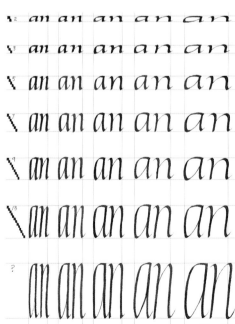

Fig. 72

All intelligent thoughts have already
been thought; what is necessary
is only to try to think them again.

All intelligent thoughts have already
been thought; what is necessary
is only to try to think them again.

All intelligent thoughts have already
been thought; what is necessary
is only to try to think them again.

G O E T H E

Fig. 73

Working Intuitively

The second approach to varying Italic is more intuitive. Begin by writing the letters with a pencil or ballpoint pen in a style that is comfortable for you, using the basic monoline Italic form as an underlying structure. As you speed up, the rhythm will appear, but the forms may become distorted. Find a comfortable medium between these distortions and legibility. Then use your broad-edged pen to write the same forms more slowly and carefully, resulting in a formal style more akin to your own handwriting (figure 73).

a book calls for pen, ink,
and a writing desk; today
the rule is that pen, ink, and
a writing desk call for a book.

a book calls for pen, ink,
and a writing desk; today
the rule is that pen, ink, and
a writing desk call for a book.

a book calls for pen, ink,
and a writing desk; today
the rule is that pen, ink, and
a writing desk call for a book.

N I E T Z S C H E

Fig. 74

Depending on the length of your text, you can modify the interlinear space. Generally, the longer the line of writing, the more space is needed between lines to allow the eye to move back to the beginning of the next line. For the sake of legibility, you won't need more than about 8 n.w. between lines, even with very long lines of writing. If you add more space than this, you don't need to increase the ascenders and descenders, but as line spacing shrinks, you'll have to shorten them. When you're writing stacked capital letters you can eliminate line spacing and still retain legibility. But, the ascenders and descenders found on lowercase letters are so important to legibility that you can't eliminate the line spacing without sacrificing clarity.

OTHER HISTORICAL MODELS

So far, you've been introduced to Roman Capitals, Foundational, and Italic, plus some variations of these styles. Though there are hundreds of other historical models, there are a few that are distinctively different yet legible. The following section will introduce you to these styles, giving you more choices for your work.

Uncial

Existing manuscripts written between A.D. 1 and 600 show many attempts by scribes to adapt the shapes of carved Roman inscriptions to the pen. These early scribes modified the classical Roman form to create new, easier-to-write styles. Rustics and Roman Square caps (see page 18) are among these scripts, along with other cursive styles that are almost illegible to the modern eye. Although many of the earliest manuscripts have been lost, there are still a few examples that show how the forms were adapted to the quill or reed.

One of the most beautiful adaptations is the hand known as *Uncial*. (The pronunciation varies from *un'-shul* to *un'-see-ul* to *un'-shee-ul*.) This hand dominated writing from the third to the eighth centuries, and continued in use throughout the Middle Ages in the design of Versals, decorative initials used to open paragraphs. Manuscripts found throughout Europe and northern Africa document the wide use of Uncial, and earlier samples of Greek writing have similar qualities. In the fifth century, Uncial evolved into a group of styles known as *Half Uncial*. These forms were used in the famous manuscript books of England and Ireland such as *The Book of Kells* (ca. A.D. 700) and the *Lindisfarne Gospels* (ca. A.D. 698).

Because Uncial was the dominant book hand for hundreds of years, lots of variations of this script evolved. The modernized version is made with a flatter pen angle than Foundational, and the **O** is a bit wider (see figures 75 and 76 on page 77). This script is neither a minuscule nor capital script; it stands alone, without separate capitals. Some of the forms are adaptations of traditional Roman shapes; others are precursors for later minuscule letters.

St. Cuthbert (Stonyhurst) Gospel, ca. 698, ink on vellum, 5.25 x 3.6 in. (13.3 x 9.1 cm)

This book shows a simple Uncial script without much decoration or refinement. The letters are tiny, less than $1/8$ in. (.32 cm) high. The fluidity of the forms suits the quill, making Uncial the first adaptation of the Roman form that could be written directly without too much retouching or pen manipulation.

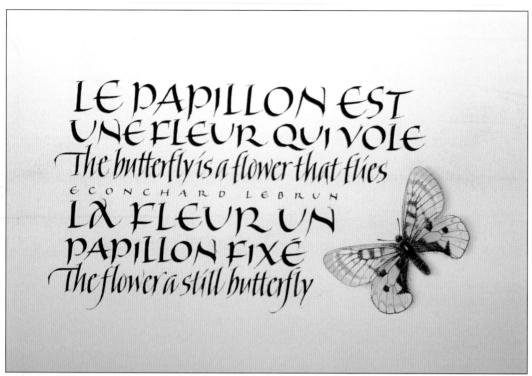

The wide open shapes of Uncial make it very legible and surprisingly adaptable to modern use, even though it combines forms that don't follow the rules of modern alphabet design. Features such as the unique shape of the **a**, the rounded form of **h** and **m**, the uppercase style of the **R** and **N**, and the use of ascenders and descenders, form a style that blends qualities of modern upper and lowercase letters.

The earlier historical versions from the third through sixth centuries are the most legible and easiest to write. The later versions used a flatter pen angle with lots of pen manipulation and finishing strokes. By the time Irish scribes wrote *The Book of Kells* in a hand known as *Insular Half Uncial*, the letters had been modified to include many ligatures and unusual forms.

Martin Jackson, *Le Papillon...*, 2001, lettering in gouache and illustration in watercolor on paper with goose quills, gold leaf, 8 x 5½ in. (20.3 x 14 cm), photo by artist

To contrast two languages, Jackson used Uncial and Italic together.

CHARACTERISTICS OF UNCIAL

Pen angle: 20° to 30°

Letter shape: Round, verging on a squashed oval similar to a grapefruit shape

Weight: Rule guidelines 2/4/2 n.w. in the beginning. (Other variations are possible, but this hand is not as variable as Italic.)

Slant/slope: Vertical

Speed: Traditionally written slowly to maintain roundness of forms

Writing Uncial

To practice Uncial, nib off guidelines at 4 n.w. for the body height with an interlinear space of 4 n.w. If you have room to cross the A/D line, the ascenders can be made slightly taller or longer.

Uncial is a wide, round alphabet that contains ample area within each form. To balance the interior space of the letters with the area surrounding them, space them widely across the page with the verticals relatively far apart.

Some of the historical versions of Uncial didn't use word spacing. It's surmised that this happened later as scribes copied Latin manuscripts that weren't in their native tongue. For instance, when we speak in our native language, we don't necessarily pause between each word, but allow words to flow together. If someone says, *Whatareyoudoingtoday?* you'll separate the words naturally, but if you hear words in a non-native language, you might have to ask the speaker to slow down to hear each word clearly. Perhaps the same thing happened with writing, and scribes found that leaving just a bit of space between words made the text easier to read (figure 77).

As you write Uncial, leave just enough space between words to separate them visually. It doesn't take much. You'll also notice that the tighter your line spacing, the less space you'll need between words.

ABCDEFGHIJKL
MNOPQRSTUVW
XYⱭZ

ABCDEFGHIJKLMNOPQRSTUVWXYZ

Fig. 75

AADGHQXY

Fig. 76
Alternate characters for Uncial

DEAR MOM, DORM IS GREAT.
BOOKS QUITE EXPENSIVE.
SEND MONEY ⁊ COOKIES!

Fig. 77
Uncial is a round, open hand. To save space, ligatures can be used, but be sure they don't make a
dark hot spot on the page, as in "mom." Note the alternate R in "dorm." The modern reader may
not respond to ligatures that are too unusual.

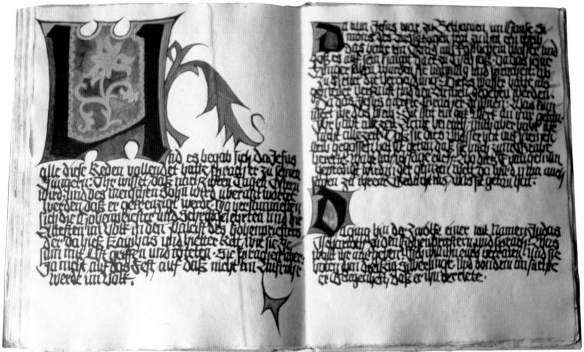

Rudolph Koch, page from the Gospels, 1921, ink on paper, 10 x 12 in. (25.4 x 31 cm), Klingspor Museum, Offenbach, Germany, photo by Annie Cicale

Koch adapted the traditional Black Letter forms in this highly original book, using masses of textured letters. He wrote out all four Gospels, and used a contemporary style of illumination for the Versals.

on on on
on on on on

Fig. 78

Black Letter

We have skipped around a bit on the historical timeline of writing to introduce several alphabets according to letter structure. Next, we'll look at *Black Letter* scripts that developed after the Carolingian era. The history of this family of alphabets is fascinating, and begins at the end of the rich economic times of Charlemagne when literary production burgeoned. Monasteries and secular scriptoriums were built, and universities were founded as more people learned to read and write. Though this percentage of the population was still small, there was an increased demand for books, still scribed one at a time on vellum or parchment. Libraries loaned their copies of these books to other libraries or monasteries, where scribes would copy them for their collections before returning them. As the pace of production increased, it placed a demand on the supply of materials.

Consequently, books were made smaller, pens were sharpened to a finer point to diminish the size of the letters, and the open Carolingian letterforms were compressed to take less space on the page. Spaces between the lines were decreased, and the essential shapes of the **o** and **n** were narrowed until the curved arches gave way to angular forms, as shown in figure 78.

By the 12th century, the evolution was complete, and these changes gave the page a dark overall texture, spawning the qualities of the hand we now call Black Letter. This family of letterforms is also called by other names, such as *Old English* and *Gothic,* which reflect the arched, pointed shapes in Gothic architecture. Variations of Black Letter include *Fraktur, Rotunda, Textus Quadrata, Bâtarde,* and a later version developed by Edward Johnston called *Gothicized Italic.*

Black Letter scripts dominated European writing for over 200 years and remained strong in northern Europe much later. Each region developed its own version of this style. No consistent style for capitals was used either. The study of manuscripts from this era shows a fascinating evolution of design. Many of these examples are very ornate, showing complex illuminations, gilded letters, and embellished book covers.

Gutenberg based the typeface used in his Bible on an elegant version of this script, while the Italians developed rounder scripts. Black Letter typefaces were used in German book production until around the middle of the 20th century, until they were gradually replaced by Roman letters.

You'll find some contemporary applications of this hand, but it is limited in use because of a lack of legibility and association with old-fashioned scripts for holidays and weddings. Nevertheless, beginning calligraphers love it!

Fig. 79

Writing Black Letter

Black Letter scripts have a relatively simple lowercase structure with ornate capital letters. The simplest version of this hand is written with a fairly consistent pen angle of about 25 to 30°. The hallmark of this style—straight lines and tight spacing—resembles a picket fence. Even the most awkward forms in this script have an exciting appearance if they're evenly spaced. Repetition is the dominant force in Black Letter, with the letters mimicking the hexagonal shape of the **o** so precisely that they aren't particularly legible. Due to this constraint, even the letters that have more counter space in other hands must be modified to eliminate some of it.

The model shown (figure 79) is written with a body height of about 3 n.w., but look at the relationship between the guidelines and the letters. In the alphabets we've studied so far, the letters sit between the guidelines, overlapping slightly in the case of a pointed entrance or a sharp curve. However, it is easier to understand the structure of Black Letter if the guidelines are used in a different way.

To make the basic vertical stroke from which most of the letters are made, you'll begin the stroke with the left-hand corner of the nib at the top of the waistline, allowing the wedge-shaped entrance to protrude above it (figure 80). The exit stroke reaches below the baseline, finishing with the right-hand corner of the nib on the baseline.

To rule guidelines for Black Letter, allow 3 n.w. for a body height and 4 to 5 n.w. for interlinear space. Begin by practicing rows of evenly spaced vertical lines resembling a picket fence, holding the pen at the 20 to 30° angle (figure 81). Practice making a couple of rows of these lines before beginning to make your first letters. Add wedges to the top and bottom to make a pattern. Break out the **o** from this pattern, noting the hexagonal form made by the adjoining strokes (figure 82). Next, write the word "minimum" to practice writing the **m**, **n**, **i**, and **u**, spacing the letters evenly to match the picket fence configuration (figure 83). You'll see the Black Letter texture emerging, and you'll understand why the dot over the **i** is so important to legibility. This word is fairly easy to space, but you'll find that words such as "wage" and "compensation" are not. You'll have to adjust the forms in these words to achieve even texture.

Fig. 80

Fig. 81

Fig. 82

Original leaf from a late-medieval manuscript prayer book, the *Book of Hours*, written in Latin, Flanders, ca. 1440-60, dark brown ink in clear Gothic textura script on animal vellum, 5 x 3½ in. (12.5 x 8.7 cm), private collection

Fig. 83

Black Letter is made of many similar forms, with a few contrasting ones that aid legibility. Figure 84 shows straight-sided hexagonal forms with tiny details on the terminations that define the letter.

Fig. 84

Fig. 85

To these are added closed forms (figure 85) that contrast with the ones above them. The curves improve legibility. Watch the counter space and keep it uniform with the other letters.

The remaining letters are open forms that are distorted from round classical forms in order to keep the texture even (figure 86). The **c** and **r** have "droopy" exits on the top, the **r** has an extension on the baseline, and the **e**, **x**, and **z** have crossbars. This fills up some of the empty space, though the forms must be spaced carefully with the others to maintain an even texture.

As you try writing these letters, remember to condense them to fit the picket fence configuration. For example, the **w** and the **x** forms are more vertical than those of other hands, and the **s** has no "yin/yang" curves in its counter spaces. An alternate version of the **s** looks difficult at first, but is relatively easy. Just follow the stroke sequence shown, lining up the first and second strokes precisely.

Fig. 86

ABCDEFGHIJKLM
NOPQRSTUVWFYZ

ABCDEFGHIJKLM
NOPQRSTUVWFYZ

Fig. 87

Black Letter Capitals

When practicing capitals, work toward an open texture. Because capitals are more open than their lowercase counterparts, they create welcome visual breaks in the dense texture of the lowercase letters.

Begin with one of the versions shown in figure 87. As you master these, look at other sources and adapt them to your own tastes. Use a modified Roman, Uncial, or Italic capital, with added curves, hairlines, and wedges. These are difficult to invent, so study manuscript sources carefully, modifying them to suit your needs.

As you can see in figure 88, the caps create a contrast with the picket fence of the smaller letters. These holes create a sparkle of light in the texture of the page. They should never be used all together, as the result will be an illegible mess. Therefore, practice them with the small letters, as shown here, to establish the rhythm.

Ann Betty Carol Dave Edna
Flo Gay Hal Ivy John Katy
Lloyd Meg Nan Olav Patte
Quin Robert Sally Tom Uva
Val Ward Xavier Yo Zap

Fig. 88

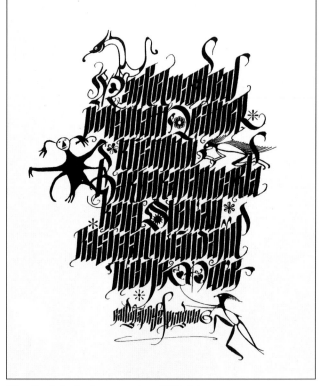

Glen Epstein, texture exercise, 1996, ink on paper, 8½ x 11 in. (22 x 28 cm), photo by artist

Student names with occasional capital letter and added ornaments.

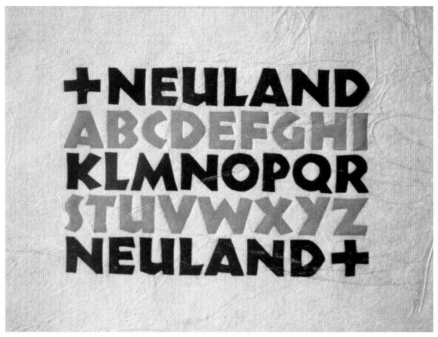

Rudolph Koch, type specimen for Neuland, early 20th century, Klingspor Museum, Offenbach, Germany, photo by Annie Cicale

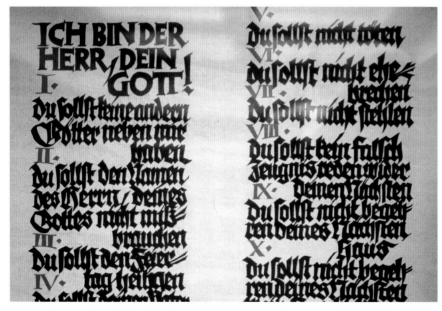

Rudolph Koch, page from the Gospels, 1921, ink on paper, 10 x 12 in. (25.4 x 31 cm), Klingspor Museum, Offenbach, Germany, photo by Annie Cicale

Koch used a version of his Neuland script to contrast with the Black Letter script.

Neuland

We've already touched on the calligraphic renaissance that took place in early 20th century England. The students of Edward Johnston followed his tradition of studying manuscripts, resurrecting medieval materials such as vellum and gold leaf for writing and illumination. Many of these manuscripts were created in service to royalty, and a contemporary style developed with a strong connection to its medieval predecessors.

Lettering artists on the European continent took a different tack. Although aware of history, they didn't adhere to the strict reverence for all things medieval of Johnston's followers. Anna Simons, a German calligrapher who studied with Johnston in England, took many of his ideas back to Germany with her, but the influence of other art movements diluted these concepts. Experiments in drawing led to new forms, tools, media, and alphabets. Pure design considerations, the ideas of the Bauhaus, and art movements such as Surrealism and Dada all influenced inventive lettering artists.

Rudolph Koch (1876-1950) was one of these early 20th-century innovators. He established a workshop in Offenbach, Germany, located near Mainz, the home of Gutenberg and the birthplace of typography. In the workshop, many artisans worked together, drawing letterforms, designing typefaces, and making handwritten books.

Besides his work for the type foundry, Koch wrote out beautiful books by hand. Drawings adorn the pages, many done with the same pen that he used to write the text. The Klingspor Museum in Offenbach houses a large collection of modern calligraphy and typography, including works by Koch and many of his colleagues.

Koch designed a number of typefaces including *Neuland*, which was originally designed from drawn forms. It is a typeface that can be adapted to the broad-edged pen and written directly (figure 89). The premise is simple: Use the broad pen to make bold letters with the widest strokes the pen makes. Unlike the constant pen angle maintained in writing the other alphabets we've studied, vary the pen angle for each stroke to maintain maximum pen width as you move it in different directions.

Koch designed this alphabet as an uppercase typeface, and as a calligrapher, you'll find plenty of uses for it without a lowercase. The letters can be packed together tightly with ligatures to create a dense texture or can be opened up to improve legibility. You can use them as bold stacked capitals or with a small amount of line spacing between them. Because of its simplicity, this style of lettering also lends itself to being drawn, painted, or carved.

ABCDEFGHIJKLM
NOPQRSTUVWXYZ

ABCDEFGHIJKLM
NOPQRSTUVWXYZ

A AB C D E F G H H I J K L M N O O P Q R S T U V W X Y Z

Fig. 89

Writing Neuland

To practice Neuland, begin with guidelines about $3^1/2$ to 4 n.w. high (figure 89). Hold the pen at the widest angle possible for each stroke, rotating it as you move from vertical to horizontal. The rebellious side of you will enjoy doing this after being restrained by the rules you've learned so far! Some of the strokes are built up with overlapping strokes, such as you see on the **O**. You may want to overlap strokes to thicken the terminations of the stems, making a stem with entasis as you did on pressurized Romans and Versals. There are a few places, such as the cross strokes on the **E**, where you might want to use a slightly thinner stroke. To do this, hold the pen at a 0° angle, and pull down to make the cross stroke. You'll have to abandon some of your hard-won control over classical proportions to make this hand harmonious.

IN THE FEW SECONDS IT TAKES YOU TO READ THIS SENTENCE, 24 PEOPLE WILL BE ADDED TO THE EARTH'S POPULATION. BEFORE YOU'VE FINISHED THIS, THAT NUMBER WILL REACH 1000 WITHIN AN HOUR—11,000. BY DAY'S END—260,000 BEFORE YOU GO TO BED TWO NIGHTS FROM NOW, THE NET GROWTH IN HUMAN NUMBERS WILL BE ENOUGH TO FILL A CITY THE SIZE OF SAN FRANCISCO. IT TOOK FOUR MILLION YEARS FOR HUMANITY TO REACH THE 2 BILLION MARK, ONLY 30 YEARS TO ADD A THIRD BILLION, AND NOW WE'RE INCREASING BY 95 MILLION EVERY SINGLE YEAR. NO WONDER THEY CALL IT THE HUMAN RACE

ZERO POPULATION GROWTH

Annie Cicale, *ZPG banner,* 1994, 42 x 96 in. (1 x 2.4 m), gouache on frosted Mylar

An adaptation of Neuland in various weights was used to express the idea in the text.

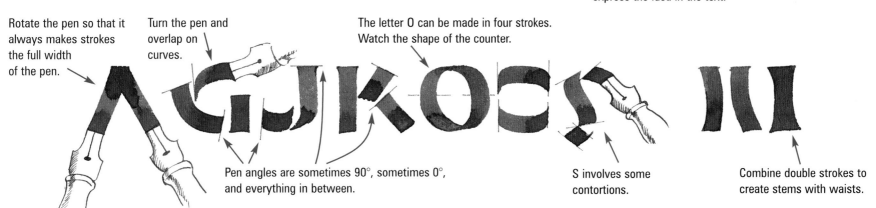

Rotate the pen so that it always makes strokes the full width of the pen.

Turn the pen and overlap on curves.

The letter O can be made in four strokes. Watch the shape of the counter.

Pen angles are sometimes 90°, sometimes 0°, and everything in between.

S involves some contortions.

Combine double strokes to create stems with waists.

Mr. and Mrs Joe Smith
12436 West 57 St.
New Arcade, MT 59830

JOHN BROWN
PO BOX 97531
FAIR HOME, NC
2 8 6 4 0

Above: Use old style or lowercase numbers with text
that has ascenders and descenders.
Below: Use modern or uppercase numbers with text
written between two guidelines.

NUMBERS

The numbers that we use today are based on Arabic forms, which were initially adopted by mathematicians because they make calculation much easier. Their shapes contrast with Latin scripts, and because of this, they stand out from the text, letting the reader know they're reading a numerical quantity. Adapt the basic forms shown in figure 90. For each alphabet style, you must develop a coordinating set of numerals, which maintain some contrast to the letters so that they are easily distinguishable.

Calligraphic numbers fall into two categories, modern and old style, and it's helpful to think of them as caps and lowercase. Leave more space between them than letters to make them more legible, and vary the forms to match the alphabet you're using.

Keep them simple when using them on an envelope. The postal employees need to read them quickly and accurately, and they won't necessarily appreciate your inventiveness!

Modern or capital style 1234567890

Old style or lowercase 1234567890

Ductus 1234567890

Foundational abc · 1234567890

Italic abc · 1234567890

Black Letters abc · 1234567890

Carolingian abc - 1234567890

Uncial ABC · 1234567890

Neuland ABC 1234567890

Swashed Italic capitals ABC · 1234567890

Fig. 90

ADAPTING A MANUSCRIPT

Mastering the basics of calligraphy can serve as a beginning for further exploration. You can modernize historical scripts for contemporary use by referring to facsimiles of manuscripts published by museums. We have reproduced a number of manuscripts for you to see, but you'll also find many excellent collections in print.

The gallery contributions in this book show hands written in various ways. In the same way that Edward Johnston used an analytical approach to letterform design through studying manuscripts, you can also write a historical hand, whether the script is hundreds of years old or written recently. The section that follows describes how to do this, and you can apply these steps to samples of writing from any era.

For instance, there are typefaces that have a calligraphic flavor to them, and these can be analyzed and written with a broad pen, as you've just done with Neuland. Many of the best type designers are also excellent calligraphers. By analyzing their work, you can understand their design process.

Try looking for new forms in a foreign script, and incorporate them into a Latin script, as shown in the examples on this page. Or pick up a new tool—a brush, a ruling pen, or even a sharpened stick—that changes the line quality and the script's flavor. Paper choices can also influence the form. A slick paper allows your writing to be more fluid, whereas a rough surface slows you down and lends a textured appearance to strokes.

To adapt a historical manuscript to a contemporary hand, do the following:

1. Select a sample of writing, looking for one that has a wide variety of characters (photo 8). It's difficult to find a **k** in most Latin manuscripts, for instance, but look for the essential letters such as **o**, **n**, **a**, **d**, and **e**, since they are building blocks for the other letters.

Photo 8
Bartolomeo Sanvito, *Petrarch's Trionfi* (detail), ca. 1480, ink and paint with gold on vellum, 8½ x 5⅜ in. (22 x 14 cm), Walters Art Gallery, Baltimore, Maryland

2. Use a good photocopier to enlarge the manuscript to a size that's easy to study and appears as though it was written with a 2- to 3-mm pen (photo 9 on page 86). You might have to enlarge it more than once to get a comfortable size.

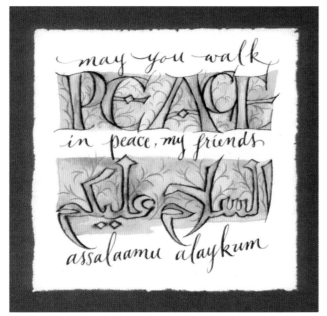

Lindley MacDougal, *Peace Card*, walnut ink and watercolor on paper excuted with pens and brush, 6 x 6 in. (15.2 x 15.2 cm), photo by artist

The artist took qualities of an Arabic script and harmonized them with those of a Latin script.

Burmese ordination text, Kammaraca, ca. 18th century, Gutenberg Museum, photo by Annie Cicale

The Roman alphabet forms the basis of our letterforms and our language, but you might find inspiration from another culture to develop a new set of letterforms.

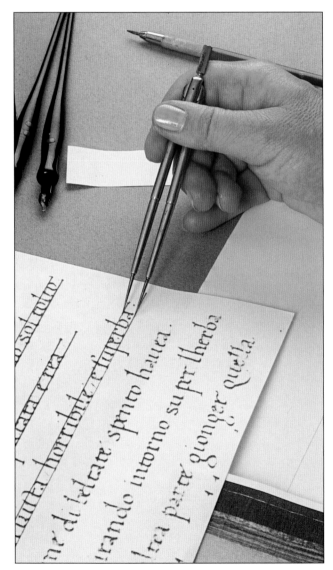

Photo 9

Photo 10

3. With a very sharp pencil, rule guidelines on the copy that fit the hand in a way that you would write it. (Some people write within the guidelines, others tend to let the letters overlap them a bit.) This will affect your analysis of the weight of the letters, so it's important to do this accurately.

4. To determine the weight, find a portion of a stroke that shows the full width of the pen. This might be on the shoulder of the **n** or the widest part of the curve on the **o**. Mark this distance on a scrap of paper or set it on a pair of dividers (photo 10), a tool used to measure distances that resembles a compass but has two points on it. Then measure the number of n.w. needed to make the body height you ruled in step 3. Measure the interlinear space as well. You'll end up with numbers indicating the n.w. of the guidelines, such as 3/4/3, the basis for Foundational, or 4/5/4, the guides you used for Italic. Don't round off fractions, a quarter of a nib width is significant.

5. Measure the pen angle by ruling a line across the part of the stroke that shows where the structure of the letter is apparent, with crisp entrances and clear turnovers. Look at the starting point of the letter, such as the entrance of an **n** or the hairline turnover of the **o**. Rule a line that shows how the pen stroke would have been held at that point. On a letter such as the **o**, you'll see the turnover at the point where the thinnest parts of the strokes meet. Entrances usually show the pen angle quite clearly, but exits sometimes have little flips or twists of the pens that can be deceiving. Ignore serifs or other strokes that have been built up. Use a protractor to measure this angle on a number of letters, and average the results. Note pen angle exceptions, such as the steeper angle on the letter **v**.

6. Rule slant lines parallel to the stems of the letters. This is usually easier on ascenders and descenders, as the line is straight for a longer distance. Again, use a protractor to measure the angle between the slant line and a vertical line drawn on the page.

7. Using a pen that is close to the apparent pen width in the photocopy, nib off and rule a practice page with these dimensions. Note that the photocopy letters have been enlarged considerably in order to show detail. However, the thins will also be enlarged and may look a little awkward, and other idiosyncracies of the scribe will show up. Ignore wobbles or clunky forms, and work to develop an elegant version. Begin to analyze the alphabet by first writing a few **o**'s and **n**'s to understand the basic shapes and structure. Use a stroke sequence that makes the letters flow from your pen, being careful to preserve the shapes.

8. Copy the text of your sample, letter by letter, line by line, analyzing both the shapes of the letters and the spacing between them (photo 11). Note any ligatures or unusual forms, and copy them as you see them. After a few lines, you'll begin to feel the structure of the forms in your hand. Don't worry if you can't understand the language or if some of the shapes don't make sense. Your goal is to get an overall sense of the hand, both letterforms and spacing.

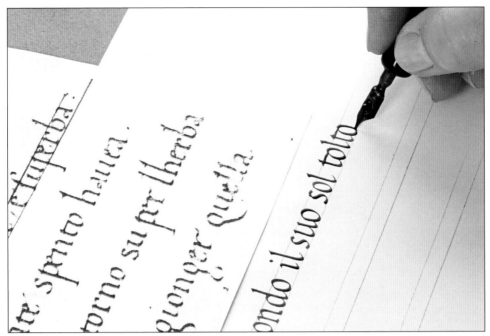

Photo 11

9. Modify any archaic forms for contemporary use, and using the basics of the Foundational, Roman, and Italic hands, design any forms that are missing. Then write out a sample of the style using a contemporary quotation. After that, continue writing it until you're confident that it's in your muscle memory, and begin to use it in your projects.

As you work in this way, you might begin to wonder whether the emphasis on copying, imitating, and analyzing leaves any room for creativity. Strangely enough, the more observant you are of work from the past, the more you'll find yourself making unique choices. The pen guided by your hand will make marks that no other person can imitate; and the more you work, the more distinctive your writing will become. No two people write in exactly the same way.

Nevertheless, for the sake of developing consistency, stick with a couple of styles until you feel a rhythm and flow that is second nature to you. Just like a musician learning new songs from sheet music, spend time with each script until you know it so well that you no longer have to refer to the ductus. Then you'll know that you are a real calligrapher.

Annie Cicale, *Bâtarde Study*, 2002, 10 x 13 in. (25.4 x 33 cm)

Beyond the Broad Edge

Although the shapes of traditional letterforms developed in a large part from the marks made by the broad-edged pen, calligraphers adapted other tools to fine writing, resulting in new styles. These tools can lend sparkle and inventiveness to your work. However, be careful that you don't sacrifice legibility when you use them.

THE DEVELOPMENT OF COPPERPLATE PRINTING

Before the invention of the printing press, scribes wrote in the most efficient and economical way possible. However, lettering tools and the resulting forms gradually changed as ways to reproduce writing evolved. *Letterpress*, the term used to describe the process of printing with movable type, made rapid book production possible. Since simple book production could be done more efficiently, the scribe was free to use his skills to adorn letters in new ways.

For instance, techniques for engraving and etching were developed to make single printed sheets called *broadsides*. During the 16th century, scribes and engravers developed a technology for reproducing ornate lettering. Working together, they designed wood or copper printing plates. Unlike letterpress, which utilized individual letters that were returned to the type tray after each print job, a carved plate was made for each text.

As a part of this process, the scribe modified the letterforms to make engraving them easier, but also took advantage of the fact that the engraver could fill the margins with decorative swashes and flourishes.

This resulting style of script influenced hand-lettered work as well. Although expensive hand-lettered books had been richly ornamented with illuminations and illustrations, the basic text scripts had been relatively spare before this time. However, when scribes executed legal documents—treatises, patents of nobility, or papal bulls—they often added flourishes, extending the letters into the margins to make complex swirls and ornamental patterns. These documents were designed to present an establishment at its best and command respect. The complexity of the lettering also made them more difficult to forge.

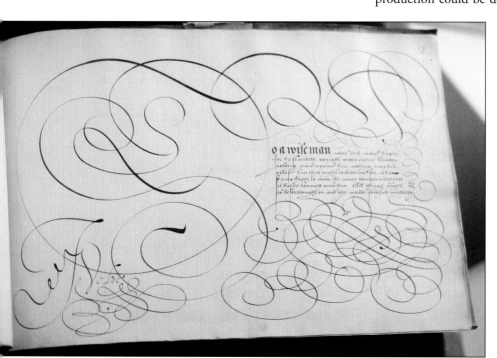

Jan van de Velde (1593-1641), manuscript of writing samples, ink on paper, approx. 8 x 10 in. (20.3 x 25.4 cm), Konijnklijke Bibliotheek, The Hague, The Netherlands, photo by Annie Cicale

Using a quill, Van de Velde was able to exert pressure to create varying thicks and thins, rather than relying on pen angle alone.

THE POINTED PEN

The copperplate printing method subtly influenced the way scribes used the quill pen. They found that by putting pressure on a more finely sharpened quill, thick and thin lines could be easily placed in different locations on the monoline skeleton without the imposed limits of a stiff quill. The engraver worked with a carving tool called a burin to incise grooves in the copper printing plate, following the lines made by the scribe's quill. To make the lines, he rotated the plate on a small pillow in front of him, adjusting the distribution of thicks and thins around the form to produce a style of flourishing that hadn't been seen before.

These engraved forms were printed from plate to the paper. Ink was forced into the plate's carved grooves before the surface was wiped clean. Then the paper was printed under pressure, pulling the ink out of the incisions.

As ornate scripts flourished, scribes found that the flexible quill could produce new kinds of thick and thin lines. As scribes worked alongside engravers, letterforms evolved that showcased the capabilities of both writing and carving.

These copper engraving plates influenced writing for several hundred years, fostering a whole family of pointed-pen writing styles. As a result, many of the techniques of broad-pen lettering fell into disuse.

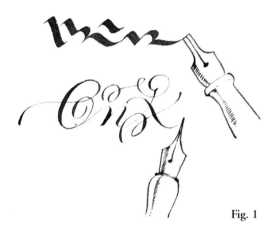

Fig. 1

A flexible, fine-pointed metal nib was developed in the early 18th century to replace the quill. These nibs were designed to make thick and thin lines by varying the amount of pressure in contrast to a broad-edged pen (figure 1). The resulting ornamental penmanship produced with these pens became the model for everyday writing, evolving from elegant Copperplate scripts of the 16th and 17th centuries to more businesslike Spencerian scripts of the 19th century.

As more people became literate, a fine hand was recognized as the mark of a cultured person. Written correspondence increased, and diaries and journals became more commonplace. The Palmer method of handwriting that many Americans learned in elementary school has its roots in these scripts.

Copperplate and Spencerian are still written in their traditional forms, but contemporary calligraphers have invented new styles that use the pointed pen in unusual ways. Study the van de Velde manuscript shown on page 88. The ornate flourishes look as though they were made with no pen lifts, or a single movement of the pen. This manuscript was most likely written with a sharpened quill. The modern scribe using a metal nib has to adjust his methods to imitate this style.

Gwen Weaver, *The Written Word Remains*, gouache on paper with metal pen, 5 x 1.5 in. (12.7 x 3.8 cm)

This is a good example of delicate pointed-pen writing in a unique interpretation of Roman forms.

To begin with, the tools we use are quite different than the quill. For instance, many of the pointed pens available today were designed for pen-and-ink drawing. Also, old steel nibs used for business writing before the invention of the fountain pen are also popular. These can sometimes be found in art supply stores and are now sold by mail order companies. Their popularity among calligraphers has led companies to produce new ones. Unlike the broad-edged pen, there are now lots of brands of pointed pens available.

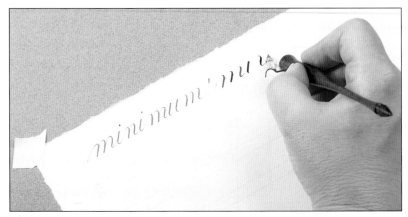

Photo 1

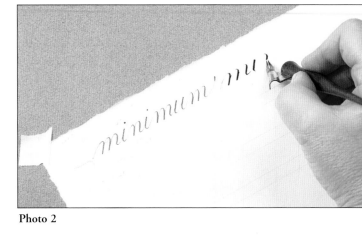

Photo 2

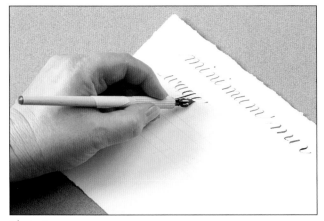

Photo 3

Try out several to find those that feel best to you. Test them on the papers you plan to use. In general, a smooth, slightly coated paper allows you to make the most delicate hairlines because the ink won't spread, and the pointed nib won't be as likely to catch on the upstroke. Using a more flexible pointed nib lends a finer hairline, but the pressure is more difficult to regulate.

The pen holder made for pointed pen writing has an elbow that juts out to the left, assisting you in the maintenance of the slant of the letterforms without forcing your hand into an awkward position. Pointed pen letters are easier to use on a flat table. Before you begin writing, rotate the paper on your drafting board, lining up the slant lines with the pen's axis. Rest the pen in the web of skin between your thumb and forefinger, rather than against the knuckle on your forefinger, so the delicate tip doesn't catch on the upstroke (photo 1), When you push down on the nib to make a downstroke, notice how it opens up (photo 2).

If you're left-handed, you can use a regular pen holder without the elbow since your hand will already be in the correct position (photo 3). Rotate the paper to the right so that the slant lines correspond with the pen.

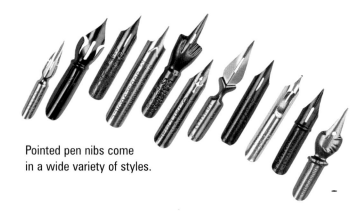

Pointed pen nibs come in a wide variety of styles.

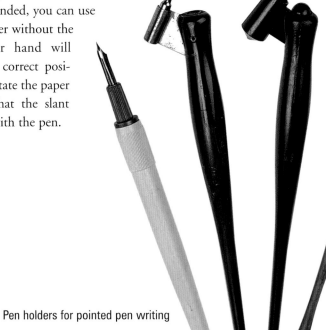

Pen holders for pointed pen writing

Copperplate Script

Copperplate is the traditional pointed-pen script. This alphabet style is composed of upstrokes (hairline strokes) and downstrokes (*shades*). The upstroke is made by moving the pen upward with no pressure on the point, resulting in a very fine hairline. To make the shade, put pressure on the nib, allowing the left tip of the nib to move left; then move the pen down, pause at the baseline, release the pressure, and move the right tip to the left (figure 2). When the shade is tapered, the pen moves while you put pressure on it and is released at the bottom (figure 3). The second portion of figure 3 shows the shades parallel to the slant lines. Because of the flexible nib, the shade's weight depends on the amount of pressure applied (figure 4). The height is dependent on the guidelines (figure 5, below).

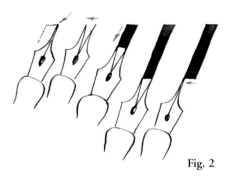

Fig. 2

Fig. 3

Fig. 4

Fig. 5

In general, you should rule the guidelines to the height that you want and then adjust the shades to create the right weight. Since the slant for this alphabet should remain consistent, you'll need to rule slant lines along with the guidelines. These can range from 25 to 35° from the vertical, depending on the amount of forward slope you want (figure 6).

This approach is the opposite of broad-pen writing, where the height of the letter is determined by the pen's width. Also, the ascenders and descenders can extend beyond the normal halfway point between the waistline and baseline. Because of these attributes, plan layouts carefully to avoid collisions in the interlinear space.

After you rule the guidelines and slant lines, remember to untape your paper and rotate it in front of you so that the slant lines are vertical, as discussed in the previous section. This orientation will help you keep the stems aligned vertically by giving you a physical comparison—your own spine. A left-handed scribe also rotates the paper, but since the pen holder is not offset, the slope lines up with the axis of the pen holder.

Fig. 6

Fig. 7

Copperplate Basics

Weight: The weight of the shades is determined by the pen's pressure.

Height: Rule guidelines to the height needed for your design, then adjust the weight to make a balanced form. A beginning proportion for ascenders/body height/descenders is 3/2/3, while a more advanced proportion is 4/2/4, with ascenders and descenders going beyond the halfway point of the interlinear space (figure 7).

Slope/slant: This attribute can range from 25° to 35° from the vertical.

Pen angle: In pointed pen hands, hold the axis of the pen in line with the slope. The pen angle doesn't affect the thick and thin lines, but will make it easier for you to maintain the slope and avoid catching the point on the upstrokes.

Speed: In general, pointed-pen hands are written quite slowly, Copperplate slowest of all.

Fig. 8

Eight basic strokes make up the letterforms of Copperplate (figure 8). As you study them, you'll see that the repetition of form and precise spacing are required to make this hand work. Practice the basic strokes to develop a pattern of consistency. Then begin to combine them to make letters (figure 9). (As we've already noted, these forms slightly resemble the Palmer hand you may have learned as a child, but it's important to put aside any preconceived ideas about their structure.)

Copperplate looks best when it's evenly spaced, and slightly irregular spacing can look sloppy. The spacing of the shades should be similar to the rhythmic marks you made when you wrote Black Letter, and, along the same lines, you'll find yourself altering the forms to make the texture even (figure 10). Because of these characteristics (the similarity of the letters and even spacing), this hand isn't particularly legible.

minimum

Fig. 10

Fig. 9

Copperplate caps are often highly flourished (figure 11). The basic shapes are repetitive, based on a slanted oval flourish. Sometimes two letters can appear so similar, such as the **I** and **T**, that only their context helps you decipher them.

In the beginning, practice these shapes with pencil before carefully inking them. The shades on these letters should be parallel to the slant lines, and letters such as **A** and **V**, which might appear at first to be based on a triangle, actually repeat the same slope of the vertical letters. The proportions of these forms vary considerably from the Romans you learned in chapter 3; the **D** and **N** are narrow, and the flourishes often take up more space than the letters themselves.

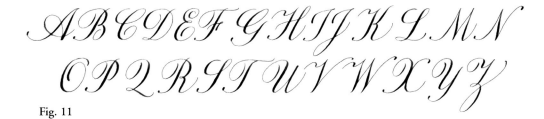

Fig. 11

Other Pointed-Pen Styles

Spencerian, another pointed-pen style, is related to Copperplate and was first developed as a business hand in the 19th century. The lowercase letters don't have the weighted shades of Copperplate, and many of its versions show a highly flourished capital. The pointed pen has been used for many other variations, some of which give a very contemporary flavor to the script.

The pointed pen can be applied to the skeletal forms of anything, from Romans to Uncial, to create a new look for an old hand. Variations in entrances, exits, and even the basic letter shapes have resulted in pointed-pen scripts that range from dramatically sophisticated to awkwardly expressive. Figure 12 shows four examples of pointed pen experiments. The first alphabet is a narrow upright version, merging the qualities of Italic and Copperplate. The second eliminates the curved entrances and exits of traditional Copperplate and distorts some of the basic forms. In the third alphabet, the pointed pen has been applied to a Foundational skeleton. In the fourth, it is used on Roman Caps.

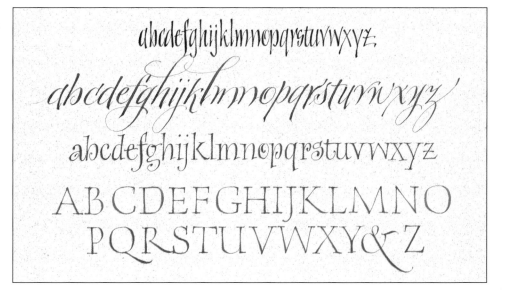

Fig. 12

The Pointed Brush

The pointed brush is somewhat similar to the pointed pen, and some of the skills you developed using the pen can be applied to the brush. To make letters with a pointed brush you must apply pressure on the downstrokes and release on the upstrokes, creating thick and thin strokes.

However, this is where the similarities between the tools end. Culturally, these tools are leagues apart. The heritage of the pointed pen is associated with elegant letters penned by ladies to their lovers, the scripts of black-tie invitations, and the official writing of legal, corporate, and civil documents.

The brush is traditionally associated with Asian calligraphy, with stark contrasts between black ink on white mulberry paper. One envisions misty sumi-e paintings and haiku on scrolls hanging in Japanese parlors, where scribes are seated at low writing tables grinding ink on a suzuri stone in meditative preparation for writing.

Pointed brushes were also used by sign painters in the past, when every grocery store had handwritten ads in their windows. When you write with a pointed brush, you may be drawn to these traditions, or you might try something more contemporary, such as writing with hot pink on black velour paper.

Contemporary Western brush lettering combines the tools of the Asian calligrapher with the forms of the Latin alphabet, making compromises to balance legibility and style. Select a brush with some spring to it, so it snaps back to a point after you put pressure on it. The best brushes for writing are made from Kolinsky sable, but you'll be able to find a synthetic bristle brush for less money to get you started. Brushes with a built-in reservoir to hold ink are available, but be sure to pick one with a point that is springy and sharp. There are even inexpensive felt-tipped pens that have a pointed brush tip, and they come in lots of colors. These wear out quickly, however. Treat yourself to the best brush you can afford, since a good tool makes things much easier.

Guidelines for brush lettering are less precise than for other styles. All you really need is a baseline for reference, since you'll judge the height and weight of the letters while writing. As you develop a style, adjust the distance between the guidelines for legibility and other design considerations. The weight is dependent on pressure, and the forms will change slightly as well.

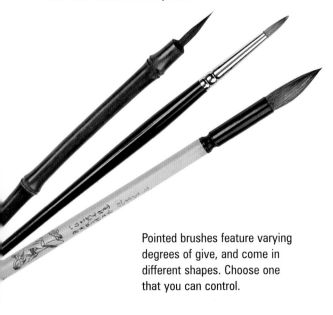

Eliza Holliday, *Joy*, 1988, gouache on paper, photo by artist

The word "Joy" was written with a flat brush, and supporting text was written with a pointed brush.

Pointed brushes feature varying degrees of give, and come in different shapes. Choose one that you can control.

Felt-tipped pens with a pointed brush tip

If you compare the brush to the broad-edged pen, one of the major adjustments to the forms is in the distribution of thick and thin lines around the skeletal form. The brush makes a wedge that's nearly 30° in the direction opposite the baseline, placing the thins on the upper right and lower left-hand side of the **o**, rather than the upper left and lower right (figure 13).

Stem stroke has an angle that is the reverse of the broad-pen angle

Entrance and exits can vary

Basic stroke, weight is dependent on pressure

Basic shapes include a-counter, o-counter, hairlines, and cross strokes; weight is dependent on pressure and changes the forms

Fig. 13

The basic strokes include the stem stroke and the basic **a**-counter, **o**-counter, the branched forms, such as the **n**, and the finishing strokes. Note the variable entrances and exits (figure 13). The letter **n** shows the basic stroke sequence for this hand. You'll want to pause often to allow the brush to spring back into its pointed shape.

As with other alphabets you've studied, learn the letters in families. Develop a uniform style with even spacing. Experiment with alternative characters, such as the **g** shown in figure 14.

Fig. 14

Brush letters can be written vertically or at a slight slant. The basic forms shown here combine attributes of Italic and Copperplate. Hold the brush loosely in your hand, changing the position for upstrokes and downstrokes. Rotate the brush to maintain thickness on angled strokes, such as the tail of the **k**. Work with the simplest shapes first before adding swashes and flourishes.

The capital forms are variable. Those shown in figure 15 are based on a simple Italic capital, with accommodations in the forms reflecting the movement of the brush. Note the spine of the **S**, for example. The jog in the middle allows the brush to move easily through the form.

In chapter four, the basic alphabets were discussed in detail to show the many subtleties required for mastering the forms. With the pointed brush, however, there are no universally agreed upon forms. Each scribe strives to develop an individual style. The principles of good alphabet design (consistency of form, uniform spacing, and legibility) apply, but the details of the forms can be worked out on your own.

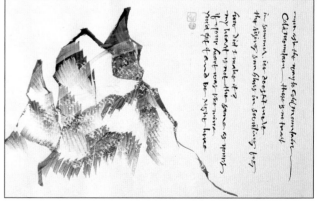

Eliza Holliday, *Cold Mountain*, 1998, gouache, watercolor and sumi ink on paper, 25 x 17 in. (63.5 x43.2 cm), photo by artist

Inspired by antique Chinese screens, Holliday used a brush to write a favorite poem, writing western style by framing it sideways to resemble Oriental calligraphy.

Fig. 15

abcdefghijklm
nopqrstuvwxyz

abcdefghijklm
nopqrstuvwxyz

Fig. 16

Ruling pens, some with adjustable metal leaves

Ruling Pens

Before the advent of the computer, every engineering student was required to take a course in drafting to learn to draw complex diagrams of processes and equipment. Tucked away in a drawer of many a parent is a drafting set with compasses, dividers, and ruling pens, just waiting for a child or grandchild to put them to good use again. The dividers can be used for measuring, the ruling pen can be used for drawing straight lines, and the compasses can be used to draw circles with ink or gouache.

The ruling pen is a tool with two metal leaves that can be adjusted to make crisp lines of various widths. It can be turned on its side to make thick and thin lines, and hence lowercase and uppercase alphabets (figures 16 and 17). This tool makes marks that are similar to those of the pointed brush, but the strokes are much more predictable and easier to control in terms of weight. The edges of the marks are often rough, lending a rustic effect.

This tool can be used to write letters based on a variety of skeletal forms. In figure 17, the capital letters and lowercase Italic forms work well together. The months of the year are written in a bouncy Italic form that includes double-stroked capitals for emphasis. Both the brush and ruling pen can be used in a variety of ways, resulting in new and unique forms.

ABCDEFGHIJKLMN
OPQRSTUVWXY&Z
January February March April
May June July August September
October November December

Fig. 17

Other Writing Tools

A trip to an art supply or stationery store might tempt you to buy lots of writing tools, including ballpoint pens, Japanese sumi-e brushes, or fancy brush cartridge pens with sable bristles. You can also make your own pens from various materials or adapt tools made for other purposes. For instance, you can cut reeds from bamboo or quills from goose feathers. You can even chisel a wooden tongue depressor to a point and use it, or cut up a soda can to mimic a ruling pen.

You can also buy pens and inks made for writing on other materials, such as glass, ceramic, stone, fabric, or plastic. In this category are tools with various points, including monoline or broad-edged pens, felt-tipped, and synthetic brushes. For instance, a monoline tool made for applying glazes to ceramics can be loaded with ink and used on paper.

Experiment with various inks and paints when using these writing tools to yield new possibilities or solve problems you might encounter. Keep in mind that there are three variables: the tool, the liquid, and the surface. In every situation, practice with the tool first to develop a style that flows freely. If you do this, you'll write with confidence when you begin your project.

When you discover combinations that work, consider the archival qualities of your materials. Something as ephemeral as an envelope can be lettered with an ink you know won't last; but for potential heirlooms such as a family tree or wedding book, you should choose more stable materials.

To sum it up, any tool can be used to make letters—from a stick in the sand to a reed dipped in berry juice. Some writing tools have a heritage of hundreds of years, while others are more recent additions to the scribe's toolbox. Scribes are constantly developing new ideas in response to their culture.

Doug Boyd, *Alphabet Study*, gel marker on black cover paper enhanced with colored pencils, flourishes added with grey colored pencil, 9 x 12 in. (22.9 x 30.5 cm)

A playful alphabet is used to experiment with form, layout, and tools.

It's possible to make your own pens from various materials.

A monoline tool made for glazes can be used for writing as well.

Drawing and Writing

Writing and drawing are related in many ways. In both, you begin by exploring a form until you understand it well enough to work with it freely and change its expressive power. For instance, a portrait artist usually studies the anatomy of the sitter before trying to capture personality.

Through repetition and study, you learn the structure of letterforms. As you've discovered, taming your pen to make beautiful forms is a lengthy pursuit. Beautiful letters can be formed with the humblest of tools, and these tools can be adapted to many media. Eventually, you create the form reflexively, leaving you free to go back and forth between the meaning of the words and how they look on the page, developing your own interpretations.

DRAWN LETTERFORMS

Think of the distinction between written and drawn forms in this way: When you write letterforms, you usually use the pen to create both sides of the strokes at once. To make drawn letterforms, you'll use lines to form the outlines. To compare these, take a look at figure 1. You can also see the contrast between pen forms and complex drafted forms in figure 2.

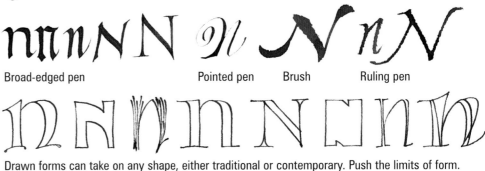

Broad-edged pen Pointed pen Brush Ruling pen

Drawn forms can take on any shape, either traditional or contemporary. Push the limits of form.

Fig. 1

Drafted forms allow you to look at the shapes of the letters in a new way because they aren't dictated by the mark of the tool. Making them is both challenging and liberating. You must think more about the shapes of letters while being free to make more decisions about the way they ultimately look.

These forms are rooted in Versals, which were often written in colored ink and made large so they could be filled in with an illustration or pattern. In the most expensive books, gold leaf was added. As the pages of the book were turned, light reflected off the highly burnished gold surfaces, giving rise to the term illumination. Many are master works, such as *The Book of Kells*, which contains pages of complex drawings with drawn letters as an underlying structure for the book's overall design. The Sanvito manuscript (see page 53) has a complex illuminated letter and border that ties the image on the facing page to the text on the right.

The pen moves, the letter is made.
Your mind is occupied with the
meaning of the words
and the rhythm of the hand
dancing across the page.
You follow a planned layout,
working your way from left
to right, down the page.
You are writing.

The serif twists, the swash leaps,
the shape you have just made
dictates your next move.
The hand darts around the page
adjusting, adding and erasing.
The words become
secondary to the forms.
You are drawing.

Text and lettering by Annie Cicale

Modern lettering artists use drawn letterforms in many ways. For instance, Versals are used in contemporary manuscript books to give contrast to text. Headings can be drawn in shapes that can't be achieved with a writing tool, and outlines filled with color and pattern. Today, calligraphers use drawn forms in books, broadsides, logos, or tag lines. They are even the basis for paintings.

Fig. 2

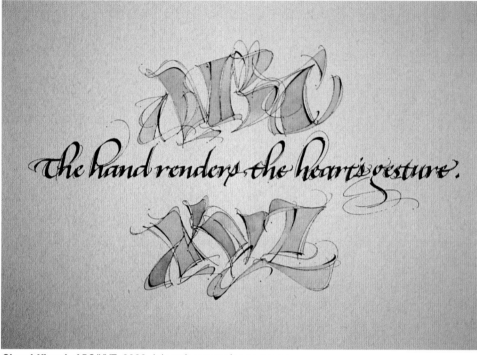

Sherri Kiesel, *ABC/XYZ*, 2003, ink and watercolor on paper, 6 x 4¼ (15.2 x 11 cm), photo by Annie Cicale

The drawn forms, colored with watercolor, contrast with the black pen forms.

Drawn letterforms have led to the invention of unusual designs and new families of alphabets that have been converted to typefaces with computer software. To learn to draft letters, it's helpful to copy these existing models. You'll find that even a typeface as spare as Helvetica has some sophisticated curves and subtle weight changes.

Today, there's no limit to what can be done with letters—in fact, the simplicity of type design programs has made the technology of designing personal typefaces available to anyone with a computer, a good sense of design, and a great deal of patience (figure 3).

Fig. 3
The Trajan typeface by designer Carol Twombly (for Adobe)

SENATVS POPVLESQVE ROMANVS

Kirsten Horel, *Yes! Wow*, gouache, ink, and pigment pens, 5 x 7 in. (12.7 x 17.8 cm)

DRAWING TOOLS

The humble graphite pencil, used for planning designs and ruling guidelines, is often overlooked by aspiring calligraphers as a drawing tool and medium for finished work.

Graphite is a naturally occurring carbon mineral that rubs smoothly on paper and erases cleanly. It can be used to create many shades of gray and a very rich surface. Other drawing media and tools that can be used for lettering include charcoal, Conte crayons, pastels, colored pencils, and pens.

Because drawing media allow the artist a lot of control, it's possible to achieve many effects that can be added to drawn letterforms. Most of the lettering we read every day is made with black ink on white paper, but the most exciting presentations include all the shades in-between.

Mark Van Stone, *Celebration*, 2003, pen and ink with digital color, 8 x 1½ in. (20.3 x 4 cm)

These drawn letterforms in a unique style were scanned into a computer before adding color.

HANDWRITING

For many of us, handwriting instruction stopped after elementary school. For the first few years of school, our teachers showed us models of letters to copy, and corrected our misshapen forms. In the higher grades, teachers didn't emphasize writing, and each person's handwriting was allowed to be unique. Unfortunately, for many of us, this opened the door to inventive writing that is barely legible (figure 4).

Even though people are still required to write as part of their jobs—jotting down data, recording messages, and filling out forms—schools are now putting even less emphasis on handwriting. Instead, students are now taught keyboarding on a computer in the first few years of elementary school.

Nevertheless, your handwriting can be an important part of your expressive toolbox, showing craftsmanship and character. A written letter, a journal entry, or a note jotted to a friend all reflect part of you that a computer font can't emulate. Most people, recognizing that they haven't given their handwriting enough attention, apologize for it but are at a loss as to how to improve it.

Whether your handwriting is a formal connected Palmer-based script or an architectural print script, there are things you can do to make it better. One of the first is to slow down! A note dashed off to your child's school about a doctor's appointment has a different purpose than a carefully handwritten note to your great-aunt. As you begin to write, decide how important the piece is, and let your speed reflect that decision.

Three basic attributes of lettering styles—shape, slope, and weight—apply to handwriting as well. You can evaluate the present state of your handwriting by studying each of these. Begin by slowly writing your script, identifying the basic shapes and all the

Palmer Handwriting

Italic Handwriting

Handwriting with no underlying model

Fig. 4

repetitive strokes. Do you connect all the letters, or do you lift your pen frequently? If you are making unusual characters, can you find a way to harmonize them? Do you write with a consistent slope or do your verticals wander all over the page? Is your writing large or small? Is the point of your pen too fat to reveal the shapes of your letters?

If you find that your handwriting is lacking, you might consider using the underlying model of Italic handwriting. Through this method, many adults have modified their writing style from a garbled form to a fluid, legible, and elegant hand with a great deal of character.

Italic Handwriting

Pioneered by Alfred Fairbank in England and Lloyd Reynolds in Oregon, Italic handwriting has proven to be a model for one of the most legible, beautiful, and rapid styles of writing.

Italic has a simple repetitive structure that can be written quite quickly, even without a great deal of pen control. If you write Italic with a monoline tool, you can achieve a tidy print script or a flowing cursive. Using an edged pen will lend your writing a more dramatic impact (figure 5).

Italic Handwriting is based on a 16th century hand used for formal documents. Exits and entrances are added which allow the letters to be joined, as an exit can go into the entrance of the next letter. It can be written with all the letters joined, or only where it makes sense to your hand. A broad edged pen, felt tip or fountain pen, can be used to make your writing more elegant. Hold the pen at a 45° angle so it will be easier to slide up on the hairlines. Write slowly at first, with speed your own personality will emerge in the forms. Stay legible!

Fig. 5

The lowercase letters of Italic handwriting are based on a slanted elliptical shape, with an arcading rhythm of branching **n**'s, **m**'s, and **u**'s. The capital letters are based on the Roman form. Swashes can be added for a flourished appearance.

To make this conversion, practice monoline letterforms on ruled guidelines. Then, begin to incorporate this approach into the writing you do every day, writing slowly and then speeding up. With time, you'll begin to see the change, and you'll produce handwriting that you're proud of. If you're writing with a broad-edged pen, look at your pen angle as well. A consistent 45° pen angle will give you the most fluid hand, with speed on the upstrokes and strength in the downstrokes. If, however, you end up changing your signature, don't forget to let the bank know!

7

Chapter Seven

Design

To effectively design a page of lettering, you must simultaneously think about the letterforms as well as their arrangement on the page. Basic design concepts can help guide you in this process and make the difference between a piece that is boring or exciting.

In comparison to this concept, the graphic designer uses shapes already created by a type designer that are incorporated into a design. But in hand lettering, you must deal with both issues at the same time.

You can enhance and strengthen the meaning of the text you've chosen by presenting its visual properties in ways that affect its impact. In other words, the visual and verbal work together to create a meaning that is stronger than either mode alone. You're already familiar with this process through modern advertising and publication design. Advertisers use lettering treatments to convey ideas more effectively in hopes that they'll become ingrained in your consciousness and affect your buying decisions.

ELEMENTS OF DESIGN

The language of design is broken down into elements and principles that work together to create meaning. It's helpful to think of each one of these individually, allowing you to modify the design in many ways to influence its impact.

• *Line:* Mathematicians define line as the shortest distance between two points. For the artist, line is more complex. Line defines forms and can create edges, contours, or textures. The tools you use and your technique both affect the line's emotional quality. Whether undulating, bold, delicate, or crisp, lines can convey many states of emotion, such as nervous, sedate, joyous, or sad (figure 1).

Annie Cicale, *The Truth*, 2001, gouache, ink, and watercolor on handmade paper, 11 x 30 in. (28 x 76.2 cm), photo by Jon Riley

Fig. 1

- **Shape:** The basic contour of an object can make reference to its counterpart in the world, while also having emotional or abstract meaning. Lettering artists are obsessed with shape, refining the letters to high levels of sophistication and subtlety. Although you begin by writing the simplest forms, experimentation can lead to hundreds of variations (figure 2). The shapes of letters depend on the precision and control as well as graceful movement—the choreography and dance of the pen.

- **Form:** In drawing, the illusion of three-dimensional form can be achieved through shading. In lettering, you might use this technique if you're trying to convey letters that look as though they have been carved, embossed, stamped, or molded (figures 3 and 4).

Any three-dimensional images that you use along with your text will influence the placement of the letters. When you superimpose letters on an illustration, for instance, be sure to place them in an area (such as a flat plane) where their legibility is not compromised too much.

- **Texture and pattern:** The root words for text, texture, and textile are all the same. When designing with letterforms, the overall texture of a block of writing influences how it's perceived. For instance, delicate, flourished Italic contrasts sharply with dense Black Letter text, and they can be used to convey different ideas. In a drawing, visual texture implies its tactile counterpart in the real world—whether rough bark on a tree or a shiny smooth apple.

Fig. 2

Fig. 3

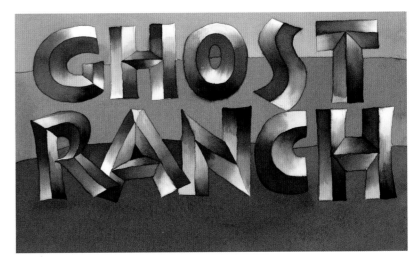

Fig. 4

Fig. 5

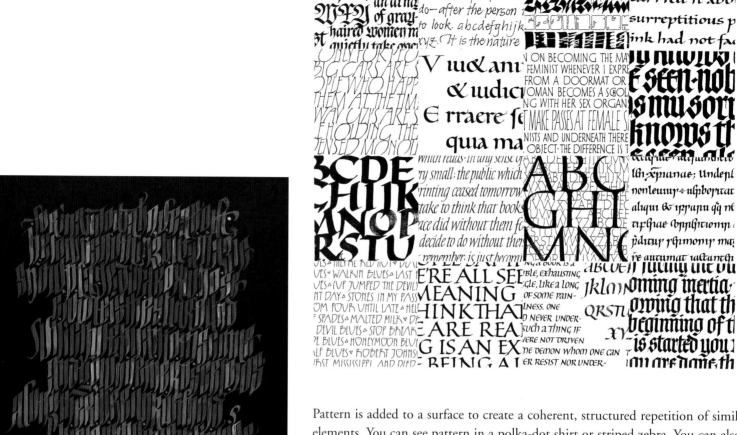

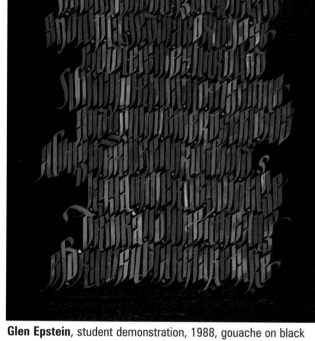

Glen Epstein, student demonstration, 1988, gouache on black paper, 8½ x 11 in. (22 x 28 cm), photo by artist

Pattern is added to a surface to create a coherent, structured repetition of similar design elements. You can see pattern in a polka-dot shirt or striped zebra. You can also see it in the text on a page. Lettering forms a pattern, but the way it's used can bring actual textures to mind. For example, a text with a gnarly texture written on a rough paper with a ruling pen might evoke the feeling of bark on a tree, or rounded forms written on smooth paper with a broad-edged pen might suit a passage about curved seashells. The effect of texture and pattern in lettering are illustrated in figure 5.

• **Value:** Value is the degree of lightness and darkness of a color. Often, we think of value in connection with shades of gray, because black mixed with white in differing amounts creates the broadest possible range of value. Increasing the value range in an image increases contrast and thus dramatic impact.

Different values can be used as shading to define forms, as seen in figure 3 on the previous page. To put it simply, an egg is just an oval before you add shading to it to create the illusion of light and shadow.

Most lettering begins as black ink on white paper. Blocks of text have various values, or shades of gray, depending on how close the strokes are, how far the lines are apart, and how much negative space has been left around the text blocks (figure 5). Various values can imply different psychological meanings. If colorful inks are used, the overall mood will be affected even more.

One intriguing aspect of value is the amount of contrast needed for legibility. Careful adjustments in values of both ink and paper can create different impacts. In Louise Grunewald's piece titled *Snow*, she used white designer's gouache on gray charcoal paper to softly capture the low light of a winter day.

In another piece called *Wonder #2*, the artist has used value gradation in both figure and ground. Inspired by a shooting star that crossed a cloudless, moonless sky in early December, she wrote this as a positive response to the tragedy of 9/11, expressing her wonder for nature's beauty in the midst of calamity. Notice that the value gradation from top to bottom is reversed in the gradation of the text. When using this principle, you must skip a step in the middle of the gradation when the value of the lettering is close to the value of the background.

• ***Color:*** Adding color, either in the ground or in the lettering itself, can change the feeling of the image. For instance, orange lettering on a deep brown ground reads much differently than pale blue on ivory paper. Traditionally, lettering was done in dark inks on pale surfaces. Today we have more options, and painted grounds, colored papers, and inks can add to the expressive power of a design.

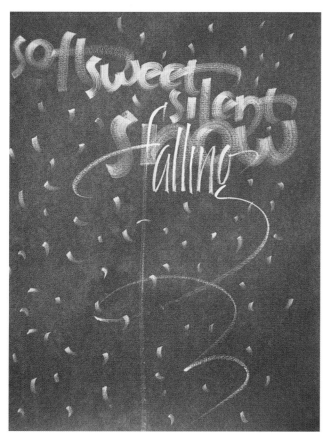

Louise Grunewald, *Snow*, 1998, gouache on charcoal paper, lettered with flat and pointed brushes, 10 3/4 x 12 3/4 in. (27.3 x 32.4 cm), photo by artist

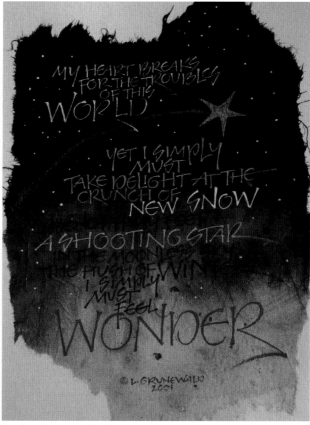

Louise Grunewald, *Wonder #2*, 2001, acrylic, rice paper, watercolor, colored pencil, and gouache, lettered with a pointed brush, 5 1/2 x 8 1/2 in. (14 x 22 cm), photo by artist

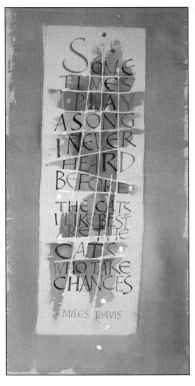

Lisa Engelbrecht, *Sometimes I Play a Song*, dimensional
T-shirt paint, acrylic inks, and foil, 10 x 20 in. (25.4 x 51 cm),
photo by artist

Fig. 6

Expressive forms and colors used in the fine arts are now an inspiration for lettering artists. Compositions done with painterly techniques couple images and words, which play supporting roles.

Calligraphers use many kinds of colored media. To create flat, smooth letters, designer's gouache can be used. It comes in tubes and can be mixed to make an array of colors. Watercolor, colored pencil, colored inks, and pastels work well for letters as well as painted surfaces for writing. The most effective uses of color in lettering designs integrate the color scheme of the ground with the letters so the words form legible textures that take an active role in the overall design.

• ***Proportion:*** In lettering, the proportions, or relationships between the parts of each style, are critical. Classical Roman letters, for instance, fall into specific width groups, and Foundational is written with a round **o** as a base.

Letters of the same weight, determined by the number of pen widths used in creating the guidelines, will have the same proportions, no matter what pen size is used (figure 6).

You can alter proportions from classic forms, developing an infinite variety of expressive styles (figures 7 and 8).

Fig. 7

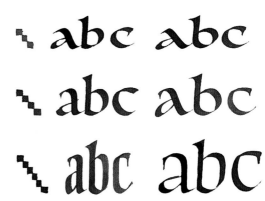

Fig. 8

Proportion must also be considered in relationship to page size and format (figure 9). You might choose to work in a square, a long narrow rectangle, or even a shape based on the Golden Mean. The nature of the space will have an impact on the overall dynamic of the arrangement. Unless your proportions are specified for a project, such as a piece for an antique picture frame that you already have or a flier that must be a certain size, you should carefully consider page proportions as a critical part of the design process. Matting and framing can be designed to enhance these decisions.

Fig. 9

| 1:3 | 1:2 | 1: √3 (1.732) | Golden section 1:1.618 | 2:3 | Standard paper size: 8½ x 11 in. (22 x 28 cm) | 1:1 | Golden section horizontal format 1.618:1 |

PRINCIPLES OF DESIGN

There are many concepts to be considered under the heading of design principles. In the following section, you'll learn about a few that can be applied to lettering. Understanding these concepts will help you see the "big picture" of your design with more clarity.

• *Balance:* If a design is balanced, all the elements work together to create a feeling of equilibrium. Balanced designs can be harmonious or discordant, depending on your design purpose. An anti-war statement requires more drama and tension than a piece about tranquility. However, most designers agree that balance must play an important role in both.

• *Contrast:* Extreme visual contrasts, such as light against dark, bright against dull, hard-edged against soft, and big against small, can create a feeling of drama, conflict, power, or excitement (figure 11). Lesser contrasts can imply serenity, passivity, and even boredom (figure 10).

• *Repetition:* Repetition can serve as a unifying factor in a design. By its very nature, lettering is repetitive.

• *Unity/variety:* A design is held together by the principle of unity and variety when the arrangement of its elements displays enough commonality to hold things together (unity), and enough diversity (variety) to make things interesting. Striking a balance between the two involves using them so that they enhance one another.

• *Gradation:* Gradation, or a gradual series of changes in size, texture, color, shape, or line, is a powerful tool for adding variety while unifying a design. Consider a series of contrasting steps: A third element introduced and placed between two extremes serves as a transitional step, tying the two together. Likewise, a third element placed at either end of a pairing extends the range and enlivens the contrast.

• *Alternation:* Going back and forth between contrasting elements can establish a feeling of rhythm in a design, lending unity to the arrangement. Think of how your feet alternate when you walk, creating rhythmic movement. Alternation between greatly contrasting elements will lend your pages a lively, dance-like quality.

• *Dominance:* Finding a focal point for your design can serve to direct your viewer to the area that you want to emphasize the most. The ways in which you can set up a focal point are many. For instance, your point of strongest contrast in the design is often what draws the viewer's attention first, no matter where it is located on the page.

Fig. 10

Fig. 11
Sara Loesch Frank, *Mountain*, 2000, ink, acrylic paint, collaged textures, gouache and shell gold on paper, 30 x 40 in. (76.2 x 102 cm), photo by artist

This startling composition shows many contrasts.

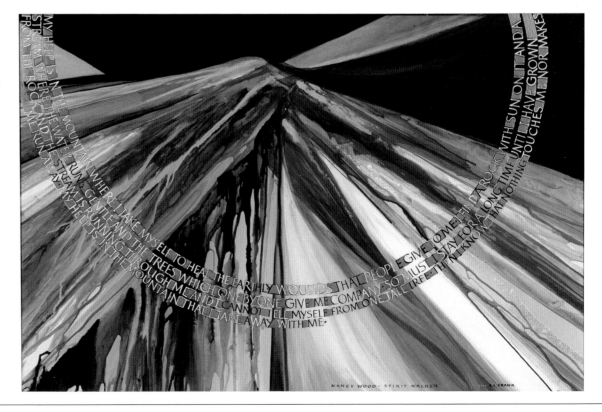

DESIGN VARIABLES

The following section describes variables you'll need to consider in each design project. The choices you make will markedly influence the overall impression of your design.

• *Format:* If you have a choice between a horizontal and a vertical format, there are several things to consider. A vertical format can feel more formal and dignified and/or imply power and strength. A horizontal format can lend a sense of serenity or calm.

Fig. 13

The proportions of your page, unless limited by factors such as a publication size or frame, are always variable (figure 13). Experiment with different proportions. If you always accept a certain format because "that's the way the paper comes," you might deny yourself the possibility of exploring something more exciting.

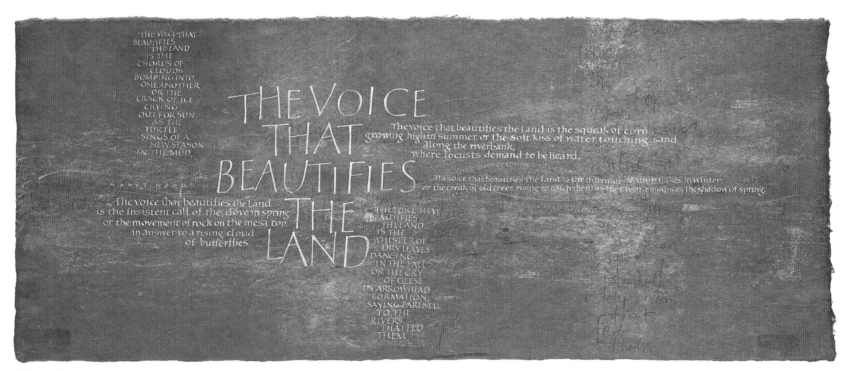

Minako Sando, *The Voice that Beautifies the Land* (poem by Nancy Wood), 2002, gouache and pastel on Washi paper dyed with persimmon juice, written with metal pens and brushes, 24 x 10.2 in. (60 x 26 cm)

The rectangular text blocks in this piece echo the proportions of the paper, both horizontally and vertically.

Some artists choose proportions intuitively, while others use a mathematical approach. A traditional proportion is that of the Golden Mean, or a rectangle whose sides have approximately a 1 to 1.6 ratio. A sheet of paper that is 10 x 16 inches (25.4 x 40.6 cm), for instance, has this proportion, and thus a classical appearance.

• **Vertical alignment:** Each line of writing has to begin and end somewhere. In every lettering design, there is some sort of vertical axis, whether a hard margin or an implied line (figure 11).

| Flush left | Flush right | Centered | Hanging indent | Block | Asymmetrical |

Fig. 11

Your alignment options include:
• **Flush left.** This is the easiest and safest form of alignment to use. Plan line breaks carefully, considering the overall shape of the text block, the grammatical requirements of the text, and the lengths of the lines.
• **Flush right.** This format is difficult with hand lettering, since you must know where each line ends before you begin it and space them very accurately. This may be your best design option; for example, you may decide that a quotation will work best on both sides of a mat surrounding a photograph. If you plan to do this, you can set the text on a computer in a size and shape similar to your hand lettering, and use that text as a guide.
• **Centered, symmetrical.** This will give a very formal appearance. The overall shape of the text block is important, with no long or short lines breaking up the design. With a centered design, you must letter out the entire piece with the same ink and pen. Then, measure each line and divide it in half to determine the starting and ending point.
• **Hanging indent.** Placing the first lines of each paragraph or stanza in the left-hand margin will give them a subtle prominence in relation to the rest of the text. In the process, keep your eye on the alignment of the right-hand margins by planning line breaks carefully. By doing this, you'll keep the emphasis on the hanging indents on the left.
• **Block.** With margins even on both sides, you can create strong rectangular blocks of text. This form of alignment is tricky, because the spacing between letters and words will be different for each line and can create an uneven textural patterning on the page. In this case, the drama achieved can be undermined by the lack of legibility.
• **Asymmetrical.** There are numerous possibilities for asymmetrical alignment. For example, draw a wandering axis down the center of the page, and let the text fall on either side of it.

Most successful arrangements of lettering are written from left to right and top to bottom. In contrast to this, if you design a piece that leads the reader on an unorthodox path, you'll create a sense of excitement. There are many options open to you. In each, make sure to carefully consider your design purpose and spatial relationships as you plan the text size and its arrangement (figure 12).

Fig. 12

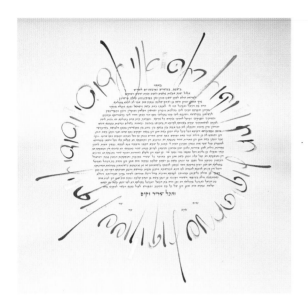

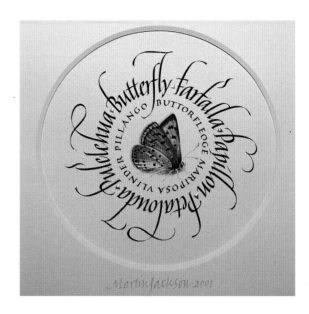

Three artists tackle a circle layout. Keeping text legible is a challenge. Using commonly known texts, repetitive words, and translations of the same word offer some solutions to legibility.

Izzy Pludwinski, *Ketubah*, 2002, gouache, gold leaf and ink on paper, 24 x 24 in. (60 x 60 cm), photo by artist

Carol Pallesen, greeting card, 1988, camera-ready artwork, ink on paper, card size is 4½ x 6¼ in. (16 x 11.4 cm), about 65 percent of the original artwork

Martin Jackson, *Butterfly Farfalla*, 2001, gouache with watercolor and gold leaf on paper, 4 x 4 in. (10.1 x 10.1 cm), photo by artist

Annie Cicale, *Illuminated Quilt*, 1989, watercolor, colored pencil and gouache on paper, 22 x 30 in. (56 x 76 cm)

For example, arranging lettering in a circular format is an adventure for both the scribe and the viewer. From the practical standpoint of legibility, it obviously makes more sense to use this format on a piece of paper, such as a greeting card, rather than a stone monument!

• *Textures:* In addition to format and alignment, you must consider a third variable, texture. Within a block of text, there are many ways to change the texture. Before settling on the final solutions, make sure you have considered the options in each of the following areas:

• *Letter, word, and line spacing:* These should all be considered at the same time. Letter spacing should be balanced to create an even texture, leaving about the same area between each pair of letters. Leaving just a bit more space between words that are uniformly spaced will keep the overall texture even without creating hot spots of white on the page. Although the model scripts in the earlier chapters in this book directed you to use a standard space between lines, line spacing can also be a design variable.

Sometimes as little as one-half nib width can change the texture considerably. Generally speaking, the longer the line of writing, the more space you'll need between lines to maintain a feeling of even texture and enable the eye to travel fluidly. This additional space allows the eye to travel fluidly back to the beginning of the next line without strain. If lines are extremely short, you can nearly eliminate line spacing and stack the words. This is much easier for styles with no ascenders and descenders, since you won't have to plan around possible collisions. In general, most scripts have no more than two times the body height for the space between the lines.

• *Style of writing:* As you learn more styles, and develop your own variations, their expressive power can be used to change the textural feeling of the design. Subtle changes within the particular style can embellish this feeling.

• *Color and value:* A light, airy texture or a contrasting dense one will result in text of differing overall value. If the text is written in color, even more variations and contrasts are possible.

• *Tools:* Using a variety of tools can produce wonderful contrasts in texture, giving you many choices as you develop a design. Constant experimentation with different pens, inks, and papers will expand your skills and expressive capabilities.

VARIABLES OF EMPHASIS

There are many ways to lend emphasis to a word or a line. Read your text out loud, and decide on sections you want to stress. The following variables can be employed to create the hierarchy that you want.

Size: Vary the size of the lettering, while keeping the same proportions.

Weight: Change the number of nib widths to change the weight, making the letters heavier or lighter.

Form: Change the style of lettering, your tool, the type and quality of paper, and the degree and refinement of the letterforms themselves. There are an infinite number of possibilities here.

Color: Try incorporating a range of color contrasts by employing a variety of media. Remember that these may include relationships of hue, value, and intensity.

Fig. 14

WORD AND IMAGE

Most of what we have discussed so far in this section has focused on the visual qualities of your text. However, you may want to combine images with text to add impact (figure 15). Word and image are intricately related, but they are processed by different parts of the brain. You'll find that you stop looking at a calligraphic piece in order to read it, and when you've read it, you'll look some more. The overall impact of your message is enhanced by the choices of symbols, icons, and images you use. You must consider both word and image, integrating them effectively to heighten the viewer's experience.

Images can run the gamut—a realistic drawing, an abstract mark, or simply a painterly ground with writing on it. The letters might dominate the piece with a surrounding decorative border, or the letters might be tucked into a corner, giving the viewer a strong image to respond to before reading the text.

Carol Pallesen, thank-you card, 1990, camera-ready artwork, ink on paper, card size is 6¼ x 4½ in. (16 x 11.4 cm), about 65 percent of the original artwork

Fig. 15

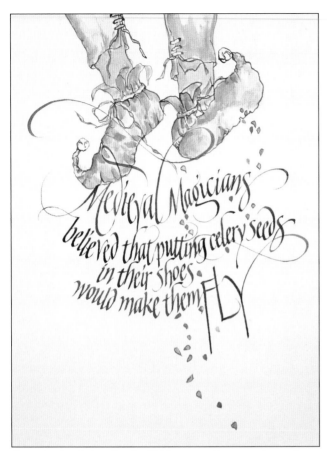

Betty Locke, *Celery Seeds*, 2000, watercolor, gouache, and pastel on paper, 8½ x 11 in. (22 x 28 cm), photo by artist

Since the European Renaissance, imagery and blocks of text were usually kept as separate and distinct elements conceived by different artists. The illuminator or illustrator often filled in his compartments after the scribe had finished the lettering. This grid format was reinforced by early typography, since type and image occupy separate rectangles in the typesetter's chase, the tray in which the type was arranged before printing it. Though illustration and drawing were combined in books, they were often compartmentalized due to this practical need to separate them during typesetting.

In Asia, word and image were traditionally used in a more integrated and unified manner on scrolls and in books. In that culture, the calligrapher/painter could use the empty spaces in any way desired, choosing to balance word and image in a format subject only to the expression of the idea.

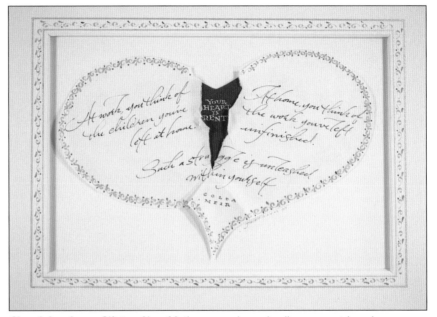

Cheryl Jacobsen, *Gift to a New Mother*, gouache and collage on mat board, approximately 6 x 9 in. (15.2 x 22.9 cm), photo by artist

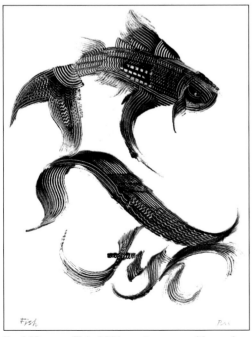

Paul Maurer, *Fish*, 2001, paste paper with combs, 7 x 10 in. (18 x 25. 4 cm)

In 20th-century Western culture, visual artists began to integrate letterforms and even use them as subject matter in their work. Abstract painters such as Paul Klee (1879-1940), Jasper Johns (b. 1930), and Mark Tobey (1890-1976) are among these artists. Other artists have also employed the abstract mark-making potential of the calligraphic tool, whether pen, pencil, or brush. This form of expression is now a valid component of contemporary art-making.

Many of these abstract artists incorporated letters simply for the sake of using them as visual elements, not for the function of forming words or writing. In these cases, legibility is not a factor. Some border on pure mark-making, incorporating illegible scribbles. Other artists or designers carefully draw words, but the forms must often be patiently deciphered by the viewer.

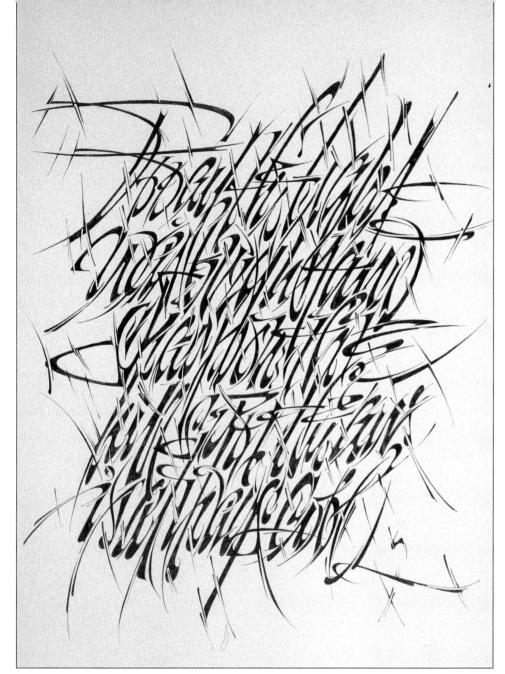

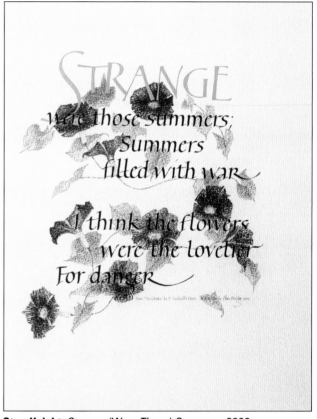

Carl Kurtz, *Today the Light*, 1998, graphite pencil on rough paper, 22 x 30 in. (56 x 76.2 cm), photo by artist

The drawing fuses the positive letter shapes with the negative spaces in a manner similar to the author's fusing light with surface. Though the piece is not particularly legible, contemplation reveals the words while reinforcing the meaning.

Stan Knight, *Strange (Were Those) Summers*, 2000, watercolor, gouache, and pastel on paper, 8 x 10 in. (20.3 x 25.4 cm), photo by artist

Here the text is woven among the flowers, but it remains quite legible.

If the artist incorporates writing, expecting the viewer to gain a message from them, the process of decoding the text of these pieces can enhance the viewers' experience while they also contemplate the structure of the form. If the text is familiar to the viewer, such as a well-known saying or quotation, it will be more immediately readable. Either way, the designer or artist working in the realm of combining text and art is the one who must intentionally make a decision as to the importance of legibility, based on their intention. If you are the artist or designer, and legibility is a prime concern, you must make that factor a priority.

THE DESIGN PROCESS

As we've discussed, effective design enhances the meaning of your chosen text. In this section we'll put the principles of design to work.

Every piece of writing has many possible design solutions. First, you'll have to think about getting all the parts to fit before elaborating on ways to make it more powerful. Through sketches and rough drafts you can try out lots of ideas, eliminating the weak ones to come up with one that makes a strong visual statement that complements and enhances the words.

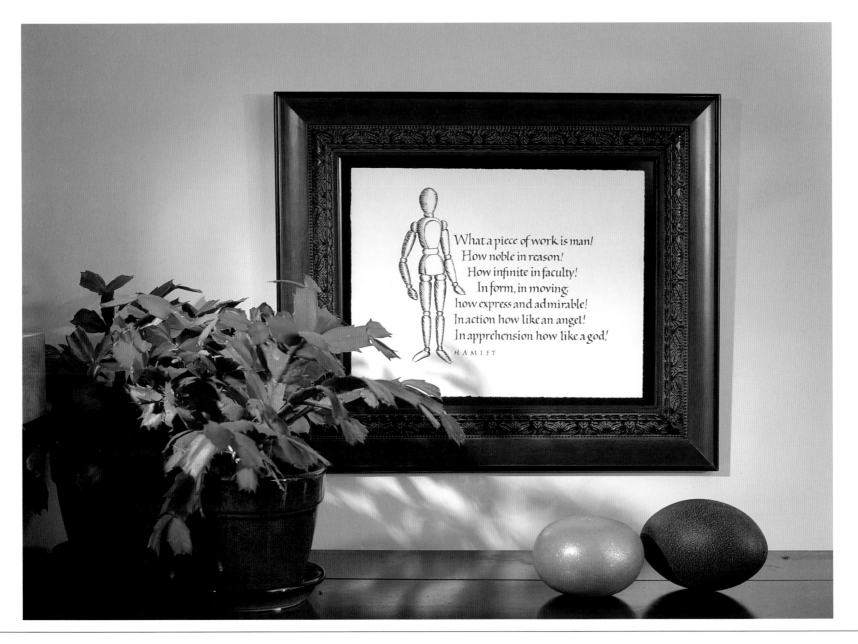

Developing a Calligraphic Design

First, write the text in your normal handwriting to get a feeling for its grammatical structure and the parts you want to emphasize. Break it up into parts of speech to determine the phrases you want to keep together. Preserve the punctuation, and credit the author if there is one. If you're using a poem, its format is probably set by the author, so you should adhere to this. If you're writing prose, you have more freedom. Think about the appropriate "look" for the piece as you write it—such as loose or formal, strong or delicate.

• Experiment with a number of quick thumbnails that indicate the positioning of the text. Try both horizontal and vertical formats. As you sketch, say the words aloud to help

Photo 1

you visualize their size, placement, and dominant parts. Think about ideas for illustrating the text, considering overall texture, scale, and placement, as well as how they'll be integrated together. Use quick abbreviations for the lines of writing, such as squiggly lines or horizontal bands.

• Complete about 10 to 12 thumbnails, adding contrasts or other enhancements where needed. In this example, a simple pen-and-ink illustration is used to complement the text (photo 1).

• Develop two to three of your thumbnails in a larger format, refining them to a penciled rough draft. Experiment with letter size, contrasts, line spacing, and arrangements of the elements (photo 2). Select the best one, and draw it on the approximate scale of your final piece. You can do this with pencil or a felt-tip pen. Make sure to include all the material, such as the source of your quotation or other text, which can be used as a contrasting element. If you don't know the name of an author, it's fine to write "Author Unknown" or some other appropriate phrase.

• Do a final rough draft based on the draft you just completed. For this step, you'll use your lettering pens to determine the pen sizes you'll need. To do this, nib off guidelines and choose a pen(s) that comes closest to the size of the letters in the draft. Rule

COPYRIGHT ISSUES

Copyright laws in the United States allow a "fair use" of copyrighted material by calligraphers using material for noncommercial purposes. Use of copyrighted material for any commercial purposes requires the artist to obtain permission from the author or publisher. This means that you may have to pay a fee for the use of copyrighted material if you plan to sell your work. Never write out a poem or a quotation and then sell your design without checking the copyright.

Photo 2

Photo 3

Photo 4

guidelines accurately with a very sharp HB or 2H pencil on layout bond paper. Write out the text. Cut apart the lines of writing and rearrange them to form a final draft. You can test different letter sizes and contrasts as you paste up your design. You still have complete flexibility in your design at this point. After you've arranged the strips to your satisfaction, rule another set of guidelines on another sheet of paper and paste these strips in place. Make sure that you accurately line up the base lines of each line of writing. This is your final rough (photos 3 and 4).

• Next, use the final rough as a guide to make a paper ruler with line spacing and letter height. Label the parts to keep track of the elements, especially if the design is complex (photo 5).

Photo 5

• Rule your good paper carefully, using a very sharp pencil to make light lines. Transfer the guidelines from your paper ruler. Rule the margins, an axis (for vertical alignment), and make any other marks you need to indicate the beginnings and ends of lines. Block in illustrations or ornaments. Be sure to mark your base lines; it's easy to get lost and write in the wrong space once you get into the rhythm of writing (photo 6).

CENTER YOUR DESIGN

If you plan to center the design, it's simple to do. Measure the length of each line on your final draft, and mark the beginning and end of each line. For instance, if one line is 8 inches (20.3 cm) long, place the ruler at the axis at 4 inches (10.2 cm), and tick off marks at zero and at 8 inches (20.3 cm). It's helpful to mark the center of each line on your draft copy as well. As you're writing, you can look and judge whether you're ahead or behind when you reach the center, adjusting your spacing for the second half of the line.

Photo 6

• When your prep work is done, tidy up your work area a bit to avoid ink spills and so forth. Relax and take a deep breath before beginning to write. Warm up with your writing tool and ink on a scrap of the same kind of paper you'll be using to adjust to its texture (photo 7). Take a deep breath and begin to write (photo 8). Keep in mind that you may want to write your text two to three times before you're satisfied with the results. Keep an eye on the text for the sake of spelling and punctuation. If you make a mistake, keep going. If you end up preferring a version that has a mistake in it, you can probably repair it later (see page 118).

Photo 8

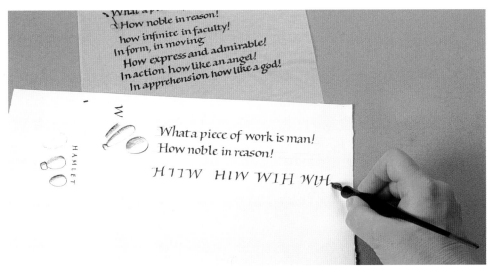

Photo 7

Photo 9

• If you've included decorative elements in your design, do the lettering before drawing or painting them (photo 9). If the spacing on your lettering varies a bit from your original design, it's usually easier to adjust the shape of the illustration. Also, if you make an error in text that you can't correct, you won't have wasted your time. Most medieval manuscripts were done in this order, and we can learn a lot from the medieval scribe's procedures.

• After the ink dries, gently erase the guidelines with a soft eraser. Proofread it carefully. When you're done, sign your name, stand back, and appreciate your work!

• If you leave plenty of room around your design from the start, you can determine the exact margins after the piece is done. If you're planning for a specific print size or picture frame, you'll need to set the margin from the beginning. Use mat board corners (from a frame shop) to decide on the exact width of the margins. Keep in mind that in a framed piece, the matting serves as a margin as well, so you can crop a bit closer (photo 10).

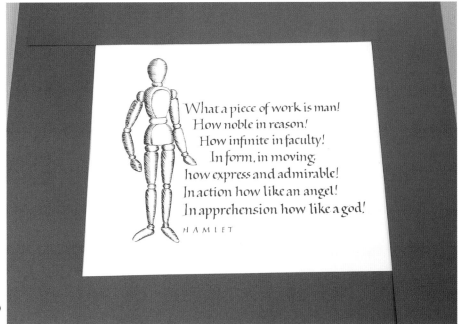

Photo 10

Evaluating Your Design

As you look at the piece, think of the design principles we've talked about. For instance, you might ask yourself whether the piece is balanced. Does one element overpower the whole? On the other hand, is there enough contrast? Most important, does your design do justice to the text? Have you enhanced the meaning of the words or is the arrangement too gimmicky? Is it legible? Have you punctuated it correctly?

It's helpful to share it with others for feedback. They will most likely try to read it right off, and if they get confused by some of your more inventive design ideas, you might want to be more traditional.

Nevertheless, these are guidelines, not rules. Many successful designs break all the rules; many boring ones follow them. Trust your intuition as you explore many possibilities.

Experience is always your best teacher. You learn by evaluating choices, looking at your finished work, and even processing the alternatives you abandoned. Even if you think that you can always do it again and better, any supposed mistakes aren't wasted. Take the things you've learned forward with you to the next project.

Correcting Mistakes

It happens on the best days. You've completed an excellent piece, only to find you've misspelled a word or dropped a spatter of paint in the wrong place. An impish demon named Titivillus was often blamed by scribes for the mistakes in medieval manuscripts. If he has entered your work area and caused some damage, you can often correct the mistake.

When you find a mistake, calm down and plan the correction. Can you save the piece, or should you do it over? How serious is the mistake? Is it a piece where correct spelling is imperative, or can you let it go as part of the serendipitous nature of the artist at work?

A tiny mistake, such as a counterspace that has been filled in with a blob of ink, can be corrected by picking it out with a scalpel. Use a rounded blade to scrape off only the top layer of paper fibers (photo 11). Use a burnisher (any smooth object such as a brush handle, spoon, or stone) to burnish the loose surface and smooth the fibers back into the paper. To match the texture and avoid a shiny spot when you burnish, place a swatch of the same kind of paper over the spot before doing it (photo 12).

Larger mistakes can be removed with a double-edged razor blade, though some caution is required. Mastering the blade takes some practice. Hold it between your thumb and forefinger, and tape into a U-shape (photo 13).

If possible, save any part of the letter that will be needed for the correct form, since there's no point in scraping if off and writing it again.

To maintain a crisp shape, first use a scalpel to cut a vertical slit along the edge of the letter, then slice just the top layer of the paper with a razor blade, a bit at a time, removing the offending ink. Rotate the paper as you work, moving away from the letterform or toward it, depending on how the counter is shaped. Work very slowly.

Photo 11

Photo 12

Photo 13

You'll find that the blade dulls very quickly, and if you move along the entire cutting edge of the blade you'll only get about two or three little slices out of each section before it's no longer sharp. Once this happens, remove the tape and slide the blade into the discard side of the razor's package. Or, wrap it securely in tape before throwing it in the trash.

Since these blades are dangerous, you should store them in an old film can or other small container when you're not using them. Otherwise, leaving them on your tool bench can result in cutting yourself while reaching for another tool.

Once you've removed the mistake, erase the areas around it lightly with a soft eraser to remove dirt and fibers. Burnish the area with paper placed over the mistake before lettering in the correction. This technique preserves the integrity of the paper, so you'll be able to write on the paper with very little ink bleeding. If your surgery has caused any fuzziness on the paper, it helps to dust the surface with a little gum sandarac before writing (photo 14).

Sometimes an "ink" eraser, either manual or electric, can be used to remove a mistake. An erasing template can be used to work the eraser into tiny areas. This abrasive kind of eraser will remove ink quickly but leave a nappy surface that may be hard to write on. Careful burnishing and gum sandarac will help.

A serious mistake can be corrected with a paper patch. Sometimes your paper is too thin for scraping away, or you might be working on the one and only sheet available. This will take a bit of skill, and you'll think of the best plastic surgeons as you carefully execute the repair.

To do this, you're going to use the scalpel to cut a hole in the text where the mistake is located (usually in the shape of a rectangle). Rewrite the text you need on the same kind of paper with the same pen and ink, and cut it out just slightly larger than the hole. Bevel the edges of both the hole and the patch with a curved scalpel blade. Apply a bit of wheat paste to the areas where the bevels overlap, and position the patch under the hole. Burnish in place, put a sheet of wax paper over the area, and set a weight on top until the paste dries. This smooth patch is barely perceptible, even if you know it's there, and probably won't be detected if the piece is framed under glass.

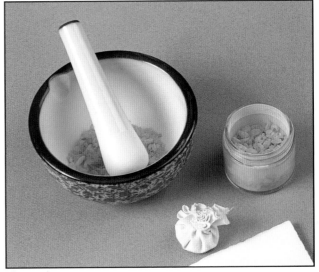

Photo 14

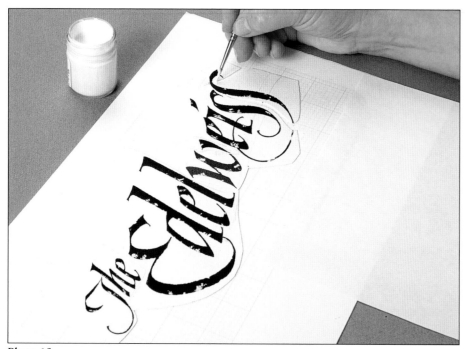

Photo 15

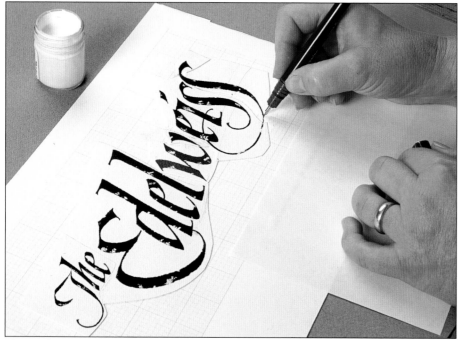

Photo 16

Surprisingly, correcting mistakes made on a colored ground are easier. If you've used gouache, you can reconstitute it with a moistened cotton swab, lifting away the mistake. The color might bleed into the background a bit, but you can move it around with a damp brush or the cotton swab until it blends in. You can even paint over the background and "bury" the mistake, though this requires some serious planning. When you're satisfied with your correction, letter the correct word in place. Again, a bit of sandarac might help the paper if it's become fuzzy.

If you're creating work for reproduction, the situation is much easier. You can cut and paste as you need to, since the printing process will eliminate the cut lines of the paper. You can retouch with bleed-proof white paint (available in small jars and sold to graphic designers for just this purpose), completely reshaping a letter if needed. A fine-pointed black pen can also be used to retouch. If you're designing a heading or a logo, you can even cut off a part of a letter and paste it onto another (photos 15 and 16).

Treat this as part of the design process. If you think of these as mistakes you're correcting, you'll be dwelling in the negative. If you think that you are improving the design by any means possible, your attitude will be healthier.

The Projects

After practicing a lettering style for awhile, you'll find lots of exciting ways to apply your efforts. Making projects such as cards, books, journals, and maps allows you to share your hard-won calligraphic skills with others.

The projects in this chapter are illustrated with specific styles of lettering, but each one teaches you techniques and concepts that can be adapted to any style that you choose. The arrangement of the elements of the design and the illustrations you include will also impact your project. Through writing and designing projects, you'll increase your skills while making wonderful things to share with your family and community.

Addressing Formal and Informal Envelopes

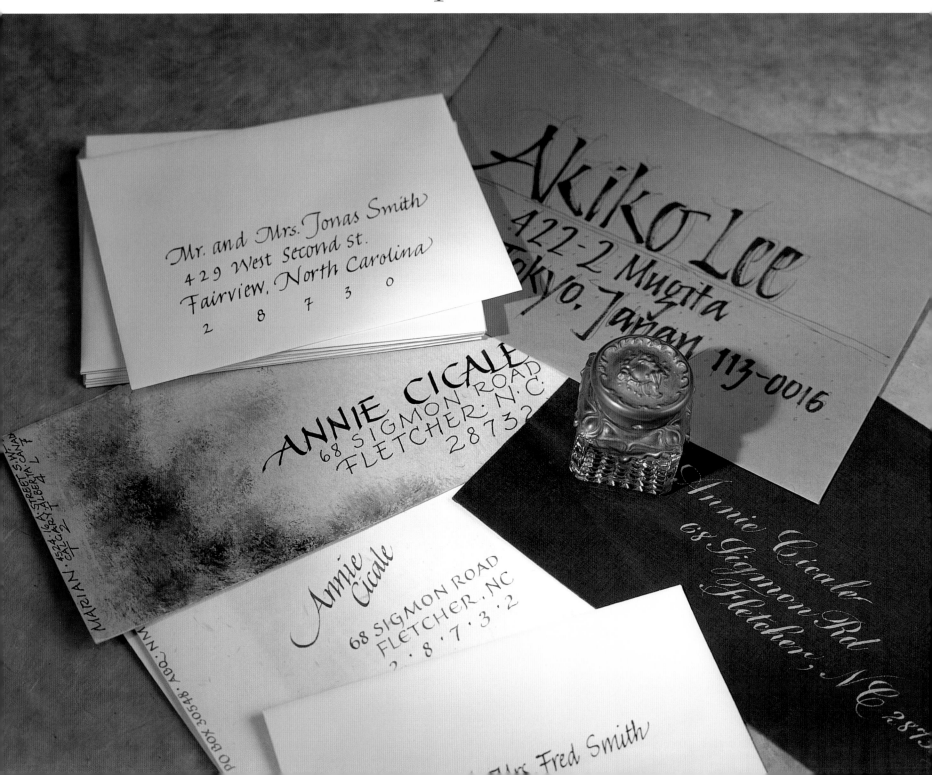

A beautiful envelope is like a gift to your friends—a surprise among the clutter of junk mail and bills. Whether you address a formal envelope announcing an important event or a decorative one that says you're sending something out of the ordinary, the recipient will undoubtedly treasure your creation.

For addressing invitations to formal occasions, such as weddings, a more traditional, conservative hand is often used. Copperplate or formal Italic are among the most commonly used hands, although many others are suitable. If you have a large quantity of envelopes to address, choose a style that you can write efficiently. Besides the impressive results, the practice that you get by working through such a project adds to the value of doing it.

Less formal, artistic envelopes are an opportunity to experiment with your lettering tools. You can try out new alphabets, add an illustration to match a stamp, or use rubber stamps or stickers for embellishment.

MATERIALS AND TOOLS

Envelopes

Gum sandarac or can of workable spray fixative (optional)

Assorted writing and drawing tools such as dip pens, fountain pens, ballpoint pens, fine-tipped markers, and brushes

Ink

Light box (optional)

Stamps, stickers, or other embellishments (optional)

INSTRUCTIONS

1 To address formal envelopes, begin with a typed list of names and addresses that you've read through carefully for accuracy. Keep the following tips in mind: For a formal affair, states are often spelled out rather than abbreviated. Make sure the spacing and the spelling of names that vary are correct; for instance, Mary Ann versus Maryann or MaryAnn. Pay attention to recipients' titles; for instance, many women prefer Ms. to Miss or Mrs., even on the most formal occasions.

2 Count the number of names on your list and make certain you have at least 10 percent more envelopes than you need for corrections. If your envelopes aren't sized, add a bit of gum sandarac or workable spray fixative so that they can accept ink without bleeding.

Photo 1

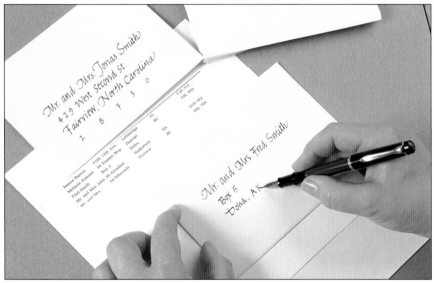

Photo 2

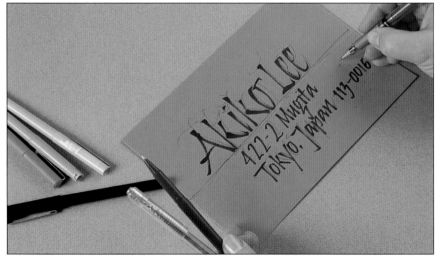

Photo 3

3 Experiment with the pen and ink you plan to use before beginning. You might want to match the lettering on the piece that you're enclosing in the envelope, or choose a coordinating style if the piece is printed with a typeface you can't imitate. Your choice of style might also be influenced by the postage stamp you choose.

4 When you're ready to write, pencil in erasable guidelines to insure that your lines are horizontal and evenly spaced. Or, you can slip a ruled template marked with a bold marker inside the envelope that allows you to see the lines (photo 1). If you wish, you can work on top of a light box to aid you in seeing lines through heavier paper.

5 Refer to your list of addresses, and carefully letter each envelope (photo 2).

6 If you're addressing artistic envelopes, make sure the address is written clearly with simple lettering. Hand-lettered envelopes can't be scanned and sorted by the post office's modern equipment and must be read individually. Use Arabic numerals and capital letters for the state's abbreviation. The zip code is essential and must be clearly written. Leave room at the bottom for the post office to attach a barcode that can be easily removed by your recipient. Embellish the letters as you wish, keeping legibility in mind (photo 3).

7 If you're concerned about dampness from handling in shipping, use waterproof ink or spray envelopes lightly with a fixative before mailing them.

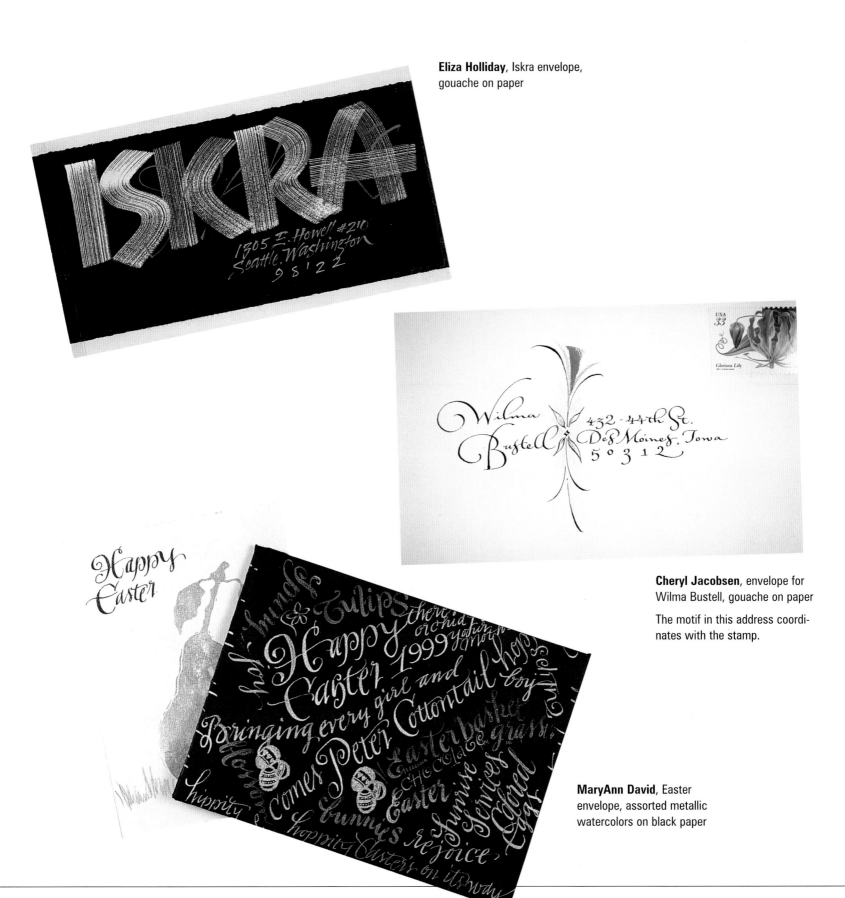

Eliza Holliday, Iskra envelope, gouache on paper

Cheryl Jacobsen, envelope for Wilma Bustell, gouache on paper

The motif in this address coordinates with the stamp.

MaryAnn David, Easter envelope, assorted metallic watercolors on black paper

Making cards is one of the most rewarding ways to use new skills and experiment with writing tools. Create a special card for a particular occasion, or letter a batch to have on hand.

Colored lettering livens up any design. In this card project, we'll show you how dropping ink or watercolor into wet ink puddles can lend dramatic effects.

MATERIALS AND TOOLS

Scraps of paper for experimentation

Scissors or craft knife and cutting mat

Metal ruler

Ruling pens or other pens of your choice

Pointed brush

Brown or black ink

Heavy-stock colored paper

Watercolor paper, text-weight paper, or other paper that will readily accept ink

Metallic inks, bottled ink in various colors, or watercolors

Frisket (medium that resists water-based paints)

Pointed brush

Eraser or rubber cement "pickup"

Glue stick

Photo 1

INSTRUCTIONS

1 On scrap paper, practice writing your greeting in a number of styles. Think about the overall shape of the word (photo 1).

2 Determine the size of your card based on your envelope. Then cut or tear the colored paper into a piece that, when folded, is slightly smaller than your envelope. Cut or tear a piece of watercolor paper to be mounted on top. The size that you choose should leave a colored margin around the edges.

3 Choose your final design, and prepare to write it on the heavier paper. We wrote our greeting with a ruling pen and brown walnut ink (photo 2). To make the special effect shown, use a pointed brush to drop touches of metallic inks onto the wet letters (photos 3 and 4). You can use concentrated walnut ink, or dilute it so that more of the colored inks are allowed to dominate.

Photo 2

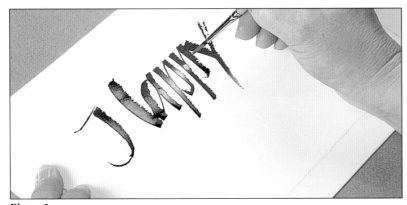

Photo 3

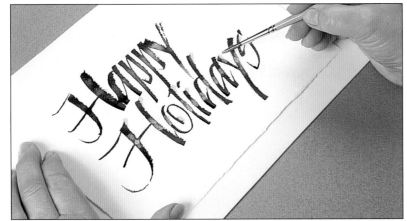

Photo 4

4 This is just one example of a technique that produces great effects. Experiment with other color and media combinations. For example, bottled inks or watercolors can be dropped into letters made with diluted color. In the example shown on page 126 that says "Thinking of You," we began by writing the word with very lightly pigmented water before dispensing and dropping in the various colors (photos 5 through 8). As you do this, make sure the puddle stays wet— you may only be able to write a few letters at a time. Use a pointed brush to drop concentrated paint into the puddle, pushing it gently into the hairlines and serifs of the form. Use more color than you think necessary, since the paint dries considerably lighter.

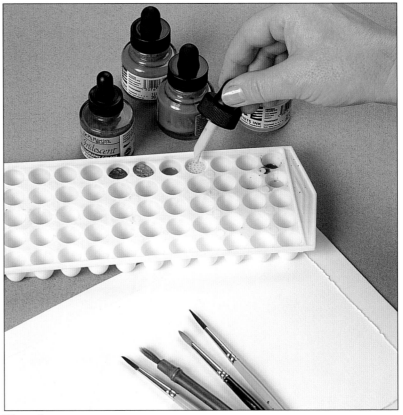

Photo 5

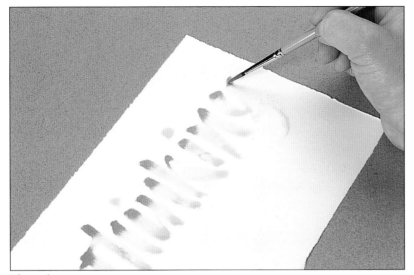

Photo 6

Photo 7

Photo 8

5 In another example shown on page 126, a ruling pen and liquid frisket was used to write the name "Steve" (photo 9). After the frisket dries, apply color around the letters. To do this, brush the lettered surface with water, then drop watercolor washes into the spaces between the letters. Allow the paint to dry. Remove the frisket with an eraser or a rubber cement "pickup" (photo 10).

6 Use a glue stick to mount the painted piece on the card. As a finishing touch, you can sew decorative lines of stitching around the edges of the piece, or use a gel pen or other monoline pen to create a decorative border.

Photo 9

Photo 10

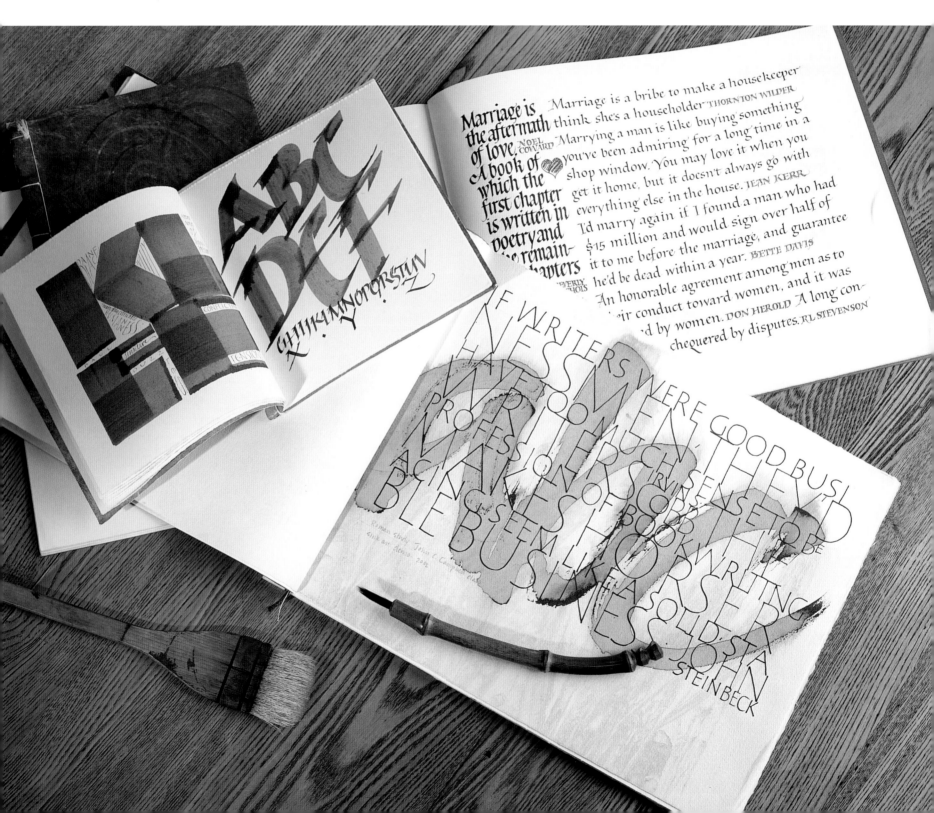

Nice lettering makes any journal or scrapbook more meaningful. Whether you write with a tidy print script or a loose, flowing cursive, your handwriting is a part of your artistic expression.

Plan the layouts of your journal or scrapbook lettering to coordinate with illustrations or photos.

Journal pages by Lorinda Moholt, handwriting and watercolor illustrations

MATERIALS AND TOOLS

Loose sheets of paper that readily accept ink (for binding later), or a commercial journal or scrapbook

Variety of lettering, drawing, and painting tools

Heavy paper (for template)

INSTRUCTIONS

1 If you're using loose sheets of paper for your journal or scrapbook, binding the book after it's done is a traditional approach that gives you more latitude to work on the single sheets. It's also more forgiving if there's something you decide you want to leave out. You can also work in a blank bound book. If you use a readymade book, try to find one that opens out flat so that the spine doesn't inhibit your hand.

2 When you buy or make a new journal, test the paper to make sure it can handle the inks and writing tools you want to use. For instance, a ballpoint pen will work on more kinds of paper than broad-edged pens, and watercolors need a heavier weight paper to avoid buckling. In general, check any papers you use to make sure that your lettering inks don't bleed into them.

3 Decide whether you want a standard page layout for each page, or whether you want the text to meander through visual elements such as drawings or photos. If you want text to appear in the same spot throughout the book, you can cut out a template from heavy paper that has a window the size of the text area. Use it to trace the shape of the area before lettering it.

Opposite page, clockwise: Journal pages shown in upper left corner by Carol Pallesen; others by Annie Cicale

Two journals by Lorinda Moholt, handwriting and watercolor illustrations

KEEPING A JOURNAL

The subject of your journal is entirely up to you, but it helps to focus on one aspect in any given book. Once you've begun a journal, compile all the bits and pieces as you go along, adding illustrations, photos, collaged images, and so forth.

Learning to know when you're done is just as important as starting. A journal from a trip, for instance, will have a more obvious conclusion than ongoing studies of design. When you're done, fill in the last page, date and sign the book, and move on to the next one.

Journal pages by Sharon Zeugin, mixed media

Carving Alphabet Stamps

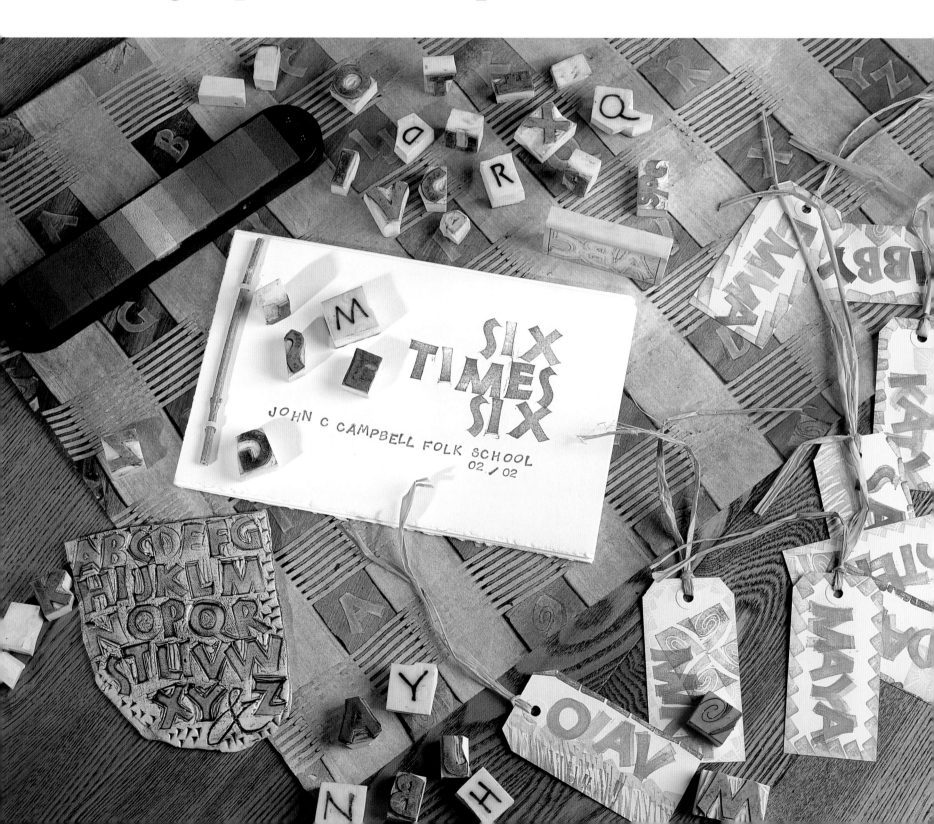

Carve a monogram or an entire alphabet! Rubber carving blocks are easy to carve. They also maintain a crisp line quality that's ideal for the precision of lettering.

These stamps can be used to print with a variety of media, or they can be used to emboss surfaces such as wet paste paper, clay, or polymer clay. Choose a bold face, such as Neuland (used here), with forgiving proportions that allow for slight slips of the knife. (Delicate shapes, such as a swash Italic alphabet, can end up looking clunky and awkward.)

INSTRUCTIONS

1 Trace around the carving block to determine the size so that you can figure out how to best arrange and carve your letters from it. (This alphabet, for instance, required five large blocks.)

2 Place the letter design facedown on the eraser (photo 1). Use the xylene-based marker to transfer the photocopy to the eraser. (Make sure you have plenty of ventilation while using this marker.) To transfer a pencil-drawn image, place it facedown on the block and burnish the back of it with your fingers to transfer the lead.

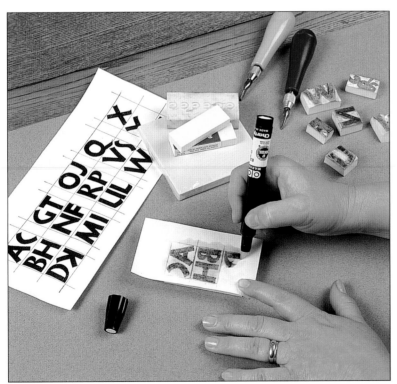

Photo 1

Photo 2

Photo 3

3 When you carve, keep your non-dominant hand behind the knife blade for safety. Use the finest V-shaped gouge in your carving set to outline the forms, keeping the edge of the V on the edge of the line, not centered over it (photo 2). Go around each form twice with this fine gouge, cutting slightly deeper the second time.

4 Use a U-shaped gouge to carve away the background so that the letters are elevated (photo 3). If you want these background lines to show partially in your printing, pay attention to the direction of the cuts so they enhance the design. If you don't want any background lines, carve away more of the material. Keep a rubber stamp pad handy to proof the design often. When satisfied, label the back of the stamp with a permanent marker, showing the name of the letter and an arrow indicating the top.

5 You can use rubber-stamp inks on pads (photos 4 and 5) or relief printing ink to print your design directly onto paper. Each has slightly different characteristics. There are many varieties of stamping inks: dye-based, pigmented, water-based, and permanent. Choose one that fits your project, and experiment with different ones. Printmaking ink is more opaque and creates a highly graphic effect. To use it, roll a thin layer of ink out with a printmaker's brayer on a sheet of glass, and roll it onto the raised portions of the stamp. Place your paper on top of the stamp and burnish it with a spoon or other tool to transfer the ink.

6 If you want to use your stamps to emboss a surface, paste paper is a popular option. While this paper is wet, you can use carved stamps to leave indentations of words and patterns. Polymer clay can be rolled out and stamped as well.

Photo 4

Photo 5

Carol Pallesen, card printed from
design using carved stamp

Photo Calendar

Collect snapshots taken during the year and use them to make a calendar for family or friends.
The handwritten calendaria (days of the month) are photocopied onto cover-weight paper, and the names
of the months are written directly onto the calendar.

MATERIALS AND TOOLS

Basic design tools: pencils, T-square, triangle, ruler

Ink

Pens

Layout paper

Fine monoline pen

Low-tack artist's tape

Light box (optional)

Sheets of semi-translucent tracing vellum (for master pages)

Cover-weight paper, cut to size of calendar pages

Piece of artist's board or mat board

Craft knife, metal ruler, and cutting mat

Designer's gouache

Gum arabic

Pointed brush

Glue stick or double-sided tape

Photos of your choice

Paper hole-punch

Heavy colored paper for front and back cover

36 inches (.9 m) of satin cord for each calendar

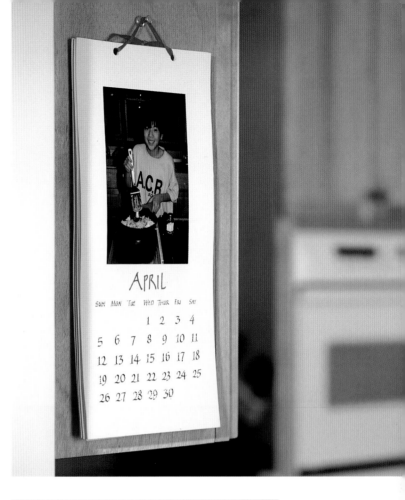

INSTRUCTIONS

1 Choose a size and format for your calendar. If you're using both horizontal and vertical photos, as we did, plan a design wide enough to accommodate both. You'll need to allow spaces for the names of the months, room for photos, and a rectangle for the calendaria. Our template measures 6½ x 13 inches (16.5 x 33 cm) and is drawn to accommodate both vertical and horizontal 3½ x 5-inch (8.9 x 12.6 cm) photos. The days are blocked off by ¾ x ⅝-inch (1.9 x 1.6 cm) boxes (photo 1).

Photo 1

Photo 2

Photo 3

Photo 4

2. Use layout paper and a fine monoline pen to make your own template. Draw a grid that contains seven columns and six rows. Six rows will keep you from having to compress the last few days of months that begin on a Friday or a Saturday.

3. Make tabs from bits of tape to hold the layout paper in place in preparation for writing the numbers. Position the template on the light box, and then place a piece of semi-translucent paper over it.

4. Write the numbers in ink or gouache on each vellum master page (photo 2), beginning with a different day of the week for each one. You'll make seven masters (photo 3).

5. Decide how many calendars you want to make. For each one, cut 12 cover-weight sheets of paper to the size of the template.

6. Reference your calendar for the coming year and make photocopies of each master page on the coverweight sheets. As you do February, April, June, September, and November, use a piece of white artist's tape to cover the unneeded numbers (photo 4).

7. Experiment with possible lettering styles for the names of the month (photo 5).

Photo 5

8 For help with the placement of both the photos and the names of the month, cut a piece of artist's board or mat board to the size of your template. Mark off the area for the photo, and cut out a section of the board with the craft knife. (The section shown in photo 6 is cut to accommodate both vertical and horizontal photos). On this same cardboard template, rule guidelines showing the placement of the top and bottom of your letters and the descender line. Use the template to assist you in marking pencil guidelines on the calendar pages.

9 Use designer's gouache to write the name of each month (photo 6). This medium lends a matte appearance and gives good coverage, even when you dilute it to flow more easily through your pen. Squeeze out about ¼ inch (6 mm) of gouache from the tube, and add a drop of gum arabic (photo 7). Mix well, adding just enough water to make a creamy fluid that flows easily from your pen (photo 8).

10 Use a pointed brush to load the ruling pen with gouache, and letter the names of the months on the calendar pages. Allow these to dry, and erase any guidelines.

11 Attach the photos with glue or double-stick tape, using the board template as a guide for placement (photo 9). Punch holes in the top of each page at the same spots for holding a satin cord.

12 Cut a front and back cover from heavy colored paper and add punched holes. Use a craft knife to cut a hole to reveal the first photo of the year. Use gouache to write a title for your calendar on the cover.

13 When all pieces are dry, string them together with the length of cord and tie it in a bow in the front, leaving it loose enough for the pages to be turned.

Photo 6

Photo 7

Photo 8

Photo 9

Flourished Guest Book

Create this beautiful accordion book to record the names of guests at a wedding or other occasion. You can adapt it for certificates, resolutions, or any document honoring a person or event.

The Italic hand, with its inventive swashes and flourishes, lends our book a formal look. The modern scribe uses these embellishments to dress up an otherwise straight-forward design. The first section of the project takes you through the steps of preparing the text block, and the second portion on page 146 tells you how to make a simple binding.

MATERIALS AND TOOLS

Basic design tools: pencils,
* T-square, triangle, ruler*

Layout paper

Ink or gouache

Pens in various sizes

Glue stick

Text-weight 100% rag paper/PH neutral

Ruling pen

Pointed brush

INSTRUCTIONS

1 Type up a copy of your text, making sure that all the spellings of any names, locations, and so forth are correct. Double-check any dates. Consider how much room you'll need to leave for guest signature.

2 Write out the text in pencil to get a feel for its grammatical structure. Break it up into phrases, and do a number of thumbnail sketches, experimenting with both vertical and horizontal formats. If you'll be including a seal, logo, or other decorative element, plan its size and location.

3 From layout paper, cut out a prototype in the size of your final text portion. (Our accordion book began with a 25½ x 20-inch [64.8 x 50.8 cm] sheet of handmade paper cut into two 25½ x 10-inch [64.8 x 25.4 cm] strips.)

4 Work up a few of the thumbnails that you did earlier into rough drafts on layout paper (photo 1). Experiment with different contrasts in your lettering, varying the style, weight, height, color, or combinations of these attributes.

Photo 1

5 Experiment with your pens, trying a number of different sizes to get the text to fit the space. Decide on the exact style of lettering you want to use, keeping in mind that slight changes in weight, line spacing, and color can make a big difference in the overall balance of the design. The longer portions of text will most likely be written in a straightforward style, but you can use more decorative or laborious styles for names or places. If you wish, cut up the various pieces of your drafts, and use a glue stick to paste them into a final comp (comprehensive layout).

6 To add flourishes to the text, look for words with ascenders and descenders. Practice these on separate sheets of paper (photo 2). Cut and paste the best ones onto your rough draft.

7 Determine the grain of the final text-weight paper. Cut or tear the paper into sheets so the grain runs parallel to the book spine.

8 With your rough draft as reference, use a pencil to rule your text weight paper in preparation for writing, making a note of where the folds will fall. Allow a ½-inch (1.3 cm) margin at one end for the gluing tab.

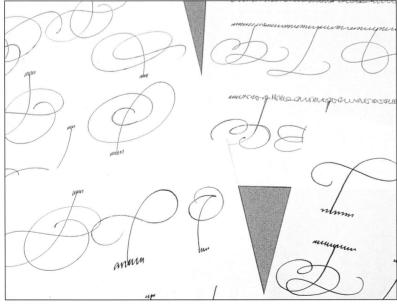

Photo 2

9 After ruling guidelines on your paper, warm up, and begin to write. It helps to write all the lettering of the same size at once before adding the other sizes. Use a cover sheet to protect writing underneath your hand.

10 Carefully pencil in any flourishes before inking them. Although you want them to look as if they're done quickly, with a single pen movement, you'll probably have to break them down into separate strokes as you would letters. Draw them with the pen, joining them at the hairlines to make them flow smoothly. It may be beneficial to rotate the paper as you add flourishes that fall at the top of the page.

11 To rule signature lines, square the artwork on your drawing board and measure carefully. (As a general rule, allow about ½ inch [1.3 cm] of vertical space for each signature, and a width of about 3 inches [7.6 cm]. You can adjust this amount as your space allows.) Rule vertical lines with your triangle to define the column widths.

12 Use a pointed brush to load the ruling pen with ink or gouache (photo 3). Make a few marks on scratch paper to adjust the width of the line and judge the ink flow. Hold the straight side of the ruling pen against your T-square and rule the lines. Don't allow any ink to creep underneath the ruler (photo 4). Allow the ink to dry.

13 Erase the guidelines and add any logos, seals, or illustrations.

14 Fold the gluing tab down. Then configure the strip into an accordion by folding it in half and bringing the ends to the middle to make four pages (figure 1, photo 5). Glue the tab onto the next strip to make a continuous book, aligning the edges carefully. This becomes the text block, to which you will add the cover.

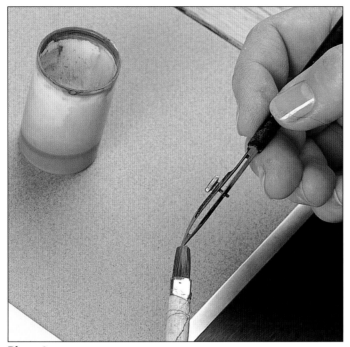

Photo 3

Fig. 1

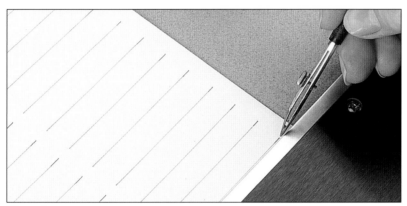

Photo 4

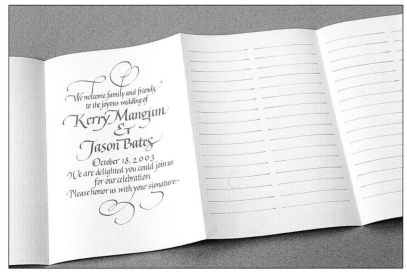

Photo 5

Making a
Soft Paper Binding

This simple binding accommodates a book that has only a few pages. The following directions are for general purposes and can be applied to many books, including the accordion book or the single signature book on page 178.

MATERIALS AND TOOLS

*Handmade paper with floral inclusions
 or other decorative paper (for end papers)*

Triangle

Cork-backed ruler

Craft knife

Awl

*Needle with an eye just large enough for
 your thread (tapestry or embroidery)*

Linen thread or pearl cotton embroidery floss

Bone folder

*Asian silk paper or other decorative paper
 (for cover)*

Bristol board or equivalent (for cover boards)

Glue stick, wheat paste, or PVA glue

Scrap paper and old phone book (for gluing)

Wax paper

Yard (.9 m) of ½-inch (1.3 cm) ribbon

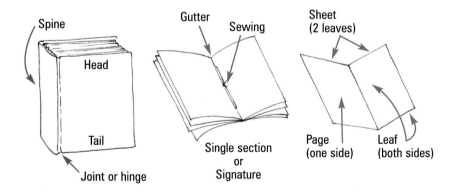

Fig. 1

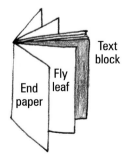

Fig. 2

INSTRUCTIONS

1 Before beginning, study figure 1 for an overview of the various parts of a book.

2 Measure the text block (figure 2), recording the height (H), width (W), and thickness (T). Cut two pieces of decorative paper for the end paper and fly leaf with the dimensions of H x (2W + T).

3 You'll use a butterfly stitch (figure 3) to sew the end papers and the text block. If you're assembling an accordion book, you'll sew only the first fold in the book. Cut a piece of scrap paper and fold it to fit into the gutter of your text block. Mark the paper with dots for

Fig. 3

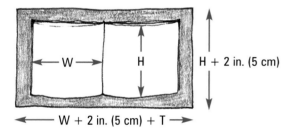

Fig. 4

placing your stitches, and use them as a guide to punch holes with the awl for the purpose of sewing the text block (photo 1). Use a needle and thread to sew the signature together (photo 2).

4 At this point, you can trim the text block and end papers if you wish to have a smooth top and bottom for your book (you can also leave torn edges). To trim it, square up the text block by holding your triangle against the spine and draw a light pencil line along first the top of the book and then the bottom. Place a cork-backed metal ruler over these lines, and draw a craft knife against it to remove the excess paper. Your knife must be very sharp to cut through the paper, so use a new blade. Use only enough pressure on the knife to cut the paper—too much will cause tearing, resulting in an unsightly edge.

5 Open the text block, and place it on top of the cover paper (figure 4). Cut the paper, leaving an inch (2.5 cm) margin on top and bottom and a bit more than this on the sides, since the cover must wrap around the closed book later.

Photo 1

Photo 2

Fig. 5

Fig. 6

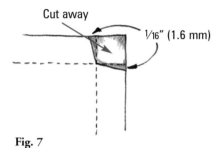

Cut away

1/16" (1.6 mm)

Fig. 7

Fig. 8

Slits

Fig. 9

Fig. 10

Fig. 11

Paste direction

End sheet

Scrap papers

Fig. 12

6 On the cover paper, use the bone folder to score fold flaps on the top and bottom of the paper for the head and tail of the book, allowing an extra 1/16 to 1/8-inch (1.6 to 3 mm) beyond the dimensions of the text block (figure 5). Make sure the folds are exactly parallel. Unfold the flaps. Next, fold the fore-edge on the front cover, allowing the same lap width (L) as on the head and tail (figure 6). Wrap the cover around the text block to determine the position of the lap fold on the back cover. Score and then fold the back lap width. Trim this back cover to match the other lap widths.

7 Cut miters for the corners according to the diagram (figure 7). Trim out the corners just beyond the fold lines. Fold the flaps back over and find the center of the overlap by positioning a ruler along the corner and through the junction of the flaps (figure 8). Mark each center with a pinhole. Open out the flaps, lay a ruler along the two pinholes, and cut slits as shown—one to the inner corner and one to the edge of the flap (figure 9). Interlock these slits to make a mitered corner with the flaps inside (figure 10).

8 Use a bone folder to score folds along the spine; one if the book is thin, two if it is a little thicker (figure 11). To make the cover more substantial, you can cut two boards to fit inside the cover paper on either side of the spine. Use Bristol board, museum board, watercolor paper, or other thick pH-neutral paper. Cut the boards to the height of the text block and about 1/8 inch (3 mm) less than the width of the text block.

9 Slip the boards under the flaps (photo 3). A dot of paste or glue will hold them in place while you assemble the book.

10 Next, you'll paste the text block into the cover. To do this, run a ¼-inch (6 mm) line of wheat paste or glue along the head, tail, and fore-edge of the end paper of the text block—on the outside—guarding with scrap paper (figure 12). Align with the cover, and paste in place. Burnish with a bone folder.

11 Turn the book over, run paste or glue along the edges of the other side, and then paste it to the cover, again aligning carefully (photo 4). Slip sheets of waxed paper between the text block and the cover to prevent paste from oozing onto the pages and gluing the book shut.

12 Press the book overnight under a stack of heavy books.

13 Tie the book closed with a length of ribbon.

Photo 3

Photo 4

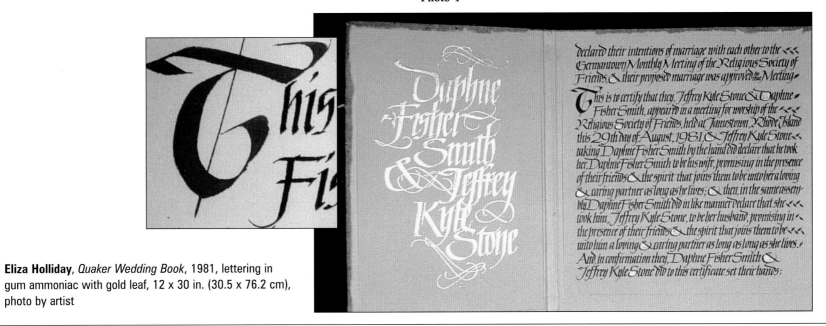

Eliza Holliday, *Quaker Wedding Book*, 1981, lettering in gum ammoniac with gold leaf, 12 x 30 in. (30.5 x 76.2 cm), photo by artist

Printed Invitation

After learning a few styles of writing, you can apply your skills to making an invitation to a party or other event. Two or three hand-lettered copies might seem simple to do, but writing more than that will leave you grateful for the invention of the printing press!

The steps of this project teach you how to design and prepare artwork for the printer. These general processes apply to all of the printing methods described on page 155. Our invitation was done with offset printing.

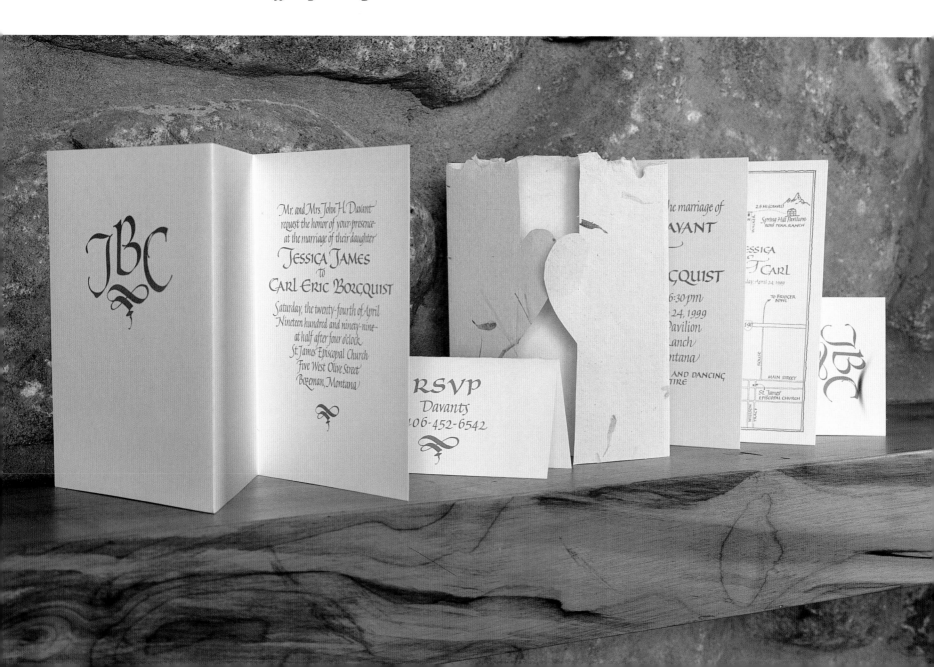

Basic design tools: pencils, ruler, T-square, triangle

Layout bond paper

Ink or gouache

Pens of your choice

Proportional scale (optional)

Paper for final draft (good grade of drawing vellum, 100% rag text/paper, watercolor paper, or blue graph paper made for calligraphy)

Non-reproducing blue pen or pencil

Bleed-proof opaque white paint

Small pointed brush

Craft knife (optional)

Illustration or Bristol board

Glue stick or spray adhesive

Tracing paper

INSTRUCTIONS

1 Type or write out the copy for the invitation or other piece. Double-check all the details (who, what, when, where). If you need to run the copy past someone else for confirmation, do so at this point. Look for images, such as drawings, photos, or other copyright-free art that relate to the content of the piece. If it's a formal event, go ahead and look at papers and coordinating envelopes at your printer. The envelope will determine the size of the finished piece.

2 To determine the printed size of your piece, use the envelope's dimensions minus a comfortable margin that allows the piece to slide in easily. You don't want to struggle while stuffing lots of envelopes!

3 When you create the lettered artwork for your piece, work larger than the final printed version. Not only does this make it easier, but when the piece is reduced in preparation for printing, the lettering will get tighter. Outline the piece's actual size on the lower left-hand side of a piece of layout bond paper. Draw a diagonal from the lower left-hand corner (O) of the shape to the upper right of it (X). Then, continue this line beyond until you reach a comfortable size for working (A) (figure 1). Draw connecting lines to create a larger shape that is proportional to the size of your printed piece.

Fig. 1 Size of reproduction Size of original

Photo 1

Photo 2

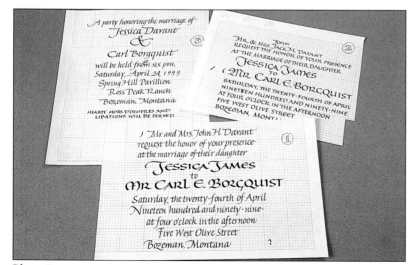

Photo 3

4 You'll need to tell the printer the reduction amount needed for your artwork. To get this number, you can use a proportional scale (photo 1), or compute the math yourself. To do this, divide the size of the final printed piece by the size of the original artwork and multiply it by 100 percent. For example, let's say you're planning a printed card that will measure 5 inches wide (12.7 cm) by 7 inches high (17.8 cm). As you create the original artwork in a comfortable format, you find that your longest line of writing is 8 inches (20.3 cm). You want to leave a margin of an inch (2.5 cm) on either side of your block of writing, so that means that you need 10 inches (25.5 cm) of width to work in. Divide the finished size by the working size, using the formula described above, and you'll get the following:

Percent reduction: 5 in. ÷ 10 in. = 0.50 in. x 100% = 50%

(12.7 ÷ 25.4 cm = 0.50 cm x 100% = 50%)

To determine the height that you need to work within to create the artwork for reduction, divide the final height by the same percentage:

Final height: 7 in. ÷ 0.50 in. = 14 in.

(17.8 cm ÷ 0.50 cm = 35.6 cm)

5 After you work through a series of thumbnails (see examples in photos 2 through 4), work up a more definitive version in a box that is the actual size of your piece. You can try out your design both horizontally and vertically.

Photo 4

6 Continue to develop a rough draft until you determine the pen sizes you'll need. Cut apart the lines of writing, and paste them into final position on another piece of layout paper, adjusting the line spacing if needed. Add any images you plan to include to make a comprehensive layout. Proof carefully at this stage, and run the design by any others involved for confirmation.

7 Although your printer can print from a pasted up version of your artwork, it's recommended that you write it one more time to guarantee the most fluid writing and the best possible printing job. This is called the mechanical and contains all the material to be reproduced, as well as directions for areas that require special attention.

8 You'll write directly on a final ruled sheet to produce your mechanical. The paper you choose can render smooth letters (such as vellum or rag text) or raggedy-edged letters (such as watercolor paper). Keep in mind that the actual surface of the paper will disappear when reproduced. Rule guidelines on your paper with a non-reproducing pen or pencil. The light blue color will drop out of the artwork on commercial printing plates and on most photocopying machines if you don't rule the lines too heavily. Another option is to draw up your final on graph paper made for calligraphy. The grade of this paper is good and takes ink well.

9 Minor corrections to this final piece can be made with bleed-proof opaque white paint and a pointed brush. You can also cut out letters of misspelled words with a craft knife and add a correction. After corrections, take your design to the printer or copy shop to have it reduced to size for your final layout (photo 5).

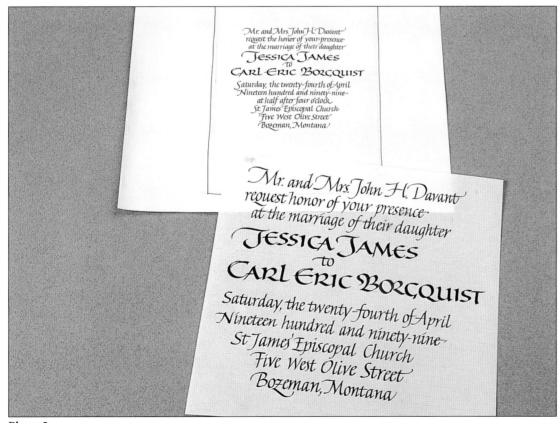

Photo 5

Photo 6

10 Mount the pieces of the design with glue or adhesive on a piece of illustration or Bristol board (photo 6). Tape a piece of tracing paper over the top, and write any specific directions for the printer. Point out areas to be printed in a second color. Label areas for a photograph or artwork that the printer will place into the final film, or areas where the exposure is especially crucial. Tape a heavier piece of paper over the board to protect your artwork.

11 Proofread the piece again; it is important at every stage of the process. If you're creating the piece for someone else, make sure dates haven't been changed and all details are correct before you commit to the printing.

12 When you take the project to the printer, provide the following information *in writing*:

• Your name, telephone number, and e-mail address

• Name of project

• Date ordered

• Date needed

• Quantity

• Reduction (if not done already)

• Dimensions

• Paper

• Ink color(s)

• Special instructions for folding, binding, and so forth

Explain everything to the printer verbally, as well. If the job is complex, you can request a blue line, a proof of the printing plate showing the color separations. If your piece has more than one color, you may want to be present at the beginning of the printing to approve final ink color and coverage. In the case of most small jobs, this isn't necessary, but the experience of watching your artwork transformed from your mechanical to final printed page will teach you a lot for your future projects.

Printing Methods

There are a number of printing methods to consider based on the number of pieces you're printing, the quality you need for the job, and the number of colors you plan to use. Price is a factor in all of these, and you'll have to decide what your budget allows before beginning your design. Check the business section of your phonebook for printers in your area. Ask them what they'll need from you in terms of *camera-ready artwork*—work that will be reproduced exactly as you provide it to them. Shop around for the most reasonable price on a job with a printer who understands and respects hand lettering and will treat your project with care. Go the print shops that you're considering and look at samples of the work that they do in order to gauge the quality of their work.

After you've decided on a printer, choose the type of paper you want to print it on, the number of copies, and ink colors. Tell the printer in advance about any special processes, such as adding a photo or reducing a portion of the design, as well as any bindery work, such as folding, cutting, stapling, or gluing. If you need additional design work done, such as supplementary photos or typography, ask about that as well.

Traditionally, calligraphers have had a choice between letterpress, offset printing, silk-screen or serigraphy, or photocopying. Today, artwork can be also be scanned into a computer and printed on a laser or ink-jet printer. Each of these methods has its advantages and disadvantages. Read below for a description of each to guide you.

Letterpress: A process in which a metal relief plate is made from the artwork, giving your work a look reminiscent of late 19th- and early 20th-century printing. Printed on high-quality paper, letterpress is often used for bookplates, fine invitations, and poetry. Most letterpress is done from handset type, but your fine writing and any photos can be photographically transferred to make the plate. Because the paper is pressed onto the plate, a faint indention is left that lends a rich look to the work.

Offset printing: The most common form of reproduction. In general, there are two grades of offset printing: one from metal plates and one from paper or plastic plates. Metal plates are used for printing large quantities (long press runs) and will reproduce fine detail in artwork and photos. Paper or plastic plates are used by "instant" printers and are good for one- or two-color printing jobs with shorter runs.

Silk-screen/serigraphy: This technique is used to print bold areas of color onto paper, fabric, or any other surface that won't go through a printing press easily. A stencil is made on a stretched piece of silk, and special ink is forced through the openings with a squeegee. Multiple colors require separate screens and precise registration. This is the most common method used for printing T-shirts (see example on page 163).

Photocopying: Also known as *xerography*, this process doesn't accurately reproduce the grays of a photograph but can be effectively used to reproduce most black-and-white artwork. Color copying, although quite expensive, is an excellent way to reproduce artwork if you only need a few copies. To save on the cost, you can gang images on a master sheet and cut them apart afterwards.

Computer technology: You can now design and print your own pieces from start to finish with a computer, its accompanying equipment, and appropriate programs. Scanning images into a computer allows you to adjust type around them and make corrections and adjustments. Once the artwork is prepared, the final printing can be done by any of the processes noted above, or on an ink-jet or laser printer attached to the computer.

Drawing and Lettering a Map

Maps provide a visual image of a landscape. Whether they're created for the purpose of helping travelers find their way or to document a place in time, they present you with unique design opportunities.

You can make an original map to be framed, or one that can be printed in multiples from a mechanical. The initial stages of the design process are the same, but the original map will require a final rendering on good paper. The camera-ready map can be done as a paste-up mechanical. The differences between these two processes are explained in this project.

MATERIALS AND TOOLS

Basic design tools: pens, pencils, T-square, triangle, rulers

Resource map or blueprint of property for your design

Illustration resources

Large sheet of high-grade tracing paper

Graphite transfer paper

Non-reproducing blue pen or pencil

Ink or gouache

Large tracing vellum for final map (for reproduction)

*Watercolor or other heavy paper
 (for original map, not for reproduction)*

*Drawing tools such as technical pens, graphic designer's
 monoline markers, or crow-quill pens*

Correction fluid or opaque white artist's paint

Watercolor, colored pencils, or other colored media (optional)

Photo 1

INSTRUCTIONS

1 Find an accurate map—a road map, government map, atlas, architectural blueprint, or an aerial photograph—to use as a basis for your map. We used a blueprint as our reference (photo 1). Many maps are copyrighted, so you can't copy them in any form. If your source is copyright-protected, ask the publisher for permission to use it.

2 Think about what you'd like to include and what you'd like to leave out on your version of the map. Start by determining the important landmarks, such as roads, rivers, towns, and boundary lines that help viewers orient themselves, leaving space for design elements that make your map special. Trace the main components on a large sheet of tracing paper (photo 2 on page 158). You can use a light box underneath the papers or graphite transfer paper for this purpose.

Design Tips for Map Components

• The neat line is a boundary around the map's edge. It can be made with a single line or a more complex border. It indicates to the viewer that roads and rivers continue beyond it, rather than trailing off into nowhere. You can use it as a design opportunity by incorporating patterning or illustrations. You can also incorporate a scale of miles/kilometers, a location grid, or latitude/longitude information.

• As you label landmarks, use a consistent system—each of the following labels should have its own style of lettering:
Points, such as those indicating towns, should be labeled in available space beginning to the upper right of the point, moving counterclockwise around the point as the room allows. Be consistent to avoid confusion.

Areas, such as those indicating counties or landmasses, should be labeled evenly across the available space. Because of the spacing, this is a good opportunity to add swashes and flourishes to some of the letters.

Lines, such as those indicating rivers and roads, should be lettered evenly along the line, spacing the letters as much as possible along them without compromising legibility.

• To indicate orientation, you can simply put the designation of "north" (N) and an arrow at the top of your map. Or, you can design an interesting compass indicating north, south, east, and west (NSEW) that relates to the map's style.

• A legend helps your viewer read the symbols on your map. Place it in a ruled box and include all the symbols you've used with descriptions. Include a scale of miles/kilometers or other distance designations. This can be transferred to the legend from your photocopy of the initial tracing.

• The map's title can be placed inside the legend box.

• Vary your text for different items, giving more emphasis to important areas. Use different styles, sizes, and colors to indicate the differences among landmarks. The population of different towns or cities is usually implied by the size of the letters. You can use different sizes of pens to indicate smaller to larger places.

Photo 2

Photo 3

Rock House FOLK SCHOOL ROAD
Little Rock To Brasstown To Murphy
Hubbell House HARSHAW ROAD
Hill House Keith House KEITH HOUSE
Campground Dining Hall
M Molton Gardens Craft Shop
History Center
New Building

Photo 4

3 Beyond that, you can personalize your map by selecting specific subject matter, such as stores, shops, churches, and other places. Research photos or other sources for the purpose of rendering them. Design your own symbols for the map, or use standard cartographic ones.

4 On the tracing paper drawing that you did in step 2, add words and drafts of illustrations in pencil to create a comprehensive layout, making sure that everything you want to include fits the available space. To check the look of the final size of your map, reduce or enlarge it on a photocopier (photo 3). The distances on the map will remain proportional, and you'll be able to render them accurately on the final version.

5 The next step is to transfer your rough draft to the final paper. You'll need to trace the main lines first. Use a non-reproducing pencil line to do this with the papers on top of a light box, or use graphite transfer paper to trace lines. Then you'll add the secondary components.

• If you plan have the map reproduced, use heavy vellum to produce your camera-ready mechanical. You can do your lettering, illustrations, and other detailed components on separate sheets of paper (photo 4) and paste them in place on the final copy. This method allows you to make them larger and then reduce them on a photocopier to fit your map. You can also paste up computer-generated symbols and other components. You'll probably do a map for reproduction in black and white, unless your budget allows for full color printing. Keep in mind that you can work up to three times larger than the final version, and then reduce your artwork. Be careful, however, that your lettering doesn't have too many fine hairlines, since these will drop out during reduction. If you're planning to print the map in one color, you can print from a very tidy pasted-up copy. Test it on a photocopier before taking it to a commercial printer. Correct any cut lines or stray marks by whiting them out with correction fluid or opaque white watercolor.

• If you're creating an original map (not for reproduction), you can use watercolor paper or a colored, textured paper that will enhance your design. Trace the major lines in pencil, and use pencil to lightly rule lettering guidelines, double-checking the alignment and space available for all the parts. You'll be doing the illustrations directly on this paper, so you'll pencil them in before finishing them.

Photo 5

FINAL DESIGN TIPS

To execute the final design, work in the following order:

• On your design with the main lines drawn in pencil, do any watercolor illustrations and washes first. Then write the lettering with a pen and ink of your choice, beginning with the words where the fit is most critical. You might want to use waterproof ink to cut down on possible smudges as you work.

• Use a technical or a monoline graphic pen for drawing in the final lines and very small writing (photo 5). These pens come in a range of widths that you can use to differentiate various kinds of borders, rivers, roads, or other elements. Rule straight lines with a ruler, and trace all the curved lines last.

• If you plan to add color with colored pencil to your map, add it after everything else is done.

Silk-Screened Pillow Design

Pillow designed by Liz Simmonds

Working with more than one color in a printed project requires the printer to make a color separation. Whether you're creating a design for offset printing or silkscreen, you can use many of the same processes. This pillow is a good example of a simple but eye-catching design, produced with a single piece of artwork. For this project, only one mechanical was needed, since none of the color areas touch at the printing stage.

MATERIALS AND TOOLS

Basic design tools: pens, pencils, T-square, triangle, ruler

Glue stick or spray adhesive (if doing paste-up)

Layout paper

High-quality drawing vellum or 100% rag text paper

Black ink

Opaque white artist's paint

Small pointed brush

Black monoline pen

Tracing paper

Colored pencils

INSTRUCTIONS

1 Design your piece, and then draw up your camera-ready mechanical on good paper, following the tips for this process in the map project on page 156. As with the map, you can draw the whole design directly on the paper (photo 1), or paste up various portions over drawn guidelines. Use opaque white paint as needed to correct mistakes. (In this project, the layout and sizing of the lettering had to be carefully planned, and the final lettering was done in black ink on white paper. A small pointed brush was used to do some of the lettering, and a monoline black drawing pen was used to do the very fine lettering.)

Photo 1

Photo 2

2 Position a sheet of tracing paper on top of the finished artwork that covers the whole piece. Use colored pencils to trace the lettering in the various colors that you want the printer to use (photo 2). Because none of the colors touch, the printer will be able to work from one piece of artwork, masking out areas that won't be printed on each separate color run. This marked piece will give you some idea of how your piece will look when printed (photo 3).

3 If you want more of a detailed idea of how the piece will look after printing, you can create a complete comp in color (photo 4). Seeing everything together, you can then make changes if you don't like some of the color combinations.

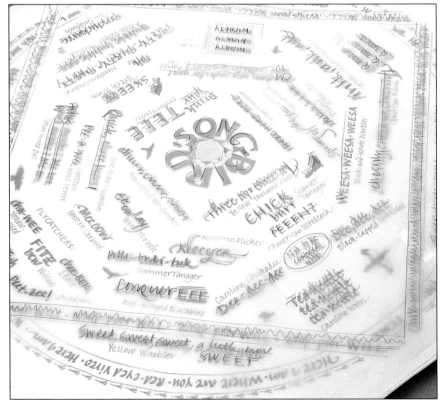

Photo 3

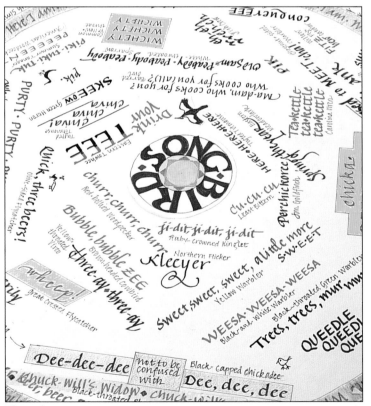

Photo 4

Screen-Printed T-Shirt Design

This calligraphic T-shirt is printed with a design that requires a more complicated mechanical than the pillow project on page 160. To create the overlapping design, two separate pieces of artwork were prepared: one for the lettering in the foreground and one for the decorative grid behind it. The two are combined through computer technology to form what is known in printer's jargon as a "knock out," as shown in photo 1 on page 164.

T-shirt designed by Annie Cicale and Pat Sheeler

Materials and Tools

Basic design tools: pens, pencils, T-square, triangle, ruler

Black ink or gouache

Smooth white paper

Tracing paper

Fine-pointed technical pen

Pointed brush

Opaque white artist's paint

Small pointed brush

Black monoline pen

Non-reproducing blue pen or pencil

High-quality white vellum

Illustration board for pasting up final artwork

Burnishing tool

Glue stick or spray adhesive

Sheet of acetate

Low-tack masking tape

Colored markers

Photo 1

Instructions

1 Plan the dimensions of your design (the border) that will be printed on the shirt. Our design is based on a horizontal, rectangular form. Do some thumbnails of your prospective design based on these proportions to figure out relationships between the background and the foreground lettering. You can then enlarge a developed draft to the actual size on a photocopier, and this will tell you the approximate size of your letters and other parts of your design.

2 To prepare the first mechanical for the top layer (as illustrated by "The Subtleties of Calligraphy" in photo 1), write out your lettering with black ink or gouache on smooth white paper. Write the words many times before preparing your final design. Carefully prepare a clean design. You can refine the letters further with a fine-pointed technical pen as well as a pointed brush and opaque white artist's paint.

3 To prepare the background mechanical, compose the letters on smooth white drafting vellum. (Our design is composed of a grid featuring variations of the letter "T". We combed through historical sources, magazines, and books for sources and invented others that we wrote on vellum.) To adapt our idea, cut out white squares or rectangles from vellum, and glue them in place on illustration board to form a grid on top of a painted black background.

4 Cut out the letters from the vellum and paste them inside the white shapes, carefully planning relationships between them (photo 2). A lot of retouching is possible at this stage. Use a fine-pointed pen alternately with a brush and white paint to clean up the forms (photo 3).

5 Once both mechanicals are finished, give them to the printer to scan. First, the layer with the letters will be photographically reversed. Then, the top piece will be used to make a knock out, a piece that shows a negative space on top of the background grid. (This section of the background, reflecting the outline of the first layer, will be blank when the background is printed. Then, the second layer will be printed in this area, filling in the lettering.) If you're computer savvy, you can make your own knock out. Ask your printer for details on the best way to do this, since each printer usually develops a process that works with his or her equipment.

6 After the knock out is prepared, glue the original artwork for the top layer to a sheet of acetate, and align it carefully over the base layer (photo 4). Tape it into place, and add registration marks for the printer to follow so that the alignment is perfect. The printer will photograph each layer to make the printing screens.

7 You'll also need to indicate colors for the printer. To work out colors, it's helpful to make photocopies of the artwork and use markers to test out color combinations (photo 5). Naturally, the color of fabric will have an impact on the color, so keep that in mind. Work closely with the screen printer to refine your color choices.

Photo 2

Photo 3

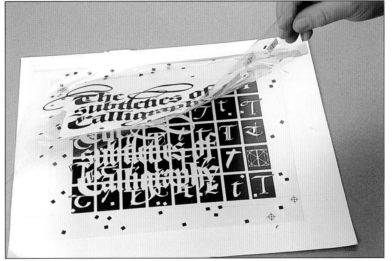

Photo 4

Photo 5

Lettered Frieze

A quotation, poem, or a series of names can be used to create a lettered frieze in any room you choose. We encircled the top of a library with the names of children's book authors and illustrators.

When choosing text for a wall frieze, you'll have to calculate the running space available. Allow some leeway in the planning, since getting all the words to fit exactly is difficult. We ranked the names on our list in order of highest to lowest preference, then used the ones that space allowed.

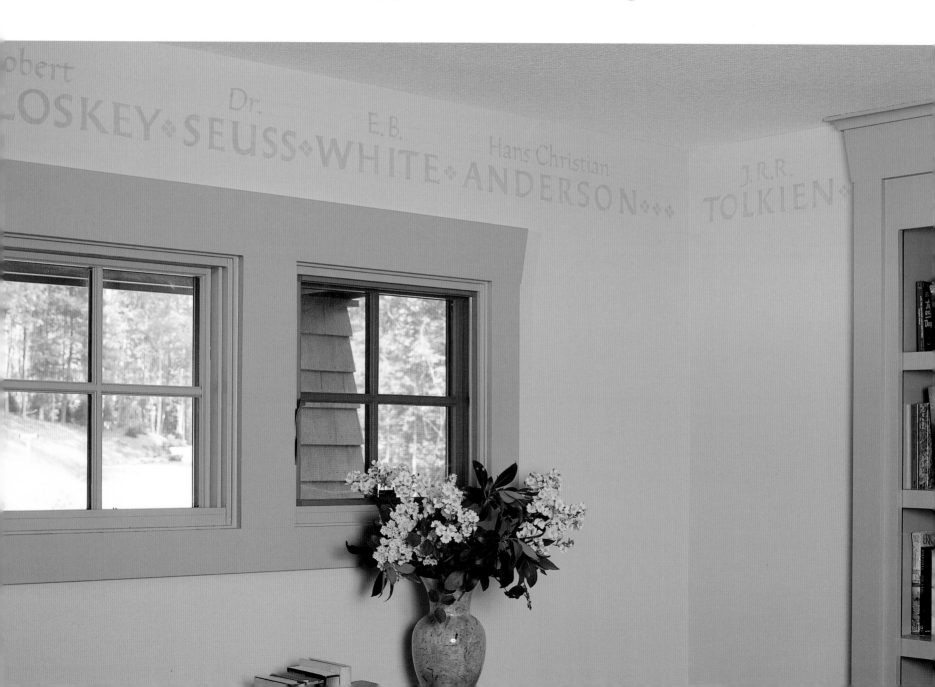

Measuring tape

Basic design tools: pens, pencils, T-square, triangle, ruler

Layout paper or other drafting paper

Roll of tracing paper or butcher paper

½-inch (1.3 cm) flat, nylon watercolor brush

Palette

Acrylic paint, or enamel paint with solvent

Low-tack masking tape

Long carpenter's level or long metal ruler

Carpenter's snap line (optional)

White eraser

Clean cotton rag

PAINTING BRUSH LETTERS

The flat brush can be used like a metal pen to make a variety of letter-forms, but it requires practice to control the flow of the paint and the forms of the letters. Use paint with enough body to maintain the shape of the brush, such as designer's gouache or acrylic paints. Sign painter's enamel works best for outdoor applications.

Paletting the brush is critical for painting letters. To do this, you need a container for your paint, a flat surface (palette), and a bit of water or solvent to keep the paint fluid. Begin by dipping the brush into the water, then into the paint. Bring the brush to the palette and work it back and forth until the edge is crisp and the paint is worked between the bristles.

Stroke the letter, working only until the brush begins to run out of paint. Palette the brush again, loading it with just enough paint for a few more strokes. This process may seem tedious at first, but it makes the difference between sharp letters and awkward ones made with an overloaded brush. Once the letters start to work for you, you'll get into a rhythm of loading the brush and painting that seems natural (photos 1 and 2).

Photo 1

Photo 2

Instructions

1 Measure and record the linear dimensions of the room that you plan to paint.

2 Draft small versions of the text you've chosen based on the overall effect you want to convey. You might choose letterforms that are refined or ones that are playful (photo 3).

3 Once you've sketched out and decided on the letterforms, plan the layout of the panels. Cut tracing or butcher paper to the length of each wall section, then lightly sketch in the letters to make them fit. These drafts will serve to warm up your hand and refine the letters you're planning to use. They'll also guide you in making templates for positioning the letters accurately.

5 If you're computer savvy, you can set the text in a font similar in proportion to the style of lettering you'll be doing (photo 4). (In our project, we used Galahad as a guide. Even though the final version of the letters is different, the proportions were helpful in creating the templates.) Use a photocopier to enlarge the computer-generated names or words to the size needed (photo 5).

6 From each template (sketched or computer-generated), you'll now paint drafts on paper that will prepare you for painting directly on the wall. These drafts will ultimately save you time. Paint the letters of each template (photo 6). Keep in mind that the end of the flat brush is soft, unlike a pen, so the trick is to learn to control the bristles as you paint.

7 At this point in the process, it's a good idea to apply a small bit of the paint you'll be using for your final letters to an inconspicuous place on the wall. To avoid overpowering the room, choose a color that contrasts minimally with the wall color while allowing legibility. Keep in mind that the paint value will change slightly after it dries.

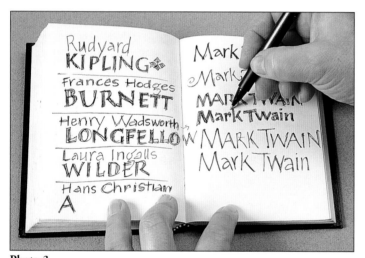

Photo 3

Photo 5

Photo 4

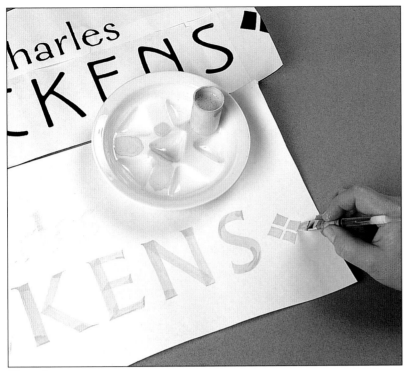

Photo 6

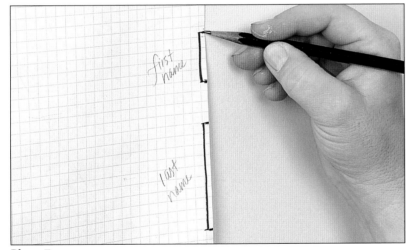

Photo 7

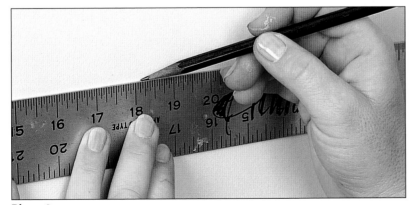

Photo 8

8 Next, make a paper ruler, marking guidelines from the ceiling down (photo 7). Check the alignment of the marks. Use the straight edge of your level or ruler to lightly pencil in guidelines around the room (photo 8). Back off from the lines as you work to make sure that they're straight and level, and use your paper ruler to keep measuring from the ceiling as you work your way around. If you have someone to help you, you can use a carpenter's snap line to make the lines with chalk instead.

9 Tape the templates directly beneath your guidelines around the room so that you can reference them as you paint.

10 Paint the letters directly on the wall, being sure to keep enough moisture in the brush to allow the paint to flow freely (photo 9). Palette the brush frequently to keep the chisel-edge. If you make a mistake, wash the acrylic paint off immediately with a clean, damp rag and repaint the area.

11 After the paint is thoroughly dry, erase the pencil lines. If you find mistakes after the paint dries, paint over them with wall paint, and repaint the letter or letters.

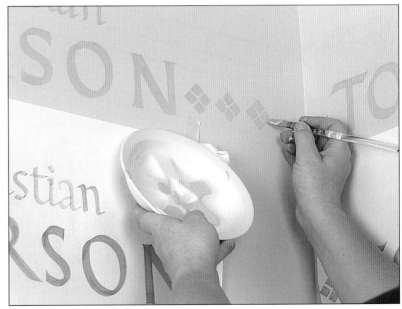

Photo 9

Lettering
a Mailbox

Once you've mastered brush lettering (see page 167), try your hand at painting your mailbox with lettering that can withstand the elements. If you want your delicate brushstrokes to last, you must begin with good paints. Sign painters use enamels made for this purpose—densely pigmented colors that require a solvent. Although you can use a standard lettering brush, a sign-painter's quill (a brush with long hairs attached to a handle with a bit of bird feather), gives you more control over the forms.

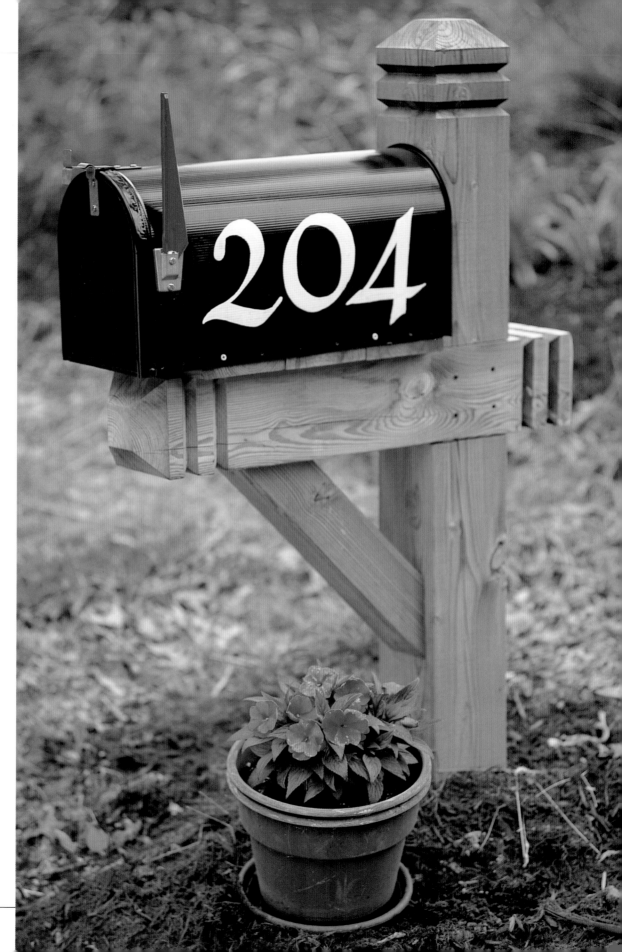

MATERIALS AND TOOLS

Pen, pencil, or marker

Clean metal mailbox

Pounce wheel (spiked wheel with handle that can be metal or plastic)

Towel or flat piece of foam

Masking tape

Small bag of carpenter's chalk made by tying up a bit of porous fabric with string

Sign painter's enamel in desired color(s) with solvent

Sign painter's quill

Photo 1

INSTRUCTIONS

1 Plan the letters or numbers that you want to paint by writing them a number of times with a pen, pencil, or marker. Notice how each shape influences the others. You must work to find a harmonious combination. For instance, note the placement of the crossbar on the number "4" in our design. Moving it up or down the stem influences the whole design (photo 1).

2 Enlarge your final design on the photocopier until it's the size you need for your mailbox (photo 2). (Our numbers are large enough to be read from some distance away.)

3 Use the pounce wheel to perforate the outline of the forms on the design, being careful to preserve the shape (photo 3). It's helpful to place a cushion such as a folded, flat towel or a piece of flat foam under the paper while punching these holes.

Photo 2

Photo 3

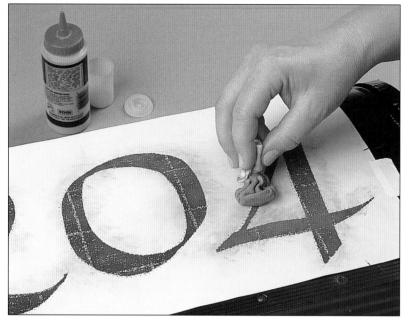

Photo 4

Photo 5

Photo 6

Photo 7

4 Tape the pattern in place on the mailbox, aligning it square with the bottom (photo 4). Use the pounce bag to dust chalk through the perforations onto the mailbox, lifting the design periodically to check your progress. Remove the design (photo 5).

5 Load the brush in preparation for painting. Palette it against a flat surface, allowing just enough paint to get between the hairs of the brush to flow freely while retaining a crisp chisel edge (photo 6). If the paint gets too thick, add solvent sparingly to the mixture on the palette to improve its flow. Our numbers couldn't be painted in a single stroke of the brush, so they were first outlined and then filled in (photo 7).

6 When the paint is completely dry, wipe off the chalk dust.

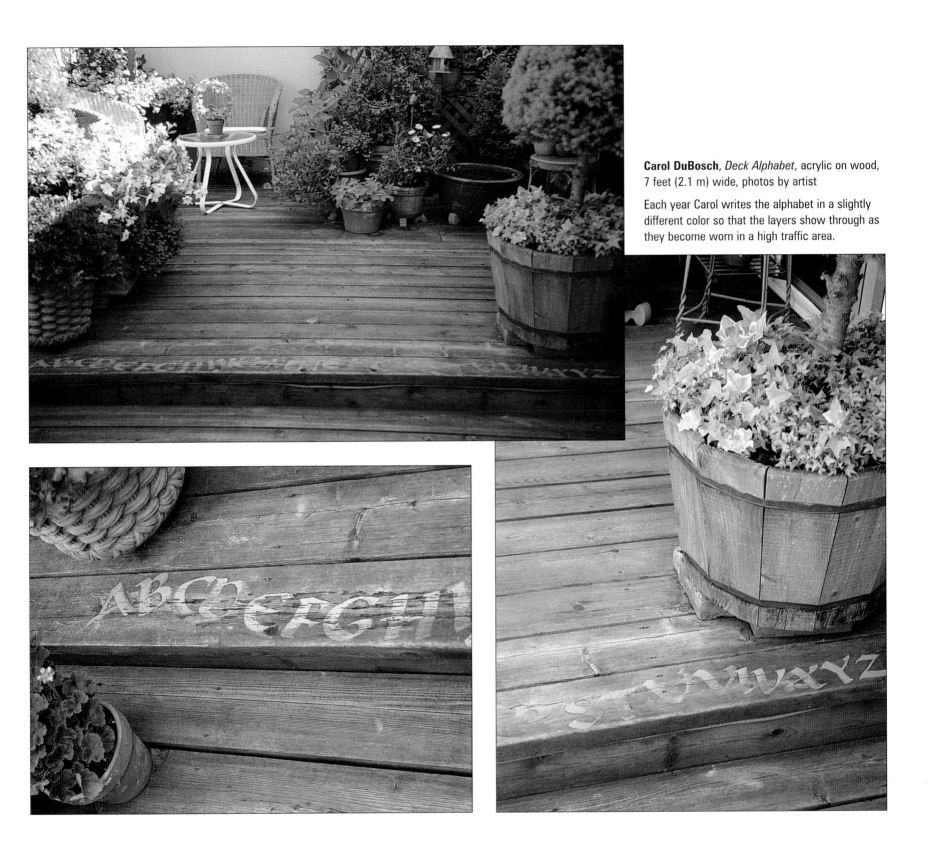

Carol DuBosch, *Deck Alphabet*, acrylic on wood, 7 feet (2.1 m) wide, photos by artist

Each year Carol writes the alphabet in a slightly different color so that the layers show through as they become worn in a high traffic area.

Lettering on Fabric

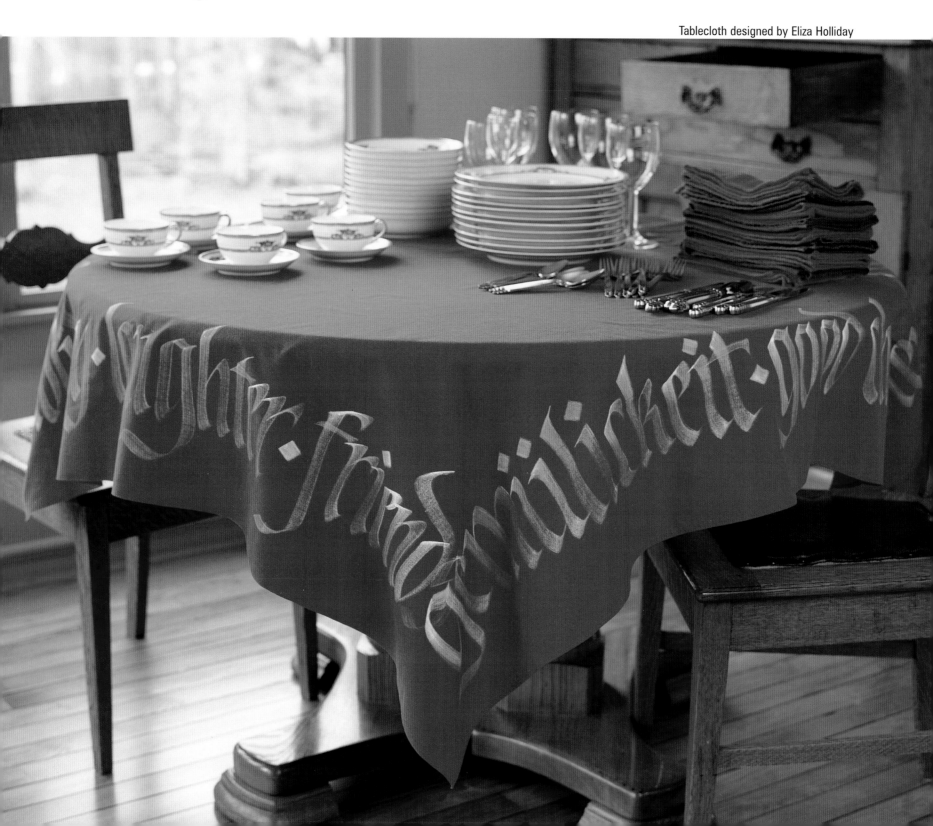

Writing on fabric has many applications, from window curtains and banners to T-shirts and pillows. You can letter on canvas, broadcloth, or silk—each has a different texture and will lend a different kind of drag to the brush. In many cases, you can drape the fabric across your drafting board, sliding it across as you work.

If you're painting something that needs to be washed, such as a tablecloth, use fabric paint or artist's acrylic paint. In this case, we brushed on the letters with acrylic paint.

MATERIALS AND TOOLS

Purchased tablecloth or fabric for sewing your own cloth (chose a heavy cloth, such as broadcloth)

Sewing supplies and sewing machine (if sewing your own cloth)

Scraps of fabric for practicing lettering

Tracing paper

Tailor's chalk

Flat brush and palette

Artist's liquid acrylic paint or paint made for fabric

INSTRUCTIONS

1 If you're making your own tablecloth, measure your table and allow about 10 inches (25 cm) of drop on the sides and the ends. If the width of the table plus the drop is wider than the fabric, you may want to cut out two side panels to sew onto a central panel, as we did for this project. Make sure to add seam allowances and hems into your calculations for cutting all the panels.

2 Before cutting the fabric, wash it to allow for shrinkage and remove the sizing. Do the same if you're using a purchased tablecloth. Iron the fabric/cloth after it's washed. If you're sewing a cloth, save some scraps of fabric for practicing after you cut out the panels. Lettering on fabric is different than paper, so you'll have to adapt your hand and the paint. If you're using a readymade cloth, practice on a scrap of fabric that's close to the texture of it.

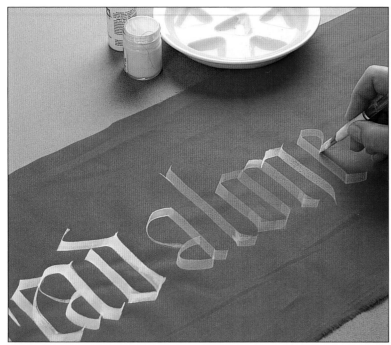

Photo 1

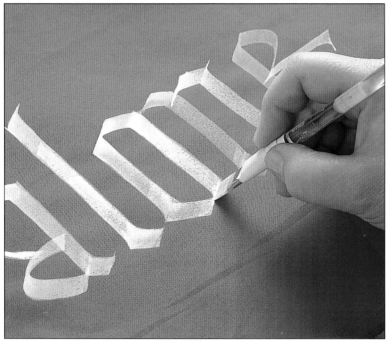

Photo 2

3 Plan your design on tracing paper, arranging the words to fit the available space. You can letter all the way around the cloth, along one long side, or along two sides. If you plan to paint letters on all four sides, you'll have to plan the corners. Either come up with an ornamental element to fill the space, or allow the beginning of one line to overlap the body height of the line perpendicular to it. If you're using lines of text, rather than a collection of words, you may have to adjust the spacing to get them to fit. You can also use ornamental forms between phrases or words.

4 Lay the fabric out on your drafting board with your design directly above or below it. Rule guidelines on the fabric with tailor's chalk.

5 After warming up on scraps of fabric, begin to letter the tablecloth. Pour some paint onto a flat palette, and load the brush by stroking it back and forth, maintaining the chisel edge while working the paint between the bristles. As you paint, you may have to palette the brush between every couple of strokes, since the paint will soak into the fabric, leaving a ghost-like effect (photo 1). It's a good idea to work your way through one coat, let the paint dry, and paint over it again to make it more opaque (photo 2). Fabric is very forgiving of this process, and the slight unevenness of the textured strokes creates a rich surface quality.

6 If you need to sew together your cloth, use flat-felled seams to sew it. Hem it on all four sides.

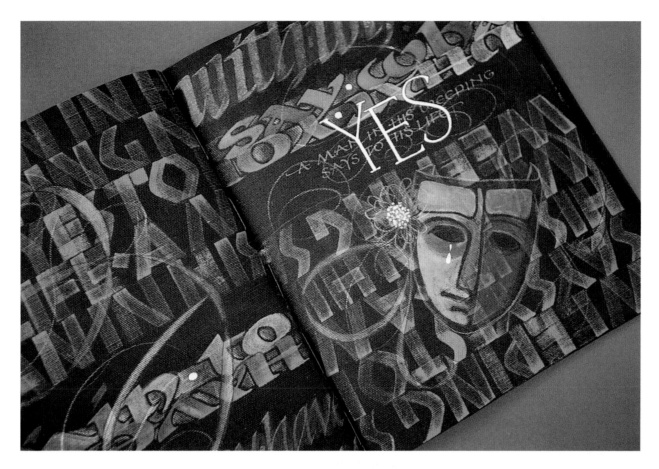

Jean Formo, *Another Language*, 1992, gouache, acrylic, patent gold leaf, colored pencil on canvas, done with brushes and metal pens, book bound by the artist, 12 x 10 in. (30.5 x 25.4 cm), photos by artist

Manuscript Book
with Medieval Page Format

The classical proportions and wide margins of medieval page format lend sophisticated elegance to a small manuscript book. You'll find that many text selections fit the proportions described in this project—whether you're writing a collection of quotations, recipes, poems, or a longer piece of prose. The formula works for both horizontal and vertical formats. A book such as this can be bound in a single signature of up to 20 pages using the binding process described on page 146.

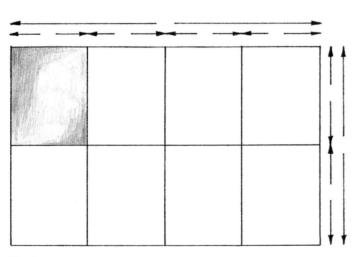

Fig. 1

MATERIALS AND TOOLS

Basic design tools: pens, pencils, T-square, triangle, ruler

Layout paper

Tracing paper

Text-weight 100% rag paper/pH neutral (suggested parent size is 22 x 30 inches [55.9 x 76.2 cm])

Craft knife

Cutting mat

Bone folder

Eraser

INSTRUCTIONS

1 The parent sheet that you choose for the pages of your book yields a certain number of sheets. If you begin with a standard-sized sheet of 22 x 30 inches (55.9 x 76.2 cm), you can cut four 11 x 15-inch (27.9 x 38.1 cm) sheets from it (figure 1). When you cut the paper, make sure that the grain runs parallel to the spine to allow for easier folding and prevent warping within the binding. To determine the grain, fold the paper in both directions to find the bend with less resistance. The grain will run parallel to the smaller curve.

2 Fold the sheets in half to form leaves with two 7½ x 11-inch (19.1 x 27.9 cm) pages. If you prefer smaller pages, fold the paper in half again to form leaves with two 5½ x 7½-inch (14 x 19.1 cm) pages.

3 Rule your page proportions on layout paper, leaving a 1-inch (2.5 cm) margin around the sheet. Use a very sharp pencil or pen to rule the sheet size (photo 1), following the sequence in "Drawing Up the Margins" on page 181. Measure the rectangle you've created for the text block, and use this to draw a template (photo 2).

4 If you're writing a piece in which the line length is determined by the content, such as a poem, recipe, or short quotation, determine the length of the longest line and make sure it fits the text block. Try out pens of different sizes as well as various styles of writing to suit the ideas you want to convey—your choices will be different for a Shakespearean sonnet versus a poem by *e. e. cummings* (photo 3). Estimate the number of lines that fit in each block to figure the number of pages of writing. In poetry, empty space is usually accepted as an integral part of the design, so you may end up with pages that contain only a few lines.

Photo 1

Photo 3

5 If you're writing prose, follow the rule of thumb of writing five to 10 words on a line, since any less can result in uneven right margins or trouble with hyphenation. To determine how many pages the text requires begin with the typewritten copy and count the number of words or lines in it. This process is called "copyfitting." (If the text is short, count the words; if longer than 200 words or so, count the lines.) Write a few lines of copy in the styles you're thinking about, keeping them at five to 10 words per line. For longer lines of text, make the interlinear space wider.

If you're calculating based on words, use a simple ratio to determine

Photo 2

how many pages you'll need for the book. For example, if 50 words require one page of your text, a 200-word text will require four pages. If your text is longer, calculate based on lines, using the ratio below:

Total hand-lettered lines:

lines of typed copy × lines of sample ÷ number of lines of typed copy used for sample

Putting this formula to use, three lines from your typed copy may take up 10 lines when you write it by hand. Thus, 40 lines of typed copy will need 133 lines in your manuscript.

$(40 \times 10) \div 3 = 133$ lines

6 You can also use a computer page layout program to calculate the number of lines. First, set up margins for your text block. Look through the collection of fonts in your computer to find one with proportions similar to the hand you've chosen. For example, Palatino Italic is a very classic italic design, and San Vito resembles a slightly narrow Foundational. You can tweak these with the letter proportion, leading, and spacing settings. Print these out, and you'll have an exact model to work from for your hand lettering, insuring accuracy and removing some of the anxiety of getting all the parts to fit correctly (photo 4).

DRAWING UP THE MARGINS

The layout of handwritten books from medieval times shows a consistent pattern in the positioning of text relative to the page. In spite of the high expense of vellum used for the pages of these books, the samples that remain contain ample margins. Perhaps medieval scribes learned to leave room around their painstaking work to prevent finger smudges from ruining it! Regardless of the origin, wide margins are still popular because they set off the text so beautifully.

In the early 20th century, Jan Tschichold uncovered the medieval canon used to determine such margins. This formula is still widely used, and works for all paper proportions. Follow the number sequence in figure 2 to establish the margins for your writing, ruling as follows:
• Draw diagonals across each page (indicated by #1)
• Draw diagonals across each sheet (indicated by #2)
• Draw a vertical from the intersection of #1 and #2 to the top of the page (indicated by #3)
• Draw a diagonal from the top of line 3 to the other intersection of lines 1 and 2 (indicated by #4)
• The intersection of lines 1 and 4 becomes the inside, upper corner of the text (indicated by point 5)
• Connect point 5 horizontally to line 2 to form the top margin (indicated by #6)
• Continue around the rectangle, counterclockwise on the left page, clockwise on the right (indicated by #7). Rule guidelines for text within this block. "Hang" elements from the top line. The bottom margin may vary depending on the length of copy for each page.

Photo 4

Fig. 2

7 Once you've determined the style and size of your text, you can use a paper ruler to indicate where to draw guidelines. Transfer these lines to good paper, and rule carefully on both sides of the paper. Line up the guidelines from front to back.

You can also accomplish this with a pair of dividers (photo 5). Use them to measure the distance from baseline to baseline and walk them down the page, piercing a small hole in the paper at each point. Mark the height of the line in the same way, using the first hole you punched for placing one leg of the dividers. Place a sharp pencil directly in each hole before drawing the guidelines across the page. Rule both sides of the double-page spread at the same time. Turn the sheet over, and use the same holes to rule the other side.

Photo 5

MEDIEVAL RULING

To define the text area, the medieval scribe often stacked up a number of sheets and punched holes through the four corners of the text rectangle all at once. Guidelines were ruled by punching a series of holes down the side of the page, and a stylus was used to score the lines, leaving a shallow groove on one side and a small ridge on the other. Scribes sometimes wrote between these lines, rather than using them as a baseline to avoid catching the quill in the groove or ridge.

Ruling up a manuscript book is somewhat laborious, since you must rule two columns for each double-page spread and both sides of the sheet. Medieval scribes passed this job down to their apprentices, but you can use this time to meditate on the job ahead as you accomplish the task.

8 If you plan to use dropped caps or decorated letters on your pages, you have several choices to make. Decide whether you want them to hang into the margin slightly or sit entirely within the text block; whether you want them to take up two, three, or even four lines of writing; and/or whether you want them to be perfectly square or rectangular (figure 3). If you're including other illustrations, plan their relationship to the text and block out areas for them.

9 As you stack up your ruled sheets, lightly number them with a pencil (figure 4). Create a title page, which is usually a right-hand page or recto page. The text will begin on page one, another recto page. The left-hand page that falls opposite this first page, or verso page, can be left blank or be illustrated.

Fig. 3

Fig. 4

10 Begin writing on page one, a recto page with a mountain fold facing you (photo 6). Letter the body of the text, leaving any illustrations for later. After completing page two, pick up a new sheet (another recto page with a mountain fold), and start writing on page three. Continue, adding new sheets until you reach the mid-point of the typewritten copy. At this point you'll cross *over* the centerfold and begin to write on the remaining pages, with a valley fold facing you. If there is any doubt as to whether you're at the halfway point, add an extra sheet. It's better to have an extra page at the back of the book than to run out of pages.

11 When you've finished writing the text, add any illustrations.

12 At the end of the book, it's traditional to add a colophon, an inscription that describes the materials used, the reasons for writing the book, and the date and place it was written. This is also the place for you to sign your name.

13 If you wish, erase the guidelines as a last step. To bind the book, use the binding shown on page 146.

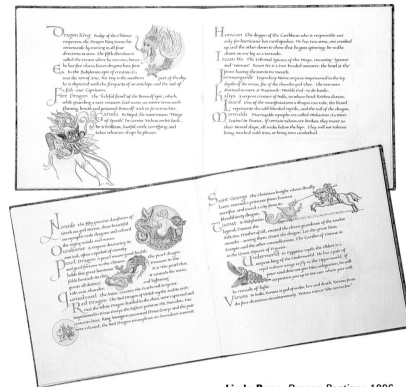

Linda Renc, *Dragon Bestiary*, 1996, ink and gouache on paper, 11¼ x 11¾ in. (28.6 x 29.8 cm), photos by artist

This A to Z collection of mythical beasts of many cultures combines traditional letterforms with illustration.

Carol Pallesen, *Life on this Planet*, 2002, casein paint background lettered with gouache, bound in fabric and leather, 12 x 12 in. (30.5 x 30.5 cm), photo by artist

This contemporary "book of hours" contains many quotations and poems about nature and the environment.

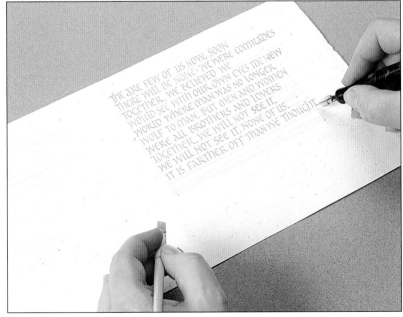

Photo 6

Glossary

Alphabet panel. A lettering design used to experiment with form and layout using the letters of the alphabet, in order, as text.

Arch. The portion of a lowercase letter formed by a curved stroke attached to the stem, requiring two strokes, as in Foundational and Humanist Bookhands.

Archival. Art materials that have been developed and manufactured to ensure longevity. In general, archival materials are pH neutral and light fast.

Ascender. The upper stem of a lowercase letter, such as those found in the letters b, d. and h.

Ascender line. The line that defines the upper stems of letters.

Baseline. The writing line on which the main body of the letter sits.

Bâtarde. A style of Black Letter that initially evolved in northern France from a Gothic cursive style of writing.

Black Letter. A generic term used to describe a condensed style of writing dominant in the 12th through 15th centuries; also known as Textura, Old English, or Gothic.

Body height. The distance between the baseline and waistline of an alphabet; also called the x-height.

Bowl. A curved stroke attached to a stem that creates an enclosed area such as found on the letters p, q, R, and D.

Bracket. A curved stroke imposed over a straight stroke, notably in entrances or serifs, giving the form a smoother shape.

Bracketed entrance. An entrance made in two strokes that creates a curved shape on one side of the entrance.

Branch. The portion of a lowercase letter formed by a curved stroke springing from the stem in one continuous stroke, as in Italic scripts.

Broadside. A sheet with writing on only one side.

Cancellaresca corsiva. The Italian term for an informal, or cursive, Italic.

Cancellaresca formata. The Italian term for a formal Italic.

Cap height. The distance from the baseline to the cap line of an alphabet, which is the approximate height of the capital letters. It is often less than the height of the ascenders on the accompanying lowercase letters.

Chancery. A class of Italic letterforms generally distinguished by lengthened and curved asenders and descenders. These scripts were used to document court proceedings in papal or legal chanceries.

Copperplate. A script used primarily in the 16th through 19th centuries, written with a pointed pen that requires pressure to make thicks and thins, and distinguished by a great deal of swashing and flourishing.

Counter. Any space within a letter, either fully or partially enclosed. The term comes from the type foundry's counter punch, a tool used to punch out these inner spaces as metal type was formed.

Cursive. Any rapidly written form of writing, which usually results in an informal appearance with more joined letters, loops, and a forward slant.

Descender. The lower stems of letters such as g, p, and y.

Designers' gouache. An opaque water-based paint used for writing in color. It is pigment-based, rather than dye-based, and results in smooth letters that flow evenly from the pen.

Dividers. A drafting tool with two points used for transferring measurements. These are often sold as a compass/divider, with one of the points being interchangeable with a pencil point.

Downstroke. A stroke that is directed downwards.

Ductus. The direction and order of the strokes used to construct a letter, often diagrammed with numbered directional arrows.

Entasis. The narrowing in the middle of a stem by either using two strokes to make it, or by using pressure at the ends to widen the top and bottom of the stroke.

Entrance. The shape of the first part of the letter, as the pen just touches the paper.

Exit. The shape of the last part of the stroke, as the pen is lifted from the page.

Flourish. An addition to a letter that reaches well beyond the boundaries imposed by the guidelines. A flourish implies movement and grace and is often the only ornament needed on an otherwise straightforward piece of writing. Flourishes are elegant when used sparingly, but overdone or poorly designed ones can result in an illegible tangle.

Font. Previously this term referred to a style and size of type, because each size of metal type was kept in its own tray. With the advent of the computer, this term usually refers to a particular style of type. A font consists of the upper- and lowercase letters, as well as numbers and punctuation.

Foot. A small stroke on the bottom of the stem used to strengthen the form. The Foundational f has a foot.

Fore-edge. The outside edge or margin of a book page, opposite the spine.

Form. As an element of design, form is used to imply a three-dimensional image. Calligraphers also use this term as a shortened version of letterform, which refers to the shape of a letter.

Foundational. A teaching hand with a very circular shape and a consistent 30° pen angle, developed by Edward Johnston in the early 20th century and based on the Ramsey Psalter.

Fraktur. A style of Black Letter written with apparent breaks in its structure, an almond-shaped o, and highly ornamented capitals.

Gothic. Another term used for the Black Letter scripts, although not in common use.

Gothicized Italic. A 20th-century script developed by Edward Johnston. It is similar to Fraktur in its almond-shaped o, but its branched letters are smoother, reflecting its Italic similarities.

Gum arabic. A resin in liquid form added to gouache as a binder. It is also part of the formulation of both gouache and watercolor, and remains water soluble after it dries.

Gum sandarac. A resin that is ground in a mortar and pestle into a fine powder, used to prevent ink and paint from bleeding into an absorbent piece of paper.

Half Uncial. Somewhat of a misnomer, this style of writing (dominant during the sixth to eighth centuries) can be thought of as a transition between the uppercase qualities of Uncial and the lowercase qualities of Carolingian and Humanist Bookhands. Because of its archaic forms, it is not particularly legible for the contemporary reader.

Humanist scripts. These forms are based on those used by the humanist scholars of the Italian Renaissance. They include the Bookhands, precursors to lowercase Romans, and Humanist Cursive (Italic).

Illumination. Decorated letters that adorn the pages of medieval manuscripts often have gold leaf on them, which reflect light as the pages turn. This phenomenon lent its name to all forms of decorated letters.

Insular Half Uncial. Scripts written in the British Isles are referred to as Insular. These scripts, representing a golden age of manuscripts in the Middle Ages, resulted in such masterpieces as the Book of Kells and the Lindisfarne Gospels.

Interlinear space. The space between lines of writing.

Italic. A family of letterforms that originated in the early 16th century, noted by a forward slant, branched letterforms, and more frequent ligatures. Its forms can range from formal precision to loose scribbles.

Italic Cursive. A looser version of Italic, noted by its forward slant and more frequent joins. It serves as an excellent model for everyday handwriting.

Letterpress. A process in which a metal relief plate is made from the artwork, giving your work a look reminiscent of printing from the late 19th and early 20th century. Printed on high-quality paper, letterpress is often used for bookplates, fine invitations, and poetry. Most letterpress is done from handset type, but your fine writing and any photos can be photographically transferred to make the plate. Because the paper is pressed onto the plate, a faint indention is left that lends a rich look to the work.

Light fast. When exposed to light over a period of time, some materials are not light fast and will change in color. For projects that are meant to last a long time, such as a family tree or a book of remembrance, it is important to check to see that all materials are light fast, i.e. they will not degrade with exposure to light.

Lowercase. A letter with ascenders and descenders, which uses the waistline to define the tops of the body height letters; also called minuscule letters in hand lettering. This typographic term refers to the fact that typesetters stored these loose types in the lower of a pair of cases.

Majuscule. A capital letter, or letters that are of equal height.

Minuscule. A non-capital, or lowercase letter. These letters can have ascenders and descenders.

Monoline. A line that does not vary in width.

Neuland. A typeface, designed by Rudolf Koch, which has been adapted by scribes into a very informal style of capital letters.

Nib. The actual pen point. It is either permanently attached to a holder, such as a fountain pen, or it can be used in pen holder.

Nibbing off. An invented term used to describe the process of making precisely placed marks to determine the height of a letter.

Nib widths (n. w.). The term used to define the height of the letter, with units made by turning the pen to a 90° angle and pulling horizontal strokes stacked on top of each other.

Old English. A somewhat archaic term used to define Black Letter scripts.

Papyrus. One of the earliest (2200 BC) surfaces upon which scribes wrote, it was made from the papyrus plant found in northern Africa.

Parchment. A prepared surface, usually made from sheep or goat skin, used to make books before the introduction of paper to Europe. Imitation parchment papers exist in the market today, but their surface is slick and not very satisfactory to write on. Genuine parchments and vellums are commercially available.

Parent size. Manufacturers produce paper in rolls, and then cut it down to various sizes for printers and artists. The size you buy your sheet is known as the parent size.

Pounce. An abrasive powder used to bring up a slight nap on very smooth paper, thus making it easier to write on.

Proportion. The ratio between the height and width of a letterform, a page, or the elements on a page. It refers to this mathematical relationship, but also to the aesthetic relationships you incorporate in your design.

Rhythm. The arrangement of multiple elements, either with evenly repeating duration or wildly alternating variations, to create a sense of movement and vitality.

Roman Capitals. A form of uppercase letters noted for their formal qualities and geometric proportions, and based on inscriptions carved during the Roman Empire.

Rotunda. A style of Black Letter, written primarily in southern Europe, in which the o is round and the remaining letters are less angular. It is often seen on large pages of music known as antiphonals.

Rustic. A very early style of writing that uses a steep pen angle and a narrow form. It has been found both on monuments and in manuscripts. Its narrowness contrasts with the wide letters of Roman Capitals, and it is a space-saving hand.

Serif. A short, decorative stroke used to finish off the main stroke of a letter. Many different types exist, incorporating slabs, brackets, hairlines, or wedges.

Size. In general, this refers to the height of the letter.

Sizing. Paper makers incorporate this substance into the paper pulp in order to make it more receptive to ink. Some papers are coated with additional sizing afterwards, making them even smoother.

Slab serif. A simple serif made by moving the pen in a horizontal direction, with no pen manipulation or retouching.

Slant or slope. The apparent forward lean of a script. Styles like Roman and Foundational are vertical, Italic is written with a slope between 3 to10°, and Copperplate is written with a slope of 25 to 35°. Ruled slant lines on your paper help to maintain this slope.

Spencerian. A business style handwriting developed in the United States in the 19th century. Similar to Copperplate, it has simpler lowercase letters but very ornate capital forms.

Structure. All the specifics, such as the nib widths, the pen angle, and the slope and stroke sequence involved in the anatomy of a letterform. This term also refers to the overlapping of strokes required to refine the forms.

Style. A particular family of letterforms, such as Italic or Black Letter; also referred to as script, hand, or alphabet. These terms refer to hand lettering, whereas the terms font or typeface are used in typography.

Sumi ink. A carbon-based ink produced in Asia, which can be purchased in either stick or liquid form. European or American manufacturers call it India ink.

Suzuri. A stone with a carved well used for grinding sumi ink sticks with water to make black ink.

Swash. An extension added to a letterform into the surrounding space. These curved forms imply formality and even luxury.

Sweet Roman Hand. A term applied to the Italic family of letters.

Textus Quadrata. A Black Letter script with a very compressed appearance like a picket fence. The o is based on a hexagon, and the remaining letters are angular.

Typeface. A style of type consisting of the upper- and lowercase letters, as well as numbers and punctuation.

Uncial. A late Roman style of lettering, in common usage during the first to sixth centuries, which appears to the modern eye to have both capital and lowercase forms. However, this hand preceded the concept of cases, and in contemporary usage is written in all caps.

Unit. A consistent distance used in measurement, whether in letter design, such as in counting nib widths; letter spacing, such as in finding the area between odd-shaped forms; or in design, with elements of a consistent size used in a repetitive way.

Uppercase. A capital letter ranging between two guidelines, with no ascenders and descenders; also known as majuscule. This typographic term refers to the fact that typesetters stored these loose types in the upper drawer.

Upright. A term used in this book to clarify the concept of unit spacing in the discussion of letter spacing.

Vellum. A prepared surface, usually made from calfskin, used to make books before the introduction of paper to Europe. Some commercial tracing and drafting papers are also referred to as vellum, and these work well for writing that will be reproduced. Genuine parchments and vellums are commercially available.

Versals. A large family of letters based on capitals, but with a wide variety of potential shapes. Traditionally these were drawn forms used to open verses or paragraphs and were much larger than the text. Versals with illustrations, gilding, or other decorations are called illuminated letters.

Waistline. The line that defines the tops of lowercase letters that do not have ascenders. It is sometimes referred to as the midline or the x-height line.

Walnut ink. A kind of ink made from walnut hulls, which produces a rich sepia tone. A commercially available version is actually made from peat moss.

Weight. The relationship of a letter's nib width to its height.

X-height. The distance between the baseline and waistline of an alphabet, also called body height.

Author's Biography

A former chemical engineer, Annie Cicale says that she became an artist when she decided to get serious about her career. She holds a BFA in printmaking and an MFA in graphic design. She has taught art from elementary school to the university level, has served on the faculty for many of the international calligraphy conferences, and teaches workshops throughout North America. Her work has been widely published.

She has also had a number of one-person shows, including the installation of *The Face of Humanity* at galleries in Tennessee, Montana, Illinois, and North Carolina. She divides her time among teaching, graphic design work, and her first love—painting.

Annie Cicale, *The Truth*, 2001, gouache, ink, and watercolor on handmade paper, 11 x 30 in. (28 x 76.2 cm), photo by Jon Riley

Acknowledgments

This book developed out of the ideas of many people, from my teachers and students to family and friends. As I wrote it, I recalled lessons and conversations from years gone by. The largest thanks possible goes to the following people:

• My teachers, beginning with Ray Campeau, Walter Hook, Marilyn Bruya, David Dixon, Ralph Slatton, and M. Wayne Dyer. I've encountered many calligraphy instructors over the years who made me realize that calligraphy is meant to be a inspiration for personal expression, not a dogmatic set of rules.

• I'd like to also thank teachers Sheila Waters, Mark Van Stone, Hermann Zapf, Ewan Clayton, Thomas Ingmire, Peter Thornton, and Denys Taipale-Knight for being who they are and being a part of my life.

• Heartfelt thanks to the late F. Edward Catich, Dick Beasley, and Leana Fay. Their voices echoed in my head as I wrote. I am truly the product of the calligraphic movement of the past 20 years, and there are many other instructors to whom I owe thanks as well.

• I have had hundreds of students who have asked many questions that have made me articulate things in a new way. In this realm, thanks especially to Virginia Melzter, who was always way ahead of me.

• Thanks to my calligraphic friends—Gini Ogle, Carol Pallesen, Pat Sheeler, Betty Devine, Patte Leathe, Gay Ayers, Nancy Culmone, Anna Pinto, Doug Boyd, Bob Phillips, Louise Grunewald, Sharon Zeugin, MaryAnn David, and Aimee Michaels—whose passion for this subject is tempered only slightly by their love of all the other important things in life.

• Thanks to the Mountain Scribes of Asheville, North Carolina—Julie Gray, Liz Simmonds, Liz Sample, and Patricia Trenchard—who gave many hours to help out with this project including sorting slides in my studio, contributing their own work, and listening to the rhythms of the language as we rolled down the highway.

• The calligraphic community has brought together many teachers and students through workshops and conferences that bring these ideas to the hands of artists around the world. Thanks go to each workshop coordinator and conference director who put in so many hours away from their drawing boards to set up these programs.

• To John Neal and Brenda Broadbrent, who supply our craft with many tools and books, and answered a few of my questions about what to include in this one.

• To my clients and family, who allowed me to reproduce real projects instead of made-up ones—especially to Jessica and Carl Borgquist, whose wedding invitation we used, and to Kerry Mangum, whose guest book we included.

• Thanks to the staff at Lark Books know how to create beautiful books with the highest standards. Thanks go to my editor, Katherine Aimone, who can tweak the English language so well, beating it into submission to be as clear as possible. Thanks also to graphic designer Kristi Pfeffer who arranged the text and images in this book with care and sensitivity. Thanks to photographer Steve Mann who shot the many photographs of artwork and demonstrations, while art director Chris Bryant envisioned a clear presentation (and cheerfully polished my ink-encrusted nibs!).

• To Lark Books' Executive Editor, Deborah Morgenthal, and Director of Publishing, Carol Taylor, for conceiving of this book in the first place.

• To Assistant Editor Nathalie Mornu, who relentlessly tracked down historical images and permissions for the purpose of reproducing them.

• To the more than 100 artists who submitted images for consideration in this book. (If we'd had 50 more pages, we still would have left out some spectacular work!)

• To my children, Katy and Dave, whose sensitivity to the written word shows in their own writings and artwork.

• And most especially, to my sweet husband Bob, whose comment, "Do you ever even think about dinner anymore?" is only one of many indications that perhaps I got too involved in this project. I'm looking forward to finding my kitchen again.

• I would also like to acknowledge the influence of the great writers whose words we use as a starting point in our craft, giving their profound ideas a visual interpretation. While every effort has been made to trace all the copyright holders of quotations used in this book, we would like to apologize for any errors or omissions and will make any necessary changes in further editions of this book.

About the illustrations:

The diagrams in this book were done with walnut ink on text laid paper and corrected in Photoshop. I attempted to keep the handwritten quality of the forms, but altered proportions and alignment to present a more "pure" version of the alphabets. Nevertheless, these are simply my interpretations of classical forms and should not be slavishly copied.

Mary Teichman, Illuminated "G" from the Desiderata poem (detail), egg tempera, ink

Marcia Smith, *Non Omnia Possumus Omes*, 2002, ceramic with painted glazes, raised lettering done with pointed pen, 6 1/2 x 6 1/2 x 2 1/4 in. (16.5 x 16.5 x 5.7 cm), photo by artist

Carol Dutoit, *Glass Quilt*, iridescent glass, painted with ground glass and pine oil, fused with clear glass, 40 x 34 in. (101 x 86 cm), photo by artist

Index

Artists Index